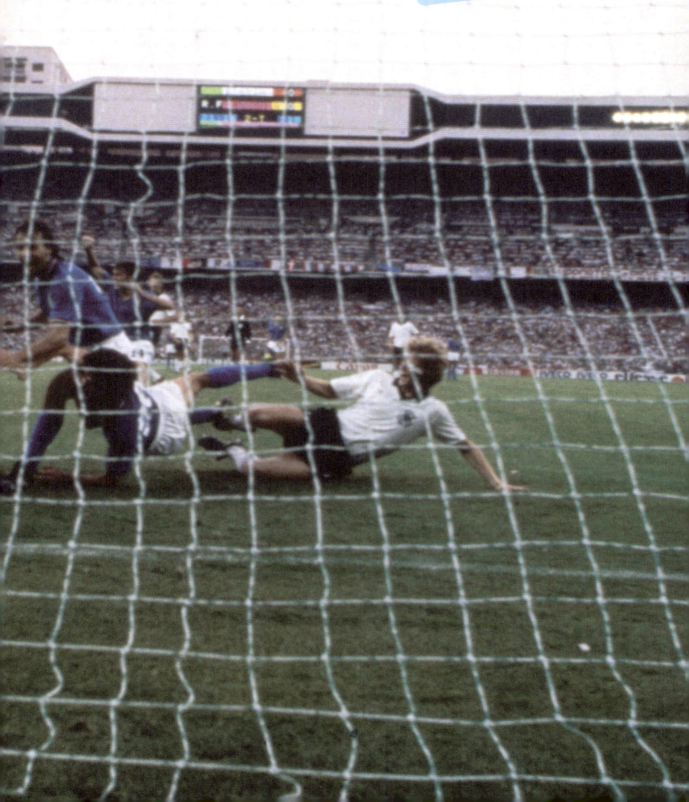

Glory and Despair

Pitch Publishing Ltd
A2 Yeoman Gate
Yeoman Way
Durrington
BN13 3QZ

Email: info@pitchpublishing.co.uk
Web: www.pitchpublishing.co.uk

First published by Pitch Publishing 2022
Text © 2022 Matthew Bazell

1

A CIP catalogue record for this book is available from the British Library.

13-digit ISBN: 9781801501248
Design and typesetting by Olner Pro Sport Media. Visit www.olnerpsm.co.uk
Printed in India by Replika Press

Glory and Despair
The World Cup, 1930–2018

Matthew Bazell

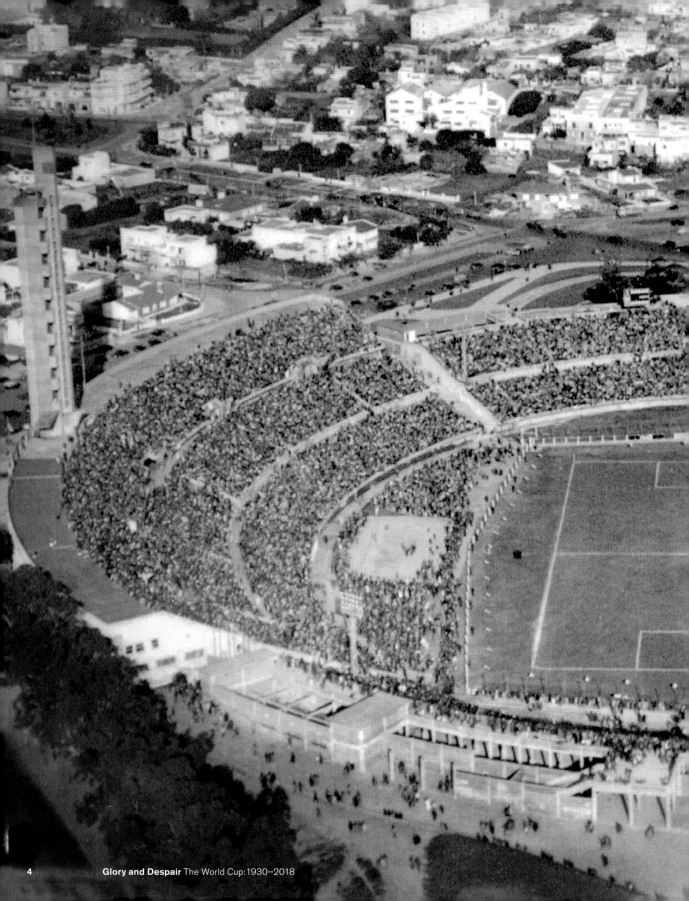

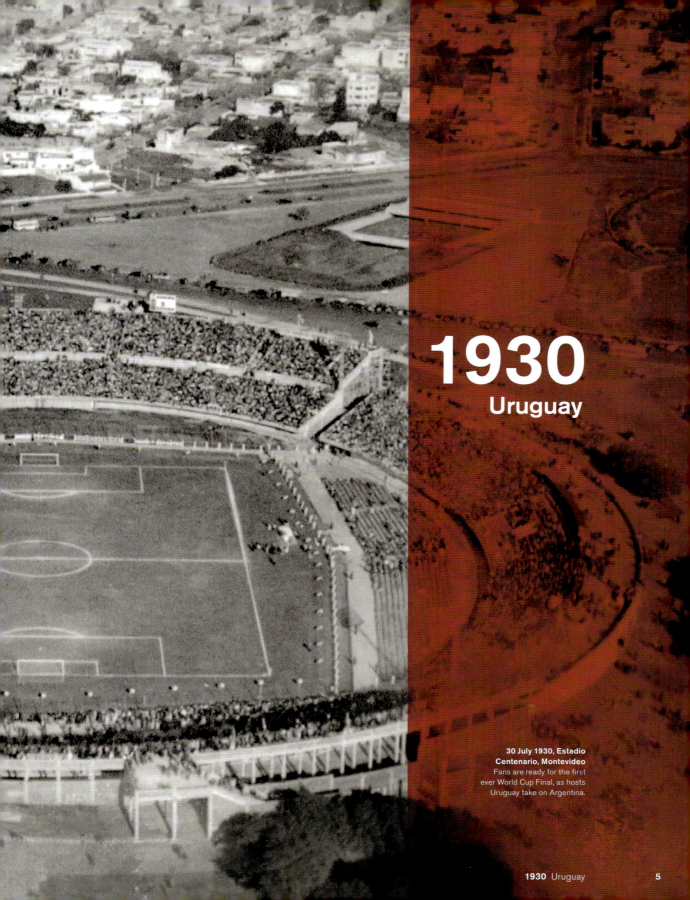

1930
Uruguay

30 July 1930, Estadio Centenario, Montevideo
Fans are ready for the first ever World Cup Final, as hosts Uruguay take on Argentina.

1930 Uruguay

FIFA had been set up in 1904 by founding members France, the Netherlands, Germany, Denmark, Spain, Switzerland, Sweden and Belgium. In 1921, Frenchman Jules Rimet became the third president of FIFA and would serve in this position for 33 years, the longest ever reign for the post. It was under his stewardship that the first World Cup was organised, and the gold trophy that was up for grabs was named Victory. When Jules Rimet passed away in 1956, Victory was renamed in honour of the father of the World Cup.

18 Argentina were the tournament's top scoring team

Uruguay had established themselves as an elite football nation by winning the gold medal in the Olympic Games of 1924 and 1928. In the days before the World Cup, the Olympics was the pinnacle of international honours in football and for that achievement, FIFA awarded them the chance to host the inaugural World Cup finals. This was a tournament where if you wanted to take part, you were in, and 1930 goes down as the one World Cup that didn't require a qualification process. Despite the idea of a world event, there was a danger that the only teams set to take part would come from the Americas. This was a time of the Great Depression and the cost of travel was a barrier for the European teams. The travel time by boat from Europe was over two weeks and initially not one European country had applied, and FIFA's world tournament was starting to look like a South American championship.

Eventually, Belgium, France, Romania and Yugoslavia agreed to the journey, and they had to be heavily persuaded. In a show of harmony and economic practicality all four teams travelled on the same boat, along with Jules Rimet. The French players got first-class cabins, while the other three teams could only afford third-class, but all four squads mixed and trained together during the journey. One player who didn't

8 Argentinas' Guillermo Stábile was top scorer

have to get on the boat was Belgium captain Raymond Braine as he was bizarrely suspended by his own FA for opening a café.

On 13 July two games kicked off at the same time to become the first World Cup matches. USA beat Belgium 3-0, and France beat Mexico 4-1. Lucien Laurent's opening goal for the French in the 19th minute put him in the history books as the first World Cup scorer; 68 years later and at the age of 90 he was a guest of honour at the 1998 World Cup Final in Paris.

Being a host nation has its perks and in 1930 the home advantage in a World Cup was evident straight away. In Uruguay's semi-final against Yugoslavia the ball was kicked out of play, only to be kicked back in again by a policeman, and then put into the back of the net for Uruguay's third goal, which incredibly was allowed to stand. To rub salt into the wound, Yugoslavia had a goal disallowed.

Other bizarre incidents included a dazed and confused USA physio being helped off the pitch – after he tripped over his own medical bag, broke a bottle of chloroform and inhaled the fumes. Most bizarre of all was the group game between Argentina and France when the final whistle was blown after 84 minutes. Argentina were 1-0 ahead and the French had already gone back to the dressing room when a decision was made to play out the remaining minutes. It would be fair to say that this news didn't go down very well with the Argentina players, and their attacker Roberto Cherro was so angry that he passed out. Luckily for the referee he didn't get to see Cherro's reaction to an equaliser, as the game still ended 1-0.

Typically, World Cups are held in different cities throughout the host country, but Uruguay being a small nation meant that the 1930 tournament would all be played out in Montevideo. In the final, at the purpose-built Estadio Centenario, Uruguay took on Argentina in front of 68,346 fans. Trailing 2-1 at half-time, the hosts came back to win 4-2 and go down as the first world champions in football history. Even in

the inaugural tournament, the glory and despair were no different from today, and the emotions were just as high. This was the most important game ever played up to that point, and after the final, the Uruguayan embassy in Buenos Aires was attacked by an angry mob of Argentinian fans. Over 90 years on from that first World Cup there are no surviving players. The last one died 80 years after the finals, and he was Argentina's Francisco Varallo, who was passed away in 2010 at the age of 100.

The first World Cup was witnessed live by the people in the stadium and no one else. In contrast, the 2018 finals were watched by over one billion people and hundreds of thousands of photos were taken, mostly from the crowd. The photographs of 1930 are scarce and should be cherished as important eyewitness historical documents.

Group 1

France	4	1	Mexico
Argentina	1	0	France
Chile	3	0	Mexico
Chile	1	0	France
Argentina	6	3	Mexico
Argentina	3	1	Chile

	P	W	D	L	GD	Pts
Argentina	3	3	0	0	6	6
Chile	3	2	0	1	2	4
France	3	1	0	2	1	2
Mexico	3	0	0	3	-9	0

Group 2

Yugoslavia	2	1	Brazil
Yugoslavia	4	0	Bolivia
Brazil	4	0	Bolivia

	P	W	D	L	GD	Pts
Yugoslavia	2	2	0	0	5	4
Brazil	2	1	0	1	3	2
Bolivia	2	0	0	2	-8	0

Group 3

Romania	3	1	Peru
Uruguay	1	0	Peru
Uruguay	4	0	Romania

	P	W	D	L	GD	Pts
Uruguay	2	2	0	0	5	4
Romania	2	1	0	1	-2	2
Peru	2	0	0	2	-3	0

Group 4

USA	3	0	Belgium
USA	3	0	Paraguay
Paraguay	1	0	Belgium

	P	W	D	L	GD	Pts
USA	2	2	0	0	6	4
Paraguay	2	1	0	1	-2	2
Belgium	2	0	0	2	-4	0

Semi-Finals

Argentina	6	1	USA
Uruguay	6	1	Yugoslavia

Final

Uruguay	4	2	Argentina

The official 1930 World Cup poster.

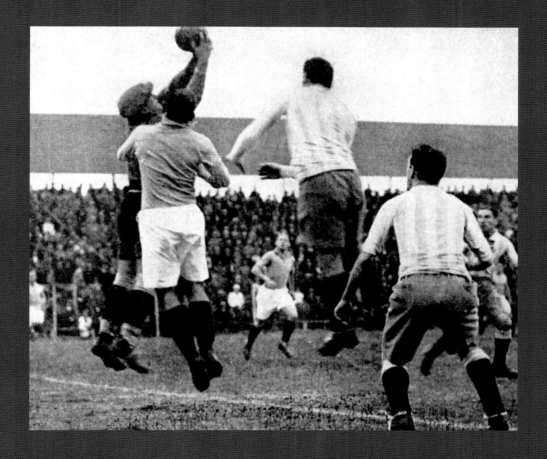

15 July 1930, Estadio Parque Central, Montevideo
Chaos erupts in the 84th minute of the group match
when the referee blows the final whistle with Argentina
1-0 ahead. After much protest from the French,
the remaining minutes were eventually played and
Argentina held on to their lead.

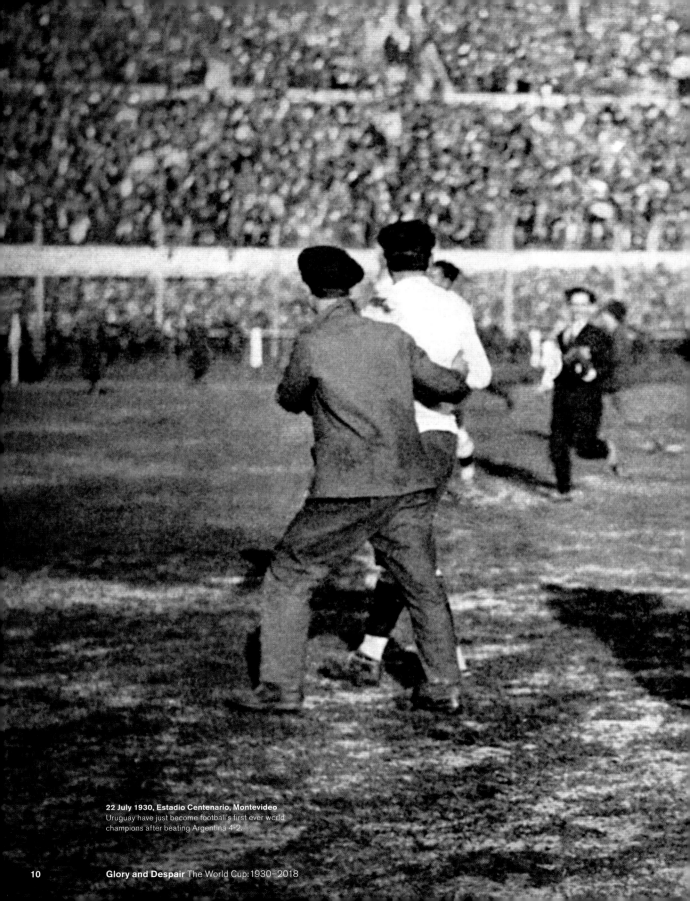

22 July 1930, Estadio Centenario, Montevideo
Uruguay have just become football's first ever world champions after beating Argentina 4-2.

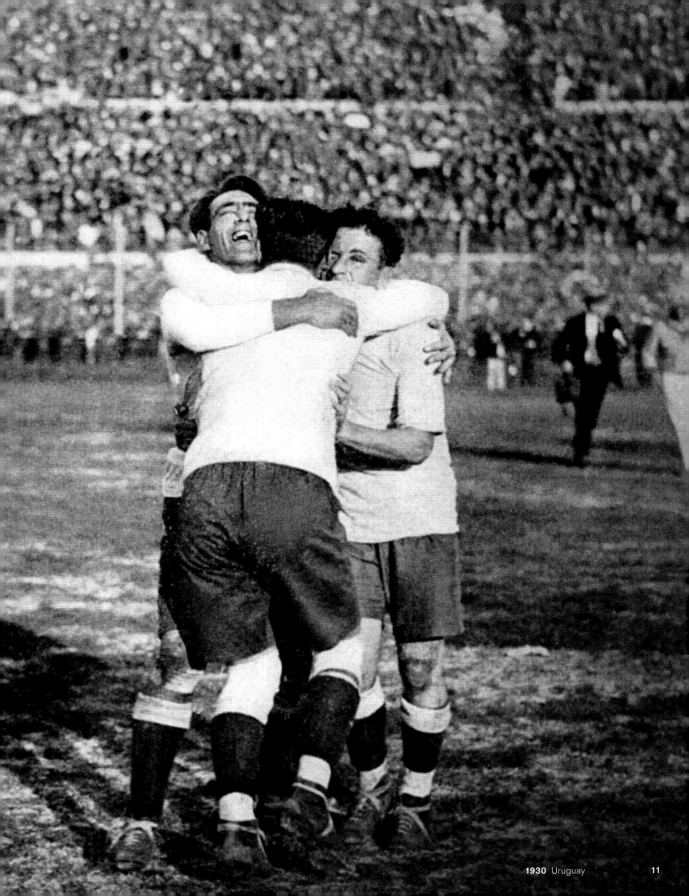

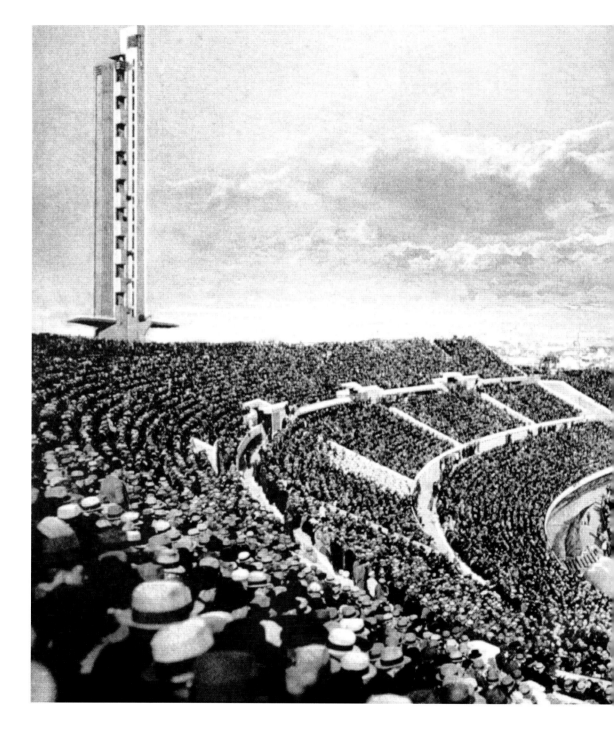

30 July 1930, Estadio Centenario, Montevideo
The official attendance for the first ever final was 68,346 and nobody else had the means to watch the game.
By 2018, over one billion people would tune in to watch.

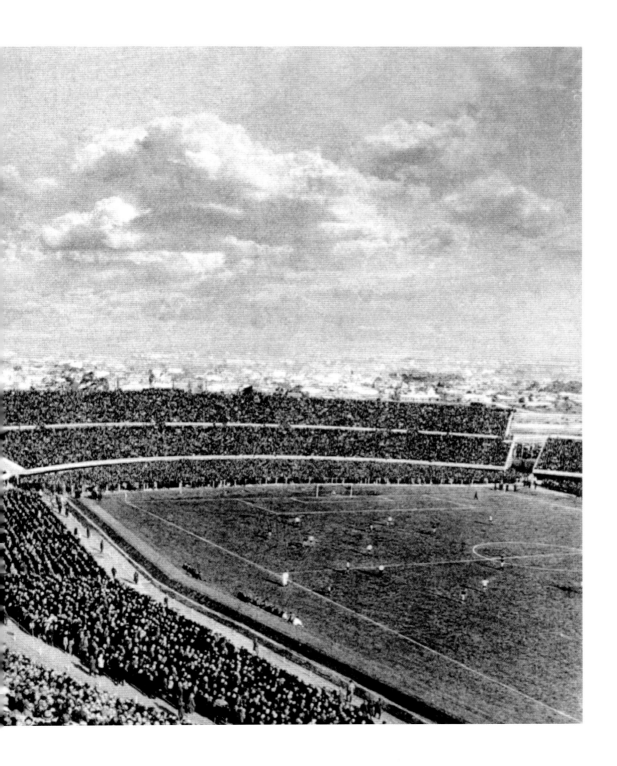

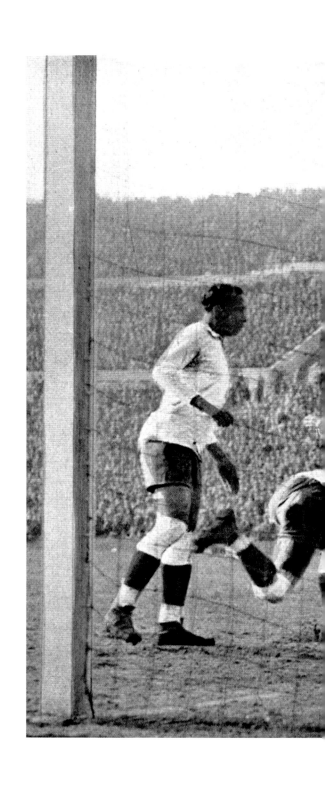

30 July 1930, Estadio Centenario, Montevideo
Argentina go 2-1 ahead in the first half of the final,
courtesy of Guillermo Stabile.

Glory and Despair The World Cup: 1930–2018

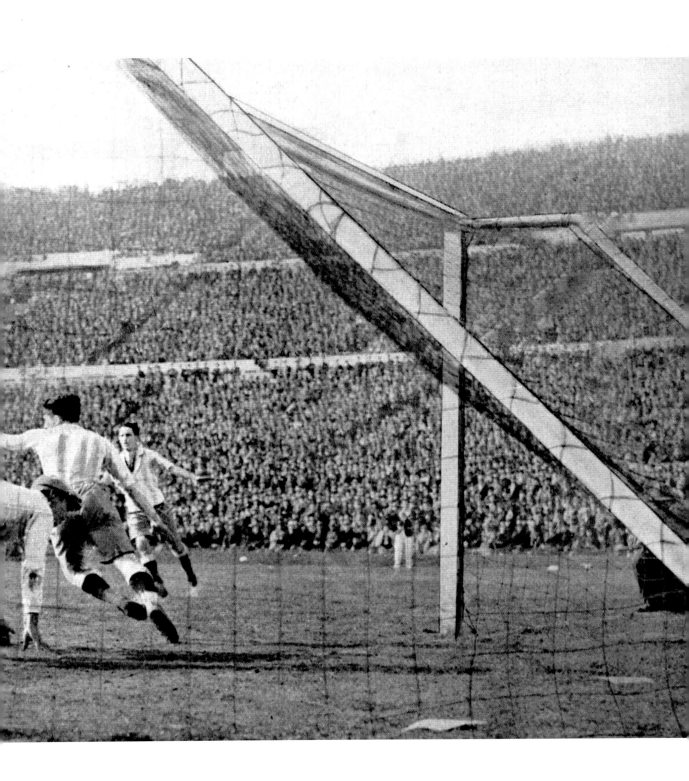

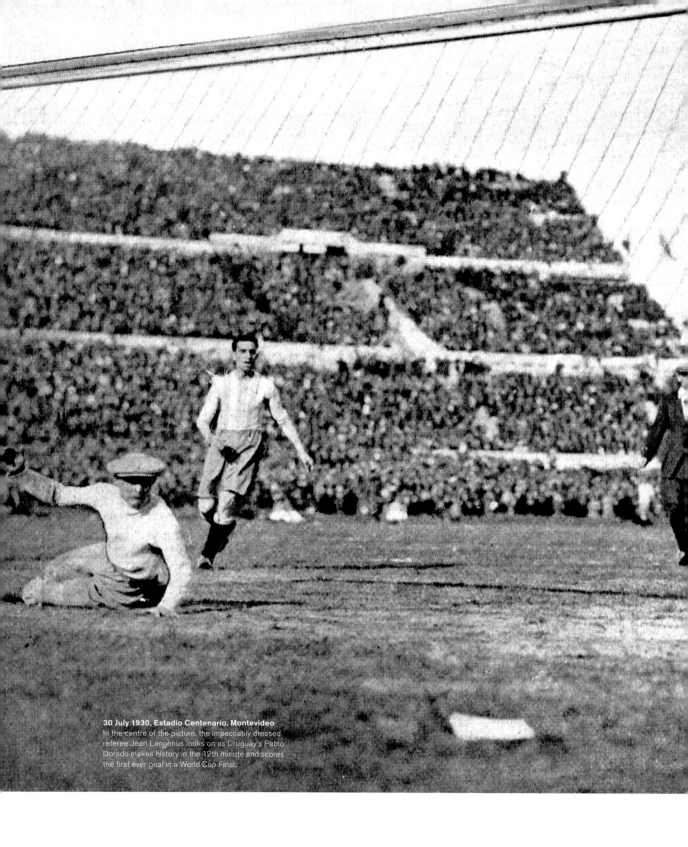

30 July 1930, Estadio Centenario, Montevideo
In the centre of the picture, the impeccably dressed referee Jean Langenus looks on as Uruguay's Pablo Dorado makes history in the 12th minute and scores the first ever goal in a World Cup Final.

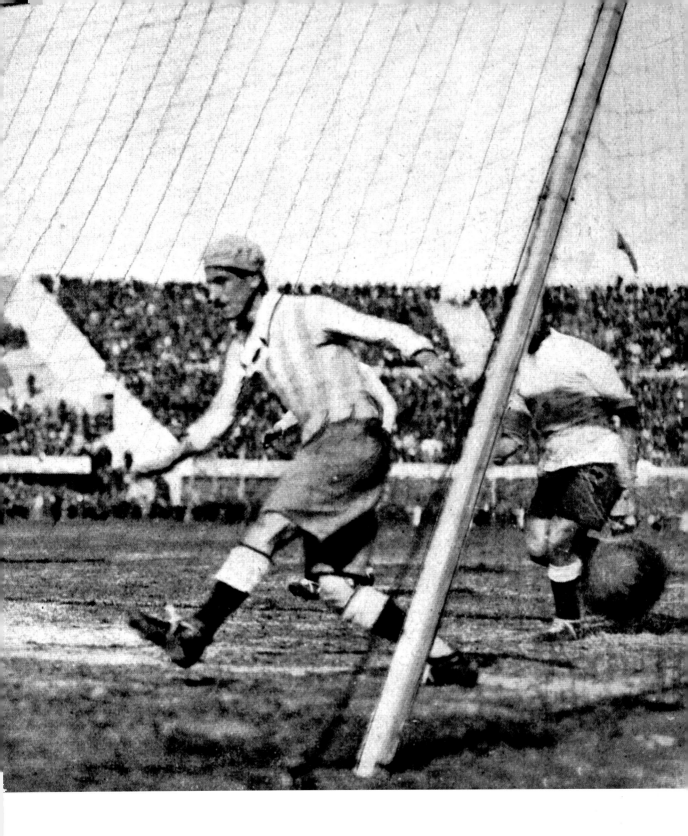

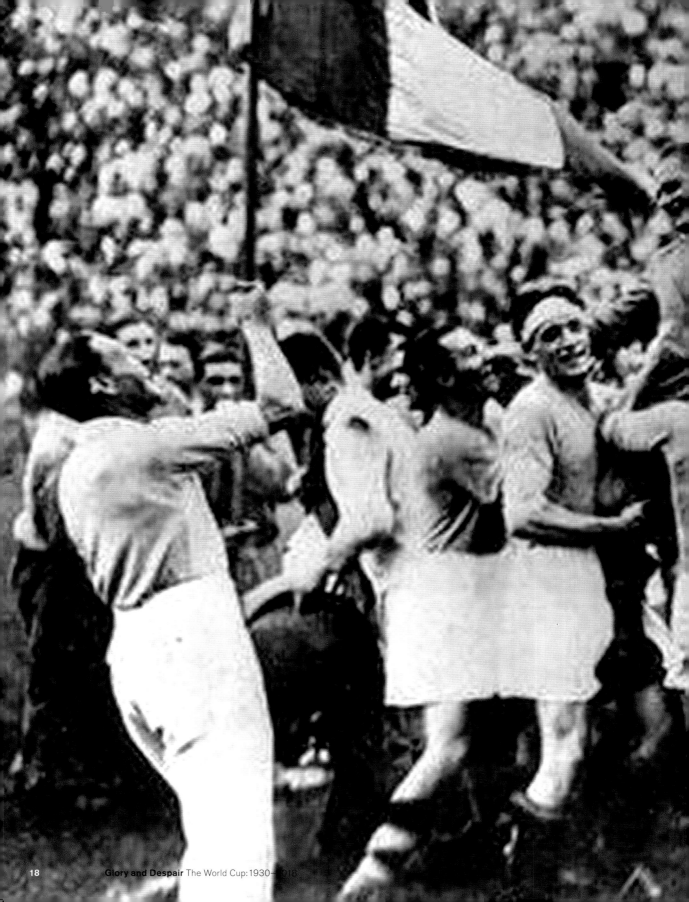

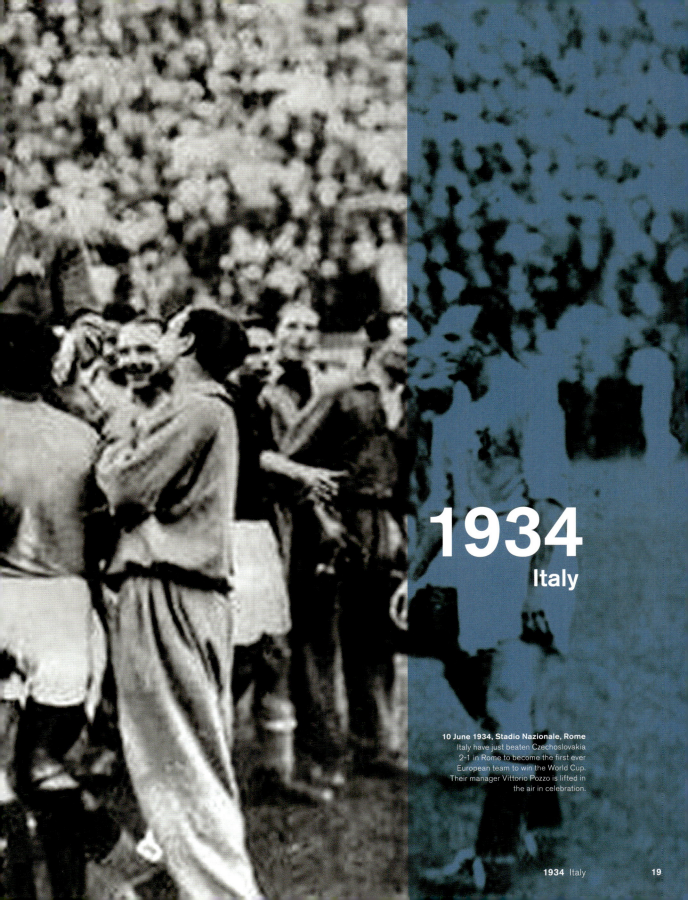

1934
Italy

10 June 1934, Stadio Nazionale, Rome
Italy have just beaten Czechoslovakia
2-1 in Rome to become the first ever
European team to win the World Cup.
Their manager Vittorio Pozzo is lifted in
the air in celebration.

1934 Italy

I'm not coming to your party because you never came to mine. That was essentially Uruguay's reasoning for not showing up in Italy, for the first World Cup in Europe. Four years is a long time to hold a grudge, especially when doing so meant you couldn't defend your world title, but Uruguay were insistent that they had been disrespected by only four European teams showing up in 1930.

11 Italy and Germany were the tournament's top scoring teams

This was the first World Cup in which teams had to qualify to take part, and bizarrely this process included Italy, who had to play Greece in a qualifier which luckily they won, otherwise there would have been a scenario of a World Cup being played without the host nation, which would have resulted in an interesting meeting between FIFA and Mussolini.

It wasn't the organisers' only bad decision. As the tournament kicked off, Mexico would have held as much love towards FIFA as the people of Amity beach did for Jaws. They qualified for 1934 and made the long journey to Italy. However, shortly before the tournament began, the United States decided they wanted to take part. Instead of FIFA saying 'sorry, too late' – they saw dollar signs and arranged a qualifier to take place in Italy between Mexico and the USA, in which the winner got to stay. The USA won and Mexico went home without playing one single game. No wonder they withdrew from 1938.

The USA only lasted for one game and were thrashed 7-1 by Italy, and eliminated. FIFA had decided

5 Czechoslovakia's Oldřich Nejedlý was top scorer

upon a straight knockout from the opening round, unlike in 1930 which had a group stage. This meant that countries making the long journey could do so for just the one match. Along with the USA, this was also the fate of Brazil and Argentina, and the next round would consist of just European teams, which is to date the only time this has happened in the World Cup's last eight/quarter-finals. The only other non-European team – Egypt – also went out in the opening game; however, their very presence would put them in the history books as being the first African team to compete in a World Cup.

Some of the decisions FIFA had taken suggested that alcohol was readily available during their meetings. The choice of host itself was highly contentious as Italy was ruled by Mussolini and had been since 1922. He became synonymous with the tournament in the way Hitler did with the 1936 Olympics. His presence would somewhat taint the Italy victory, as some later cried corruption related to Mussolini having an influence on which referees were selected for Italy's games. However, others felt that Italy were the best team of the era regardless of any accusations of foul play and pointed to the fact that they had won honours outside their own country, including the 1938 World Cup in France.

The final was played at the packed out 'Stadium for the Fascist Party' (now a rugby stadium, and yes, it has been renamed) in Rome, and Czechoslovakia faced the hosts after beating Germany in the semi-final. Italy had recorded a 1-0 victory over a strong Austria side who were a pioneering football nation and boasted the forward Matthias Sindelar. Nicknamed The Paper Man for his lightness and grace, Sindelar was perhaps the finest player of the 1930s, and this would be the only World Cup that he would play in as Austria ceased to exist by the time of France '38. Sindelar died five years after the 1934 World Cup, in circumstances that remain clouded. He was found dead in a room in Vienna along with his girlfriend at the age of just 35. Some suggest suicide while others point to accidental poisoning. As there were suggestions that Sindelar was Jewish (which is also unclear because he was brought up Catholic) and that he was on a Gestapo file, many believe that he was murdered by the Nazis in a cover-up.

World Cup debutants: Italy, Czechoslovakia, Germany, Hungary, Netherlands, Austria, Spain, Sweden, Switzerland, Egypt.

The very physical and hard-tackling Luis Monti had marked (or roughed up) Sindelar out of the semi-final, and carries possibly the most unique stat in the tournament's history: he is the only man to have represented two nations in a World Cup Final. Four years earlier Monti had competed in the 1930 final for Argentina, the country of his birth. He fell out with his home nation, and FIFA had no issues with him switching to Italy, the country of his descent.

With 81 minutes gone of the 1934 final, it looked like Monti would lose two consecutive finals as Antonín Puč had put the Czechs ahead ten minutes previously. The film coverage from the game is so brief and scarce that additional acted out footage was filmed and included in the cut, such as a goalkeeper making a diving save – or a ball going into the roof of the net; however Puč's goal was caught on camera. With nine minutes remaining Raimundo Orsi levelled for Italy to be followed by an Angelo Schiavio winner in extra time. After two World Cups, the host nation had been triumphant on both occasions.

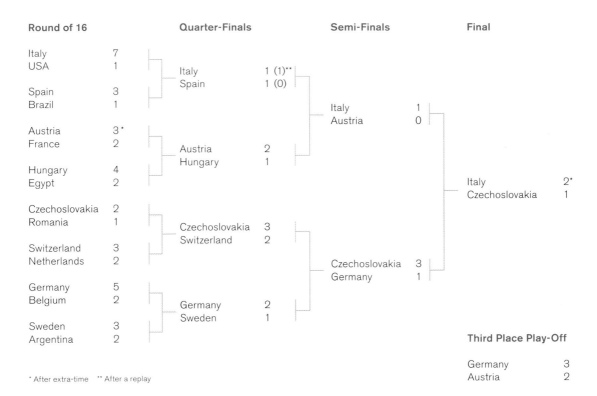

Round of 16		Quarter-Finals		Semi-Finals		Final	
Italy	7						
USA	1	Italy	1 (1)**				
		Spain	1 (0)				
Spain	3			Italy	1		
Brazil	1			Austria	0		
Austria	3*						
France	2	Austria	2			Italy	2*
		Hungary	1			Czechoslovakia	1
Hungary	4						
Egypt	2						
Czechoslovakia	2						
Romania	1	Czechoslovakia	3				
		Switzerland	2				
Switzerland	3			Czechoslovakia	3		
Netherlands	2			Germany	1		
Germany	5						
Belgium	2	Germany	2				
		Sweden	1				
Sweden	3						
Argentina	2						

* After extra-time ** After a replay

Third Place Play-Off

Germany	3
Austria	2

The official 1934 World Cup poster

10 June 1934, Stadio Nazionale, Rome
Before the final, the Swedish referee Ivan Ekind stands in between the two captains. Italy's goalkeeper Gianpiero Combi (left) wears a stylish white belt to keep his shorts up, whilst Czech goalkeeper Frantisek Planicka probably still holds the record for the biggest team badge ever worn in World Cup history.

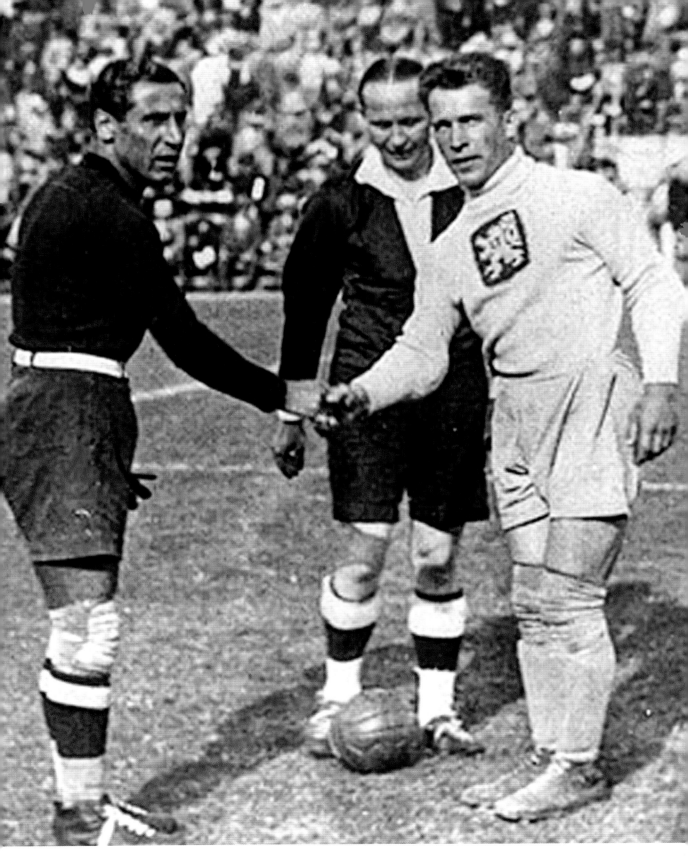

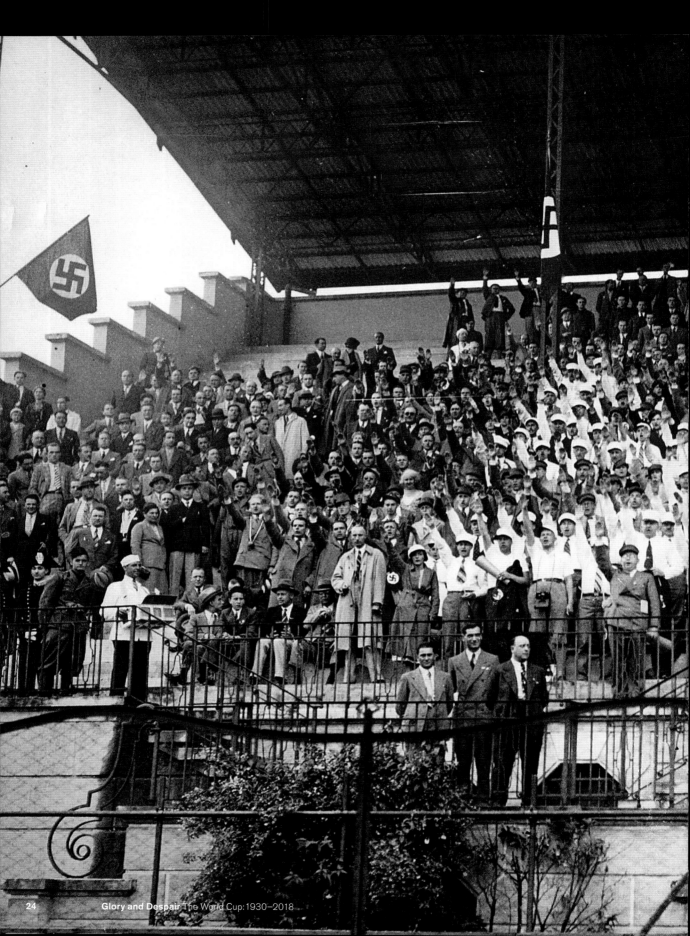

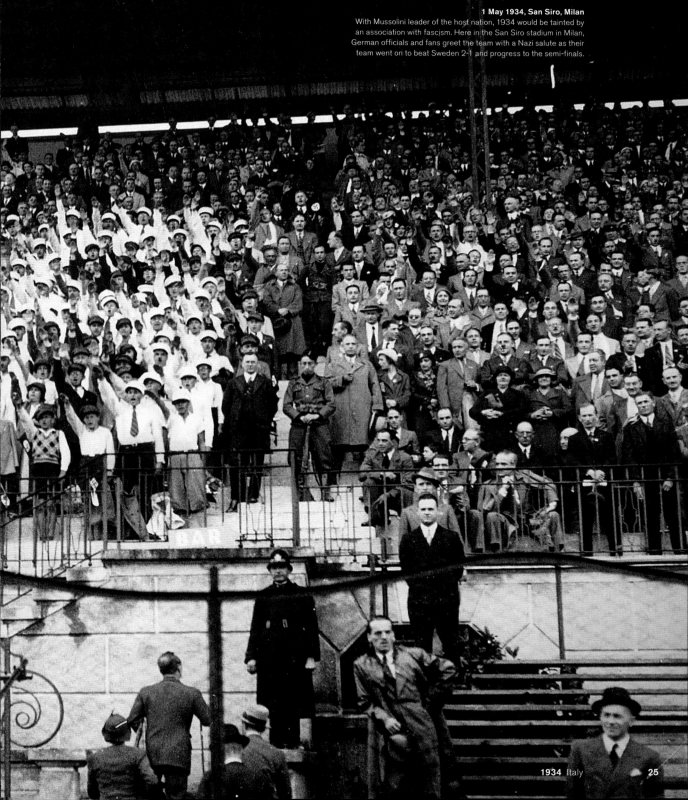

With Mussolini leader of the host nation, 1934 would be tainted by
an association with fascism. Here in the San Siro stadium in Milan,
German officials and fans greet the team with a Nazi salute as their
team went on to beat Sweden 2-1 and progress to the semi-finals.

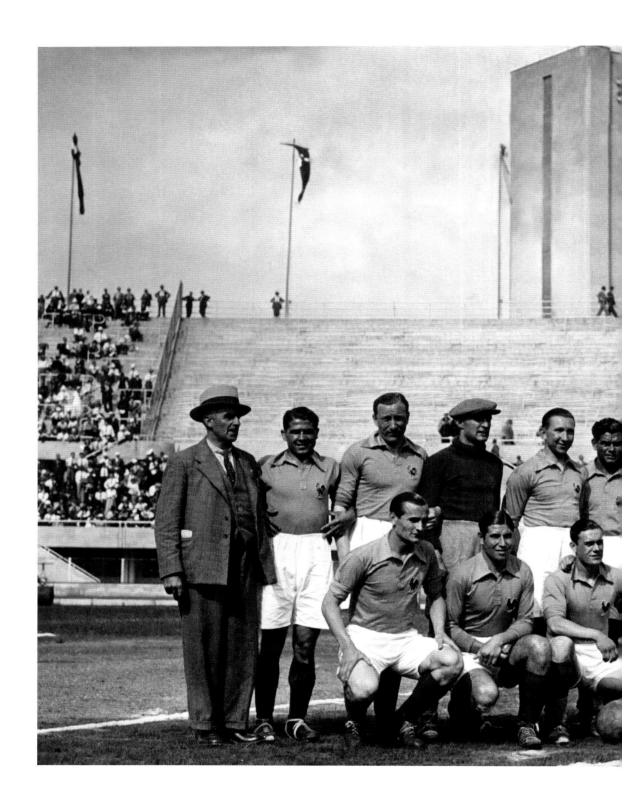

27 May 1934, Stadio Benito Mussolini, Turin
In an art deco stadium in Turin, the French team
get ready to take on Austria in the round of 16.

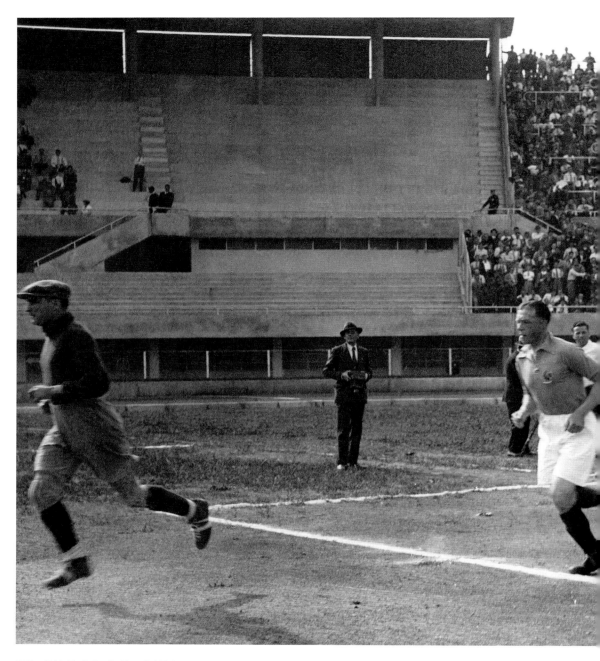

27 May 1934, Stadio Benito Mussolini, Turin
France and Austria enter the pitch for a last 16 tie that would finish 1-1 after 90
minutes and require extra time. The Austrians, who boasted the legendary Matthias
Sindelar in the line-up, would win 3-2 and progress to the quarter-finals.

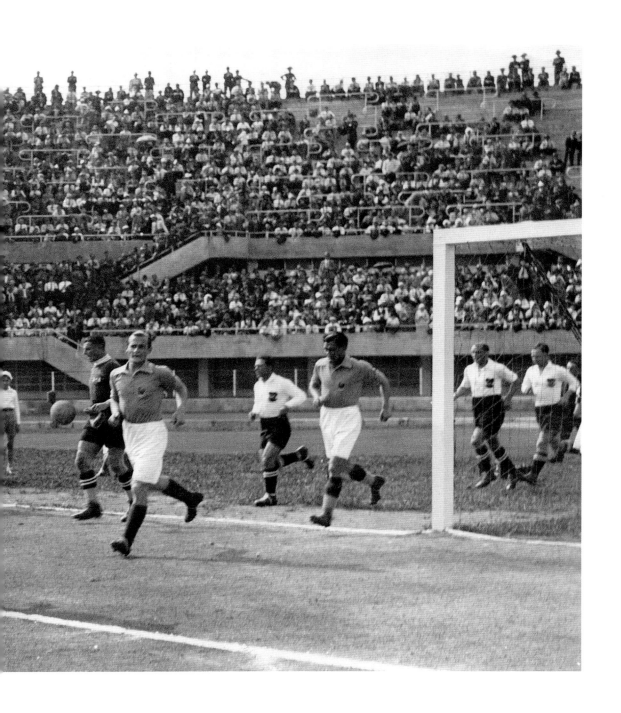

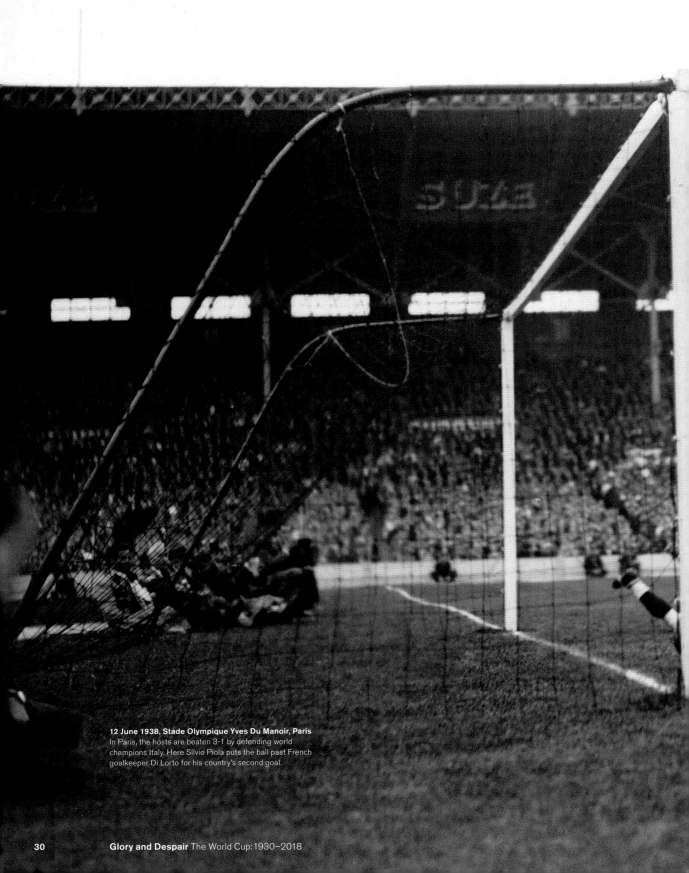

12 June 1938, Stade Olympique Yves Du Manoir, Paris
In Paris, the hosts are beaten 3-1 by defending world champions Italy. Here Silvio Piola puts the ball past French goalkeeper Di Lorto for his country's second goal.

1938
France

1938 France

On 3 September 1939 France declared war on Germany. Less than a year earlier the World Cup had been held on French soil, with defending champions Italy reigning victorious. To the backdrop of a fascist Europe, the fallout from a divided and chaotic continent would lead to horrific conflict with the consequence for football meaning that 1938 would be the last World Cup for 12 years.

15 Hungary were the tournament's top scoring team

As was the case in 1934, both Italy and Germany were represented by different national flags than today. The Italian tricolour featured a naval ensign placed in the middle, while the German national flag had changed from a black, white and red design to a black swastika against a white circle on a red background. Like 1934, this was very much a European World Cup, with Brazil the only nation representing South America.

Due to disputes with FIFA, the British teams were still absent from the tournament, thus denying the great Stanley Matthews the chance to play in a World Cup while in his 20s; a time when he was arguably the best player in the world. FIFA had asked England to enter when Austria pulled out due to the fact that it no longer existed as an FA, or indeed a country. A few months before the tournament, Austria was merged into Germany after Nazi troops marched into the country unopposed.

Spain were not taking part because the country had been plunged into a horrific civil war in 1936;

7 Leônidas of Brazil was top scorer

the world wasn't on the edge of chaos, it had already started. England declined FIFA's offer to participate, meaning that 15 teams instead of 16 were involved. To make up for the shortfall, Sweden were simply given a bye in the round of 16 and awarded a 3-0 win against Austria (FIFA could have at least given Austria a goal!).

The standout match of the tournament was Brazil's 6-5 win against Poland, which goes down in history as the highest scoring World Cup game where the deficit was only one goal. As in 1934, it was a straight knockout competition, in which the winner only had to win four games, meaning that Italy only played eight games en route to winning two World Cups, which is only one more than when they won their third crown in 1982.

The Hungarian team who Italy played in the 1938 final had been scoring for fun, with 13 goals in three matches. Within the first 16 minutes of the final there had already been three goals, though the Italians were in the ascendancy with a 2-1 lead and they added another before half-time. Hungary got one back in the second half to make it a close finish, but Italy scored again to win 4-2 and become the first nation to win the World Cup back-to-back; a feat that only Brazil would emulate in 1958 and '62. This makes Italian manager Vittorio Pozzo one of only two men to lead a country to two separate World Cup triumphs, along with Brazil's Mário Zagallo (1970 and 1994).

One of the most unique elements of the 1938 World Cup was the presence of Indonesia, known then as the Dutch East Indies. The colonist rulers preferred to use Dutch players; however, the team was a mixture due to indigenous talent that was too good to be left out. Unfortunately, the players were not good enough to avoid going down in the record books as the nation to have made the fewest appearances in the finals – and with the fewest goals (the record not counting the countries who have never qualified for the World Cup). They were knocked out in the opening game, 6-0 against the free-scoring Hungarians, and to date have not been back in the finals. More significantly, Indonesia also makes the record books for being the first Asian country to compete in the World Cup. Japan most probably would have been that first

World Cup debutants: Poland, Norway, Cuba, Dutch East Indies (Indonesia)

team had they not pulled out of their qualifying match against the Dutch East Indies due to having invaded China in a precursor to the world conflict that lay ahead.

Cuba's only tournament appearance came in 1938, and they go down in history as the team with the second lowest amount of World Cup games having played just two. They are however the first team from the Caribbean to compete in a World Cup. In 1938, Cuba won their first match but then got thumped 8-0 by Sweden and would never be seen again in the competition. This win took Sweden to the semi-final in what has to go down as the easiest route to the last four in World Cup history, considering they were given a walkover against Austria in the first round.

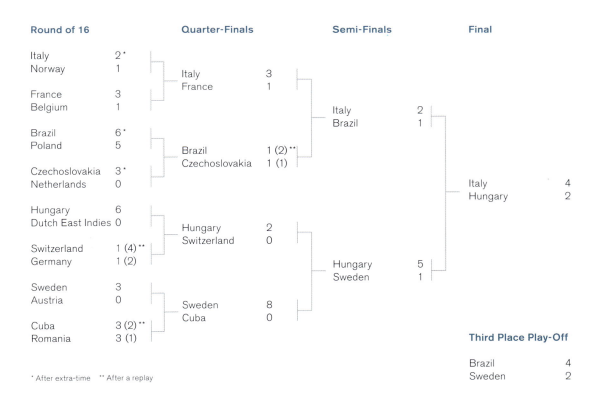

Round of 16		Quarter-Finals		Semi-Finals		Final	
Italy	2*						
Norway	1	Italy	3				
		France	1				
France	3			Italy	2		
Belgium	1			Brazil	1		
Brazil	6*						
Poland	5	Brazil	1 (2)**				
		Czechoslovakia	1 (1)				
Czechoslovakia	3*					Italy	4
Netherlands	0					Hungary	2
Hungary	6						
Dutch East Indies	0	Hungary	2				
		Switzerland	0				
Switzerland	1 (4)**			Hungary	5		
Germany	1 (2)			Sweden	1		
Sweden	3						
Austria	0	Sweden	8				
		Cuba	0				
Cuba	3 (2)**						
Romania	3 (1)						

* After extra-time ** After a replay

Third Place Play-Off

Brazil	4
Sweden	2

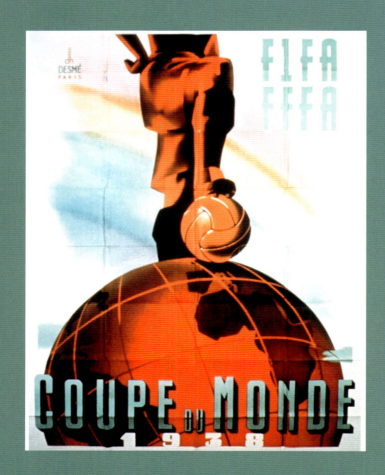

The official 1938 World Cup poster

19 June 1938, Stade Olympique Yves Du Manoir, Paris
Before the final in Paris, the French referee Georges Capdeville stands between Italian captain Giuseppe Meazza (left) and Hungarian captain Gyorgy Sarosi (right).

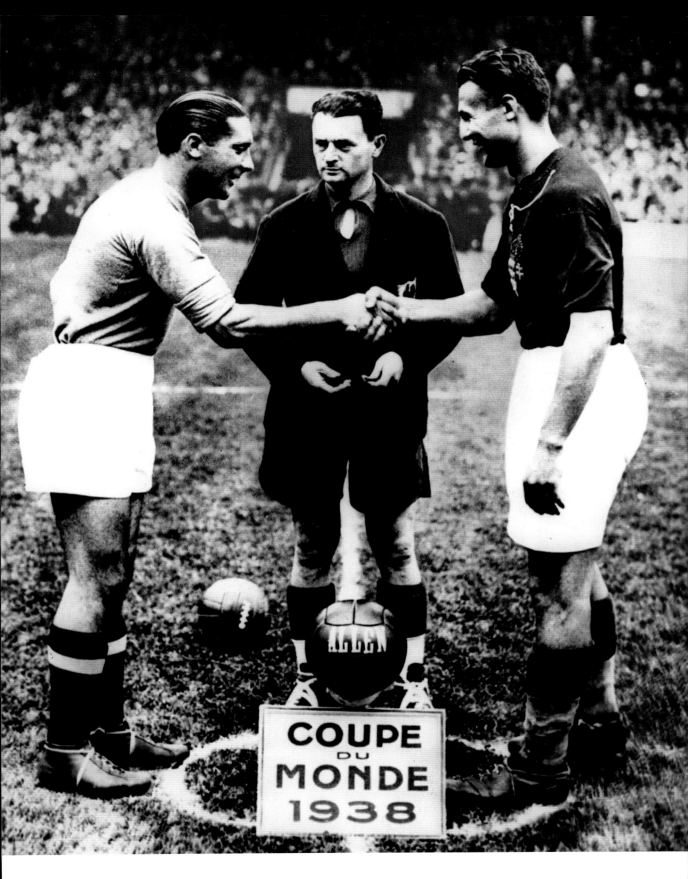

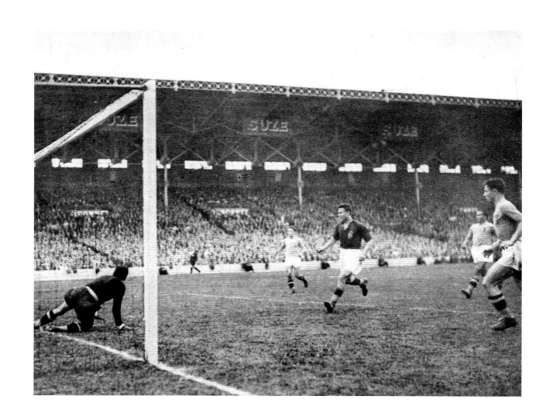

4 June 1938, Parc des Princes, Paris
Germany and Switzerland line up ahead of a round 16 tie.
This game would finish 1-1 and five days later Switzerland
would win the replay 4-2.

12 June 1938, Stade Victor Boucquey, Lille
Switzerland (in white) take on Hungary in the
quarter-final in Lille. Hungary won 2–0 to progress to
the semi-final where they would beat Sweden 5–1.

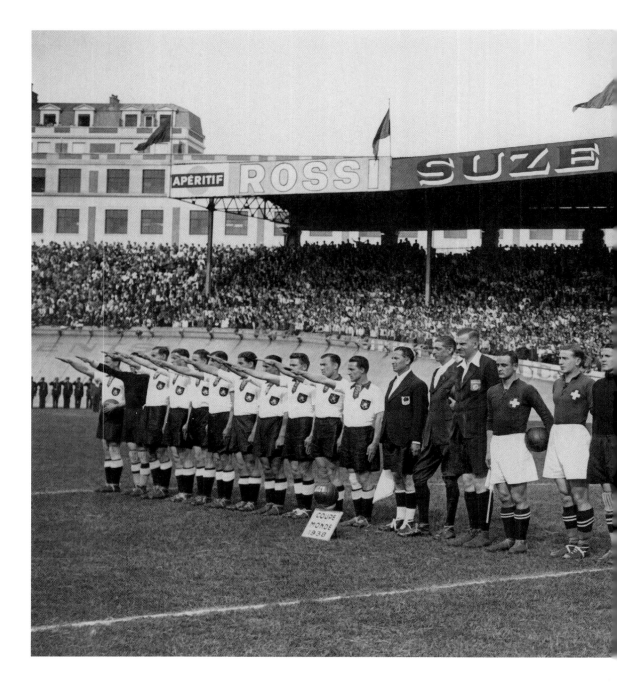

4 June 1938, Parc des Princes, Paris
Germany and Switzerland line up ahead of a round 16 tie. The game would
finish 1-1 and five days later, Switzerland would win the replay 4-2.

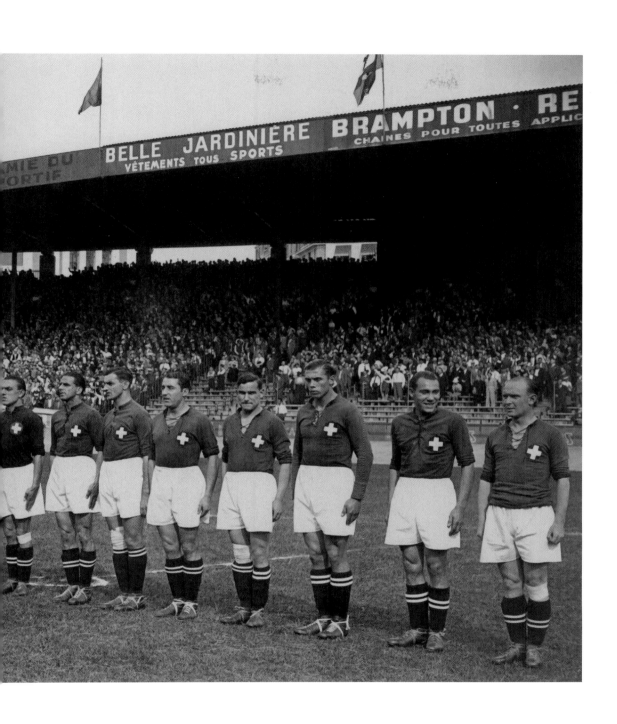

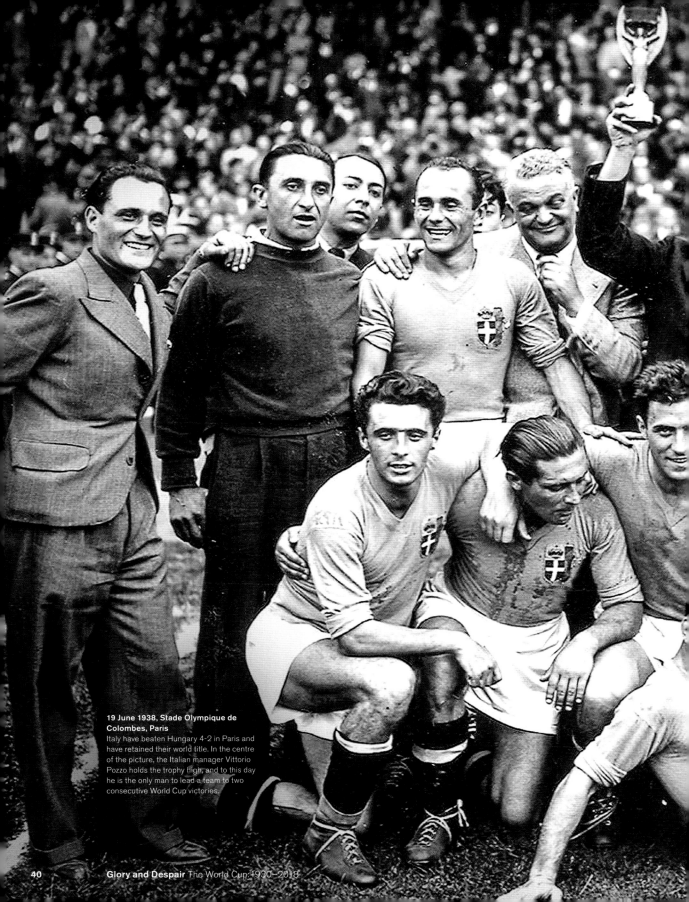

19 June 1938, Stade Olympique de Colombes, Paris
Italy have beaten Hungary 4-2 in Paris and have retained their world title. In the centre of the picture, the Italian manager Vittorio Pozzo holds the trophy high, and to this day he is the only man to lead a team to two consecutive World Cup victories.

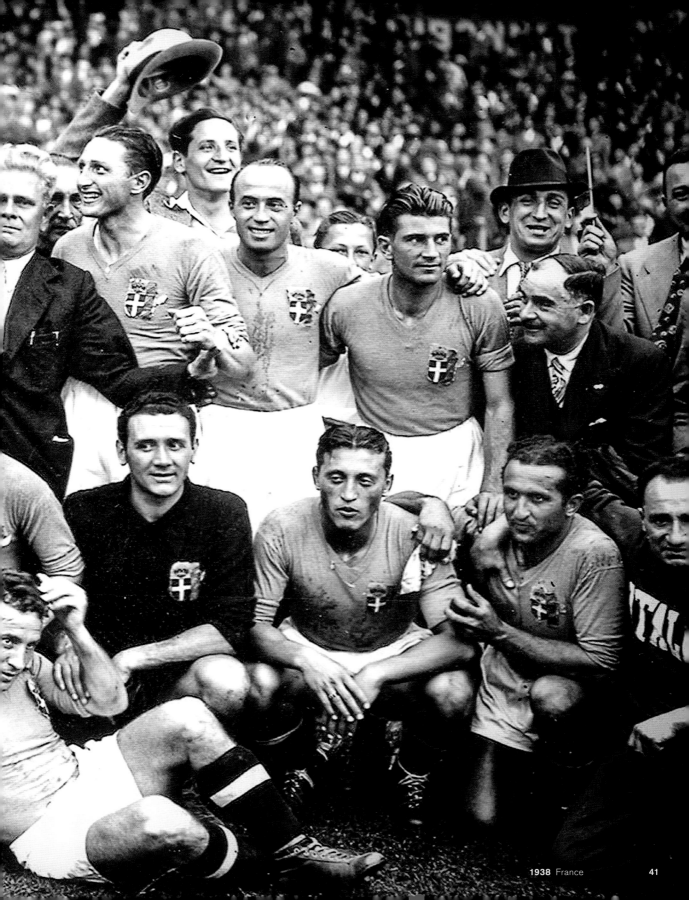

1938 France 41

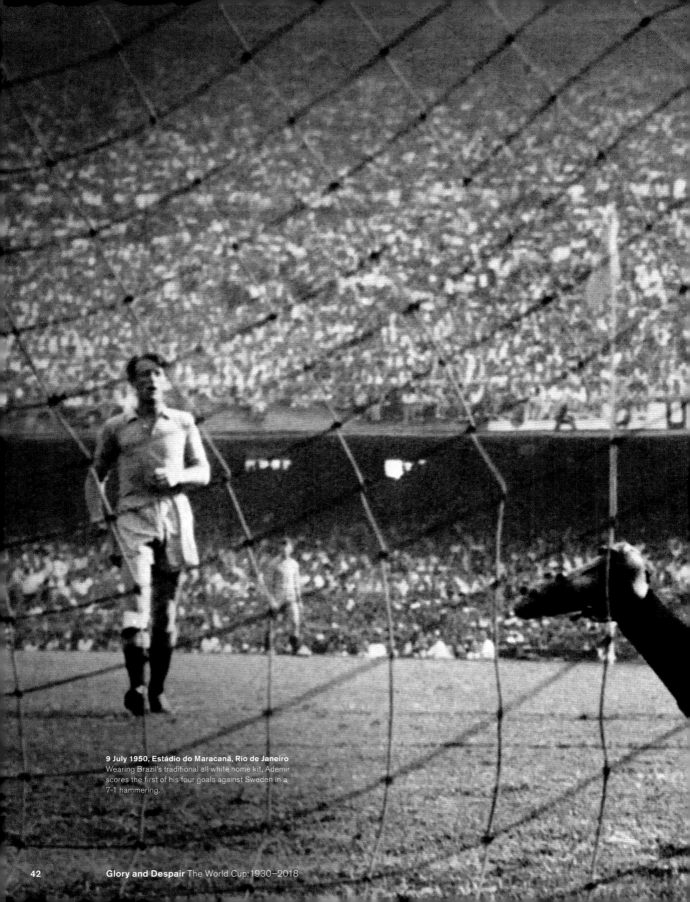

9 July 1950, Estádio do Maracanã, Rio de Janeiro
Wearing Brazil's traditional all white home kit, Ademir scores the first of his four goals against Sweden in a 7-1 hammering.

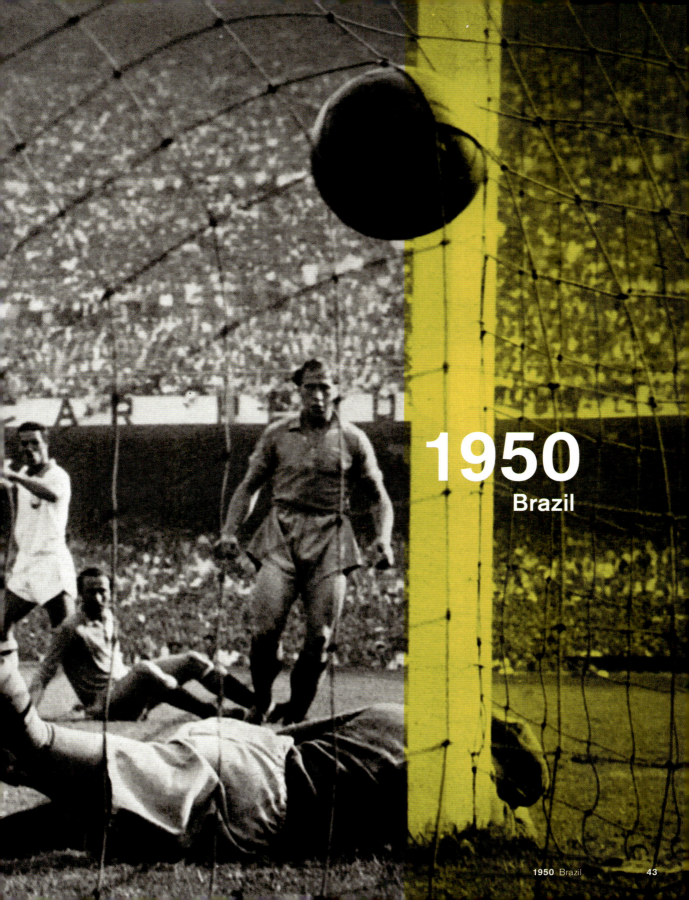

1950
Brazil

1950 Brazil

If World War Two had never happened there would have been World Cups in both 1942 and 1946, but instead, the 1940s is the decade which never had a chance to acquire a rich football identity. Even though the war had ended in 1945, the world was too broken to pick up exactly where it had left off. Brazil was chosen to host the World Cup and needed time to be ready, so everyone would have to wait until 1950. Old wounds had not fully healed, and both Japan and Germany would not enter due to the fallout of World War Two, and for the Germans this would be the last World Cup at which they would not be present.

22 Brazil were the tournament's top scoring team

The opening ceremony in Rio had a panache that suggested that the World Cup had reached a level of prestige which made being there an absolute priority; however, it wasn't a case of being there at all cost. Instead, a whole host of teams pulled out of the qualification process including Belgium, Ecuador and Peru. Austria withdrew because they didn't think they were good enough; Argentina because they didn't get on with the Brazilian FA; Scotland because of gentlemen's honour and not finishing top of their qualifying group with England. Gaps needed to be filled so Portugal and Ireland were invited, but said no. France said yes but then pulled out before the tournament began, meaning that Group 4 was made up of just Uruguay and Bolivia and consisted of just one game.

Turkey qualified but decided against going due to the cost of travel, but the most notable absentees were India.

8 Ademir of Brazil was top scorer

They did qualify, and unlike the teams who pulled out they really wanted to be in Brazil. They were in the final draw and pitted in Group 3 along with Sweden, Italy and Paraguay. However, FIFA rules stated that players had to play in footwear, whereas the Indians played football barefoot. Counter claims suggest that India pulled out because of travel cost. Either way, this meant that only 13 teams would participate.

Italy competed despite not having qualified. They were invited along after others pulled out, and while that seems generous, it had followed absolute horror. The core of their team had been from the great Torino side who died in an air crash in 1949. The world champions were utterly depleted but at least they got to defend their title. A year before the Torino tragedy, that great Italian team had been heavily beaten 4-0 by England in Turin, in a performance that would have given confidence to the English that they would mark their debut in the tournament with a triumph. Instead they suffered a humiliation and in perhaps the biggest ever World Cup upset, England were defeated 1-0 by the USA and eliminated in the group stage.

1950 uniquely stands out as the World Cup that never had a final. Instead, there were four groups, and the winner of each would then go on to compete in a final group. Spain, Sweden and the original world champions, Uruguay, were in the final round along with the hosts Brazil, who were ready to win the World Cup for the first time. The swashbuckling image of Brazil appeared to have been born in 1950. Playing in their traditional colour of all white (yellow wasn't introduced until 1953) they thrashed Sweden 7-1 then Spain 6-1. Uruguay beat Sweden, but drew with Spain meaning that in the final game all Brazil needed was a draw to become champions. This encounter is often cited as a World Cup Final, but it just turned out that the two strongest teams in the group happened to meet in the final match. Had Uruguay not beaten Sweden then Brazil would have been crowned world champions before it had been played.

That said, the Brazilian media and public had already proclaimed the team as champions. Gold medals were made. Banners were printed. Speeches were written and carnivals organised. Instead, what transpired was a horror story that would be known as the 'Phantom of 50'. The single worst moment in the history of Brazilian football was also known as Maracanãço (the blow of Maracanã). The loss hurt so much that there were reports of suicides, two of which apparently took place in the stadium.

It was all going so well as 200,000 people packed into the Maracanã and Friaça put the hosts in front early in the second half. Juan Alberto Schiaffino equalised in the 66th minute, then with just 11 to

World Cup debutant: England

go Alcides Ghigga made it 2-1 to Uruguay. A silence hung over the Maracanã which was described as disturbing. Ghigga had won his country a second World Cup, and would die on 16 July 2015, 65 years to the very day of this game. He was 88 years of age and the last surviving player to compete in the 'Phantom of 50'.

With just three match victories, Uruguay hold the record for the lowest number of wins for a World Cup-winning team (Sweden finished third with just two, which is also a record low). However, they must have felt pretty good about themselves in 1950. Their record was played two World Cups, won two World Cups. Given the structure of the 1950 tournament it also leaves Uruguay with one of the most unique stats in the history of the competition: they have won more World Cups than they have been in World Cup Finals.

Group 1

Brazil	4	0	Mexico
Yugoslavia	3	0	Switzerland
Brazil	2	2	Switzerland
Yugoslavia	4	1	Mexico
Brazil	2	0	Yugoslavia
Switzerland	2	1	Mexico

	P	W	D	L	GD	Pts
Brazil	3	2	1	0	6	5
Yugoslavia	3	2	0	1	4	4
Switzerland	3	1	1	1	-2	3
Mexico	3	0	0	3	-8	0

Group 2

England	2	0	Chile
Spain	3	1	USA
Spain	2	0	Chile
USA	1	0	England
Spain	1	0	England
Chile	5	2	USA

	P	W	D	L	GD	Pts
Spain	3	3	0	0	5	6
England	3	1	0	2	0	2
Chile	3	1	0	2	-1	2
USA	3	1	0	2	-4	2

Group 3

Sweden	3	2	Italy
Sweden	2	2	Paraguay
Italy	2	0	Paraguay

	P	W	D	L	GD	Pts
Sweden	2	1	1	0	1	3
Italy	2	1	0	1	1	2
Paraguay	2	0	1	1	-2	1

Group 4

| Uruguay | 8 | 0 | Bolivia |

	P	W	D	L	GD	Pts
Uruguay	1	1	0	0	8	2
Bolivia	1	0	0	1	-8	0

Final Group

Uruguay	2	2	Spain
Brazil	7	1	Sweden
Brazil	6	1	Spain
Uruguay	3	2	Sweden
Sweden	3	1	Spain
Uruguay	2	1	Brazil

Table	P	W	D	L	GD	Pts
Uruguay (C)	3	2	1	0	2	5
Brazil	3	2	0	1	10	4
Sweden	3	1	0	2	-5	2
Spain	3	0	1	2	-7	1

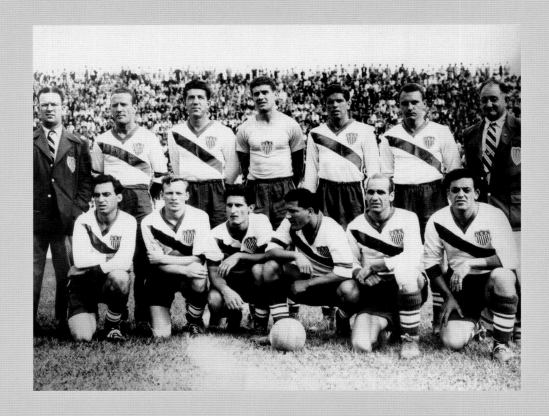

29 June 1950, Estádio Independência, Belo Horizonte
The USA team that beat England 1-0 in what became known as the 'Miracle of Belo Horizonte'. Haiti-born Joseph Gaetjens scored the only goal of the game and legend has it that some media outlets mistook the 1-0 scoreline as a typo and thought it to mean 10-0 to England, though that's now claimed to be an urban myth.

29 June 1950, Estádio Independência, Belo Horizonte
England's Tom Finney in a blue away jersey, goes up for a header with the USA's Charlie Colombo (left) and Walter Bahr (right). England were wearing blue for the first time, and due to the result of this game would not do so again for many years.

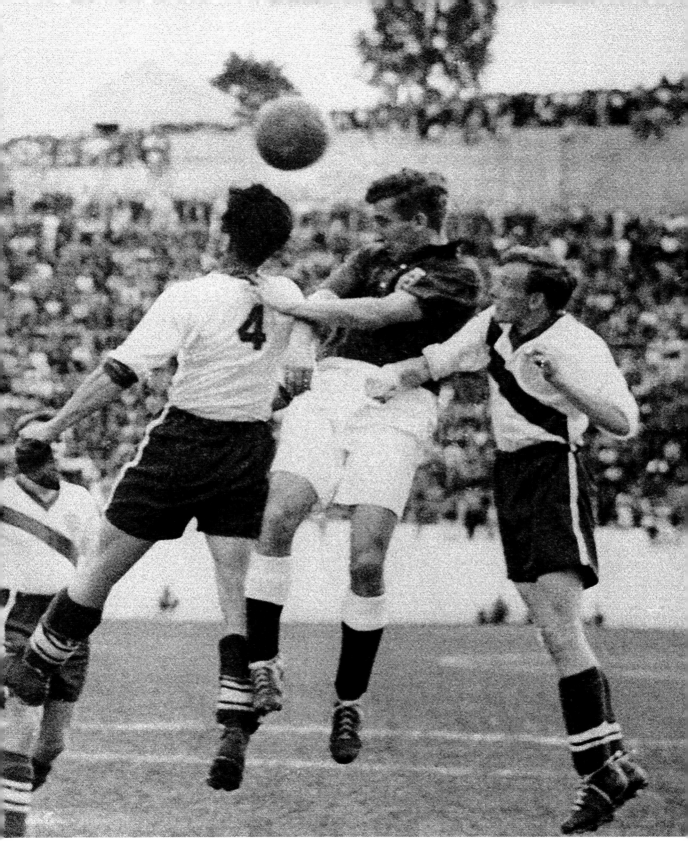

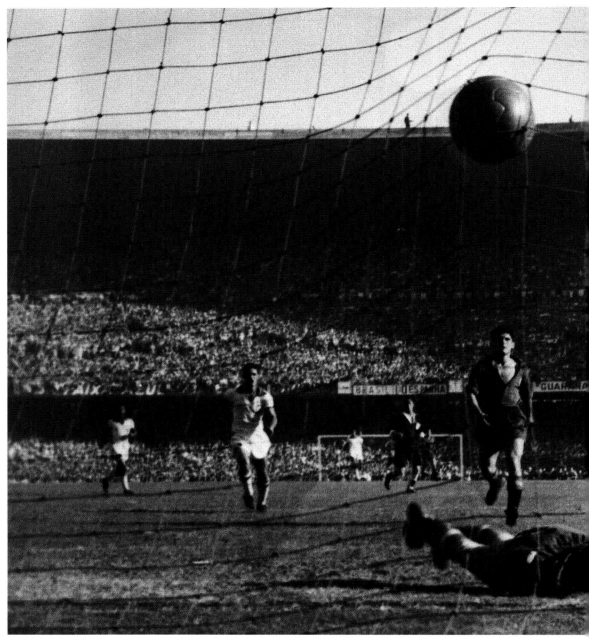

13 July 1950, Estádio do Maracanã, Rio de Janeiro
Jair makes it 2-0 to Brazil as the hosts hammer Spain 6-1 in the second group phase. Having also destroyed Sweden 7-1 in the other game in this group, the Brazilians looked destined to win the World Cup for the first time. Uruguay were playing Sweden at the very same time as this game. The score was 2-2 with five minutes to go when Uruguay found a winner. Had the score stayed at 2-2, then Brazil would have won the World Cup on this day, with the weird scenario of a game still having to be played after a team had been crowned as champions.

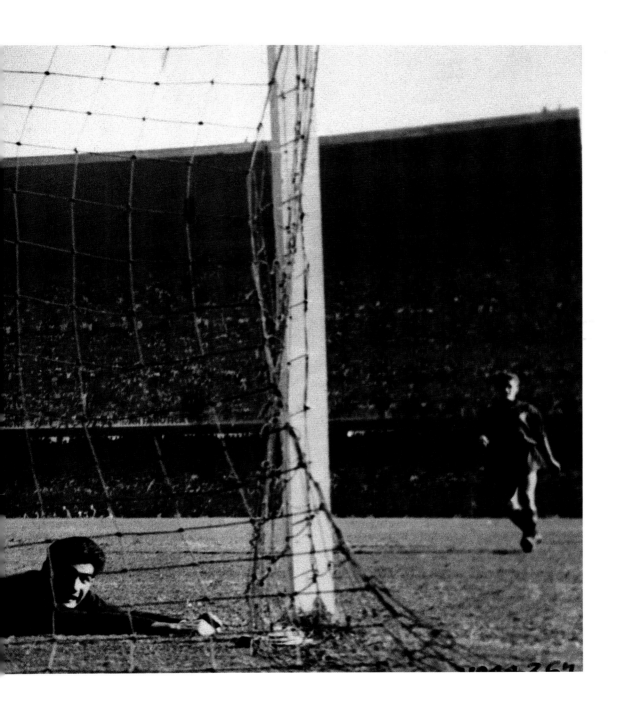

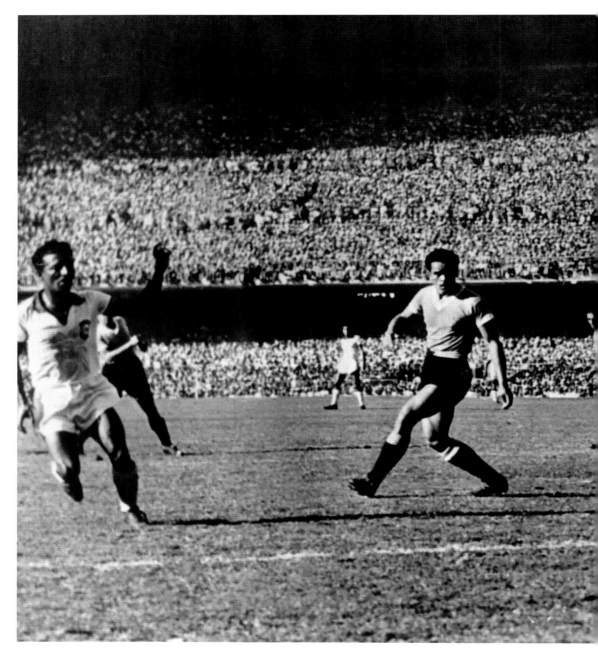

16 July 1950, Estádio do Maracanã, Rio de Janeiro
The final group game between Brazil and Uruguay. The Uruguayan goalkeeper Maspoli makes a crucial save. The day had been built up as a celebration by the Brazilians with there being no doubt that the host nation would be crowned as world champions. Two second half goals from Uruguay won the game 2-1, and against all odds the original world champions of 1930 had reclaimed their crown.

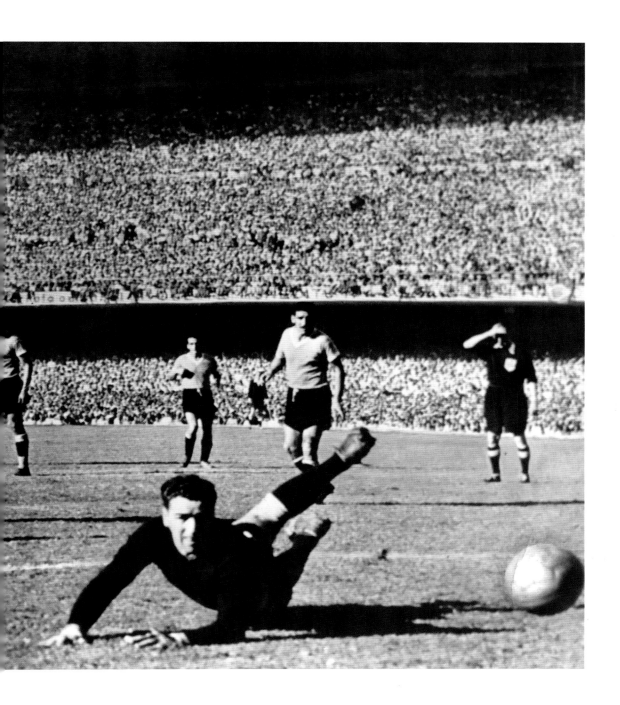

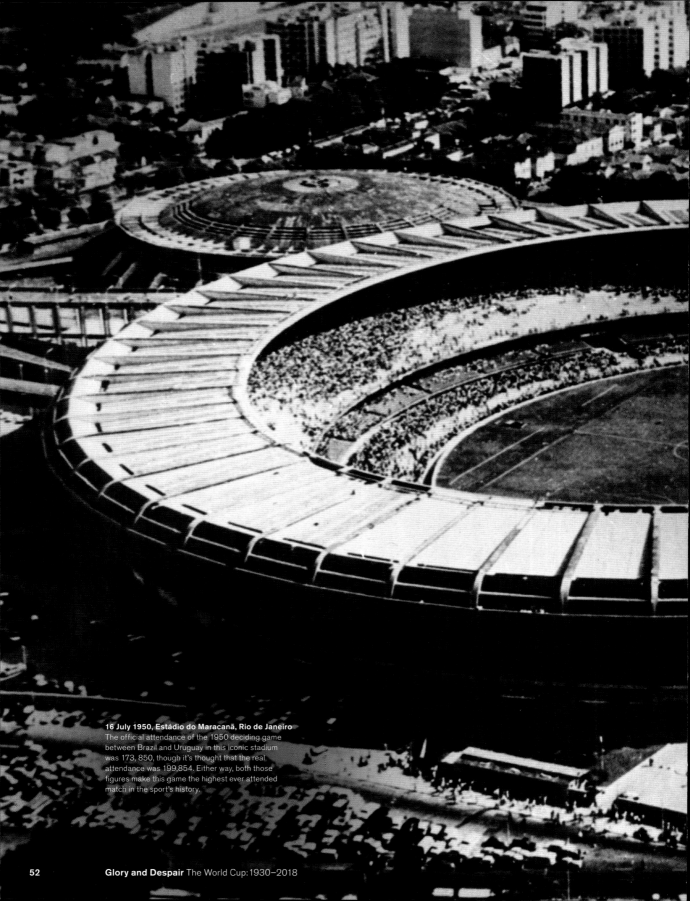

16 July 1950, Estádio do Maracanã, Rio de Janeiro
The official attendance of the 1950 deciding game
between Brazil and Uruguay in this iconic stadium
was 173, 850, though it's thought that the real
attendance was 199,854. Either way, both those
figures make this game the highest ever attended
match in the sport's history.

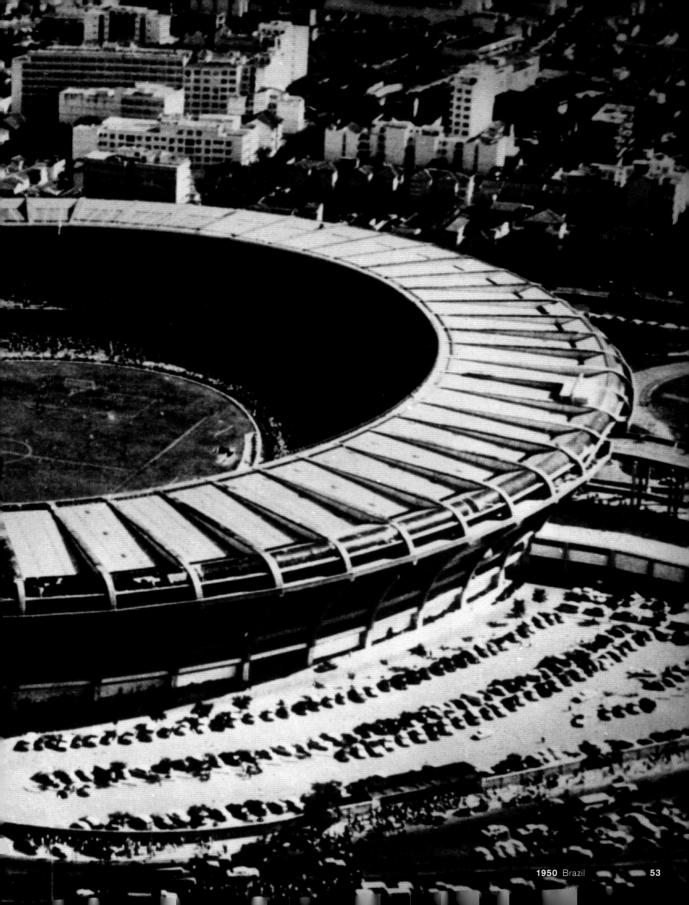

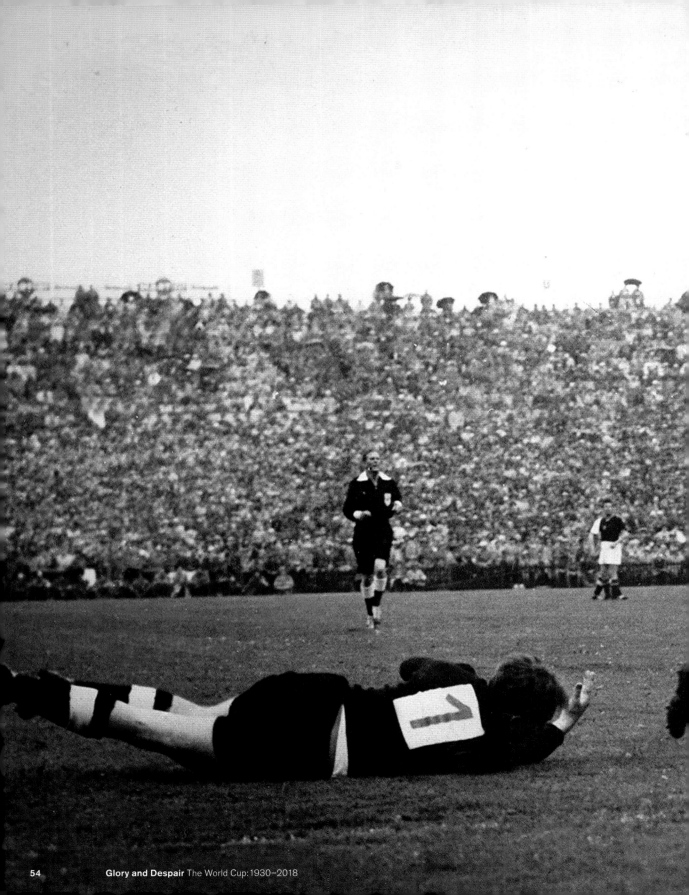

1954
Switzerland

4 July 1954, Wankdorf Stadium, Bern
German goalkeeper Toni Turek dives in vain during the final between Hungary and West Germany.

1954 Switzerland

Nine years after Europe tore itself apart in conflict, the third World Cup to be hosted on the continent would take place in a tiny but picturesque country – and one that had managed to remain neutral throughout the war. Four of the nine highest scoring matches in World Cup history come from 1954, and that

27 **Hungary were the tournament's top scoring team**

doesn't even include an eight-goal draw between England and Belgium that was played out in the group stages. A total of 140 goals were scored in just 26 games at 5.38 per game. Turkey scored seven in one game and then conceded seven in their next match. South Korea managed to concede 16 times in just two games. Hungary netted 27 goals, higher than any team in World Cup history, and they didn't even win the tournament. West Germany did lift the trophy, scoring 25 goals along the way, which was the second highest total in World Cup history.

A unique element of the 1954 World Cup group stages was a ruling that allowed for 30 minutes of extra time if it was a draw after 90 minutes. This meant that England v Belgium and Brazil v Yugoslavia both went into extra time, and on both occasions still ended up being tied, which meant one point each. This concept was dropped for all future World Cups and extra time would only be used for the knockout rounds. Another unique element was that the group stage wasn't a round robin structure in which all four teams faced one another, and instead each team only played two games.

One of the most notable ties was the quarter-final between Austria and Switzerland. Imagine scoring four goals in the first half of a game – and still losing. This happened to the hosts as Austria won 7-5 in what remains the highest scoring World Cup game (it was 5-4 to Austria at half-time). Also in the quarter-finals, Hungary beat Brazil 4-2 in what goes down as one of the most bad-tempered and violent games in World Cup history. This was the precursor to the Battle of Santiago in 1962 and was known as the Battle of Berne.

11 **Sándor Kocsis of Hungary was top scorer**

In the Wankdorf Stadium two Brazilian players were sent off and one Hungarian; the spark for the violence being a pitch invasion by Brazilian officials and journalists who were upset at a penalty that was awarded to Hungary. The match descended into a series of fouls and assaults which carried on into a full-scale brawl in the dressing rooms after it had finished. English referee Arthur Ellis, who officiated the encounter, would later comment that in the modern era the game would have been abandoned as there would have been so many dismissals. He said, 'I thought it was going to be the greatest game I'd ever see. I was on top of the world but they behaved like animals. It was a disgrace. It was a horrible match.' What an irony that Switzerland of all places would be the host of such a battle.

Hungary faced a tough semi-final against Uruguay which required extra time. It set up a David versus Goliath final against West Germany, in which the Hungarians were playing the part of Goliath. They had not been beaten in 32 games and were playing a country coming out of the ashes of defeat, destruction, humiliation and poverty. When Hungary beat West Germany 8-3 in the group stages two weeks earlier it wasn't a massive shock. With the legendary Ferenc Puskás as their star player, they were considered the best team in the world, and a year earlier had won 6-3 at Wembley, the first overseas team (other than Ireland) to have beaten England on home soil.

Along with Japan, West Germany had been banned from entering the 1950 World Cup due to the fallout of the war. It wasn't a return of the kings as up to this point in time they hadn't cemented a fearsome reputation, and it would require a miracle for anything other than a Hungary victory. The favourites were 2-0 up after just eight minutes, first through Puskás then Zoltán Czibor, and another heavy thrashing looked on the cards. Incredibly the Germans had levelled by the 19th minute with two goals in the space of eight minutes courtesy of Max Morlock and Helmut Rahn. The free-scoring Hungarians, who had averaged 5.4 goals a game, just couldn't put the ball in the net for the winner and seal their legacy as the best team in the world. West Germany scored the final goal in the 86th minute and the game would be known as the Miracle of Berne.

In the dying moments Puskás scored a goal that was ruled offside, and would lead to years of debate as to whether he was actually onside. The TV footage used in 1954 just wasn't clear enough to come to a

World Cup debutants: Scotland, Turkey, South Korea

conclusion either way. One thing was for sure: Hungary were never able to call themselves world champions. Worse was to follow in 1986 when they got hammered 6-0 by the Soviet Union in the group stage, and they have failed to qualify for a World Cup since. Yet despite only appearing in nine finals tournaments they still rank as the 17th best overall World Cup team due in part to their exploits in Switzerland.

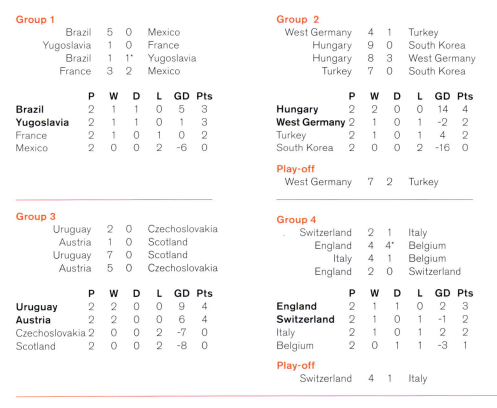

Group 1

Brazil	5	0	Mexico
Yugoslavia	1	0	France
Brazil	1	1*	Yugoslavia
France	3	2	Mexico

	P	W	D	L	GD	Pts
Brazil	2	1	1	0	5	3
Yugoslavia	2	1	1	0	1	3
France	2	1	0	1	0	2
Mexico	2	0	0	2	-6	0

Group 2

West Germany	4	1	Turkey
Hungary	9	0	South Korea
Hungary	8	3	West Germany
Turkey	7	0	South Korea

	P	W	D	L	GD	Pts
Hungary	2	2	0	0	14	4
West Germany	2	1	0	1	-2	2
Turkey	2	1	0	1	4	2
South Korea	2	0	0	2	-16	0

Play-off
West Germany 7 2 Turkey

Group 3

Uruguay	2	0	Czechoslovakia
Austria	1	0	Scotland
Uruguay	7	0	Scotland
Austria	5	0	Czechoslovakia

	P	W	D	L	GD	Pts
Uruguay	2	2	0	0	9	4
Austria	2	2	0	0	6	4
Czechoslovakia	2	0	0	2	-7	0
Scotland	2	0	0	2	-8	0

Group 4

Switzerland	2	1	Italy
England	4	4*	Belgium
Italy	4	1	Belgium
England	2	0	Switzerland

	P	W	D	L	GD	Pts
England	2	1	1	0	2	3
Switzerland	2	1	0	1	-1	2
Italy	2	1	0	1	2	2
Belgium	2	0	1	1	-3	1

Play-off
Switzerland 4 1 Italy

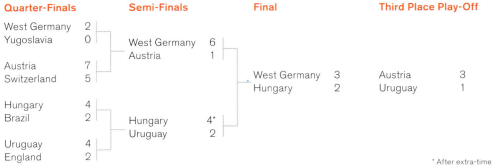

Quarter-Finals		Semi-Finals		Final		Third Place Play-Off	
West Germany	2						
Yugoslavia	0	West Germany	6				
		Austria	1				
Austria	7						
Switzerland	5			West Germany	3	Austria	3
				Hungary	2	Uruguay	1
Hungary	4						
Brazil	2	Hungary	4*				
		Uruguay	2				
Uruguay	4						
England	2						

* After extra-time

The official 1954 World Cup poster.

26 June 1954, St Jakob Stadium, Basel
England's Nat Lofthouse takes on Uruguay's Victor Rodriguez Andrade in a quarter-final in Basel. The defending world champions Uruguay won 4-2 to progress to the semi-final.

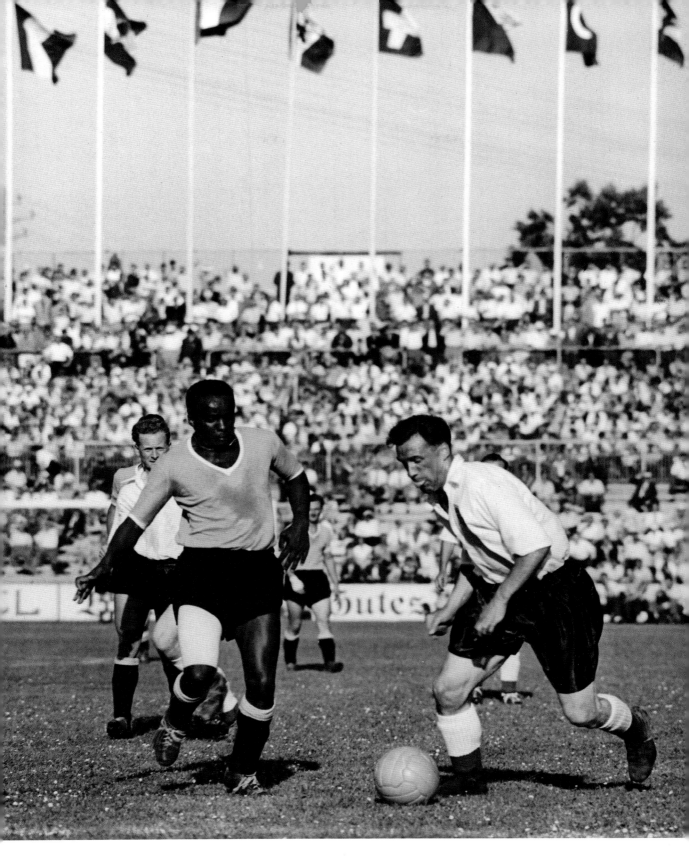

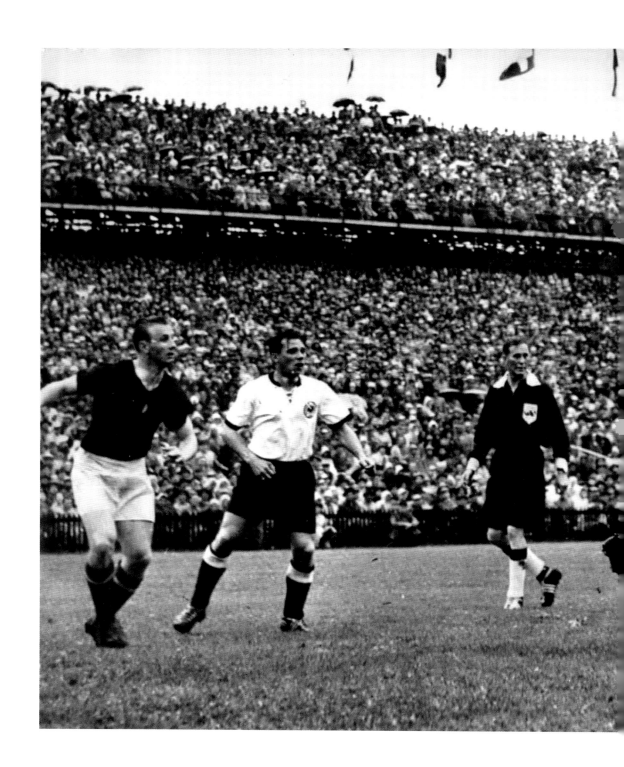

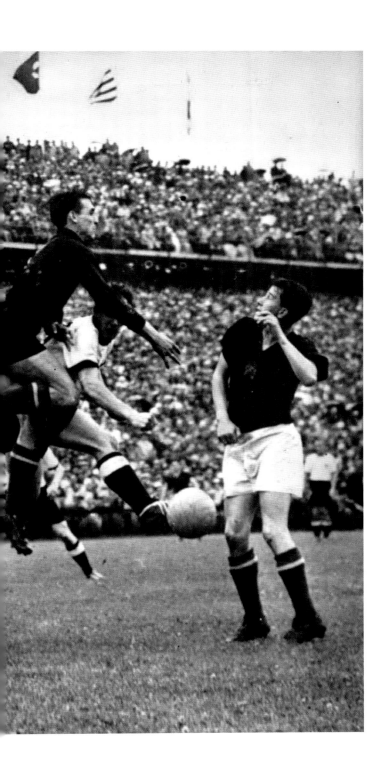

4 July 1954, Wankdorf Stadium, Bern
Hungarian goalkeeper Gyula Grosics scrambles
for the ball in the final against West Germany.

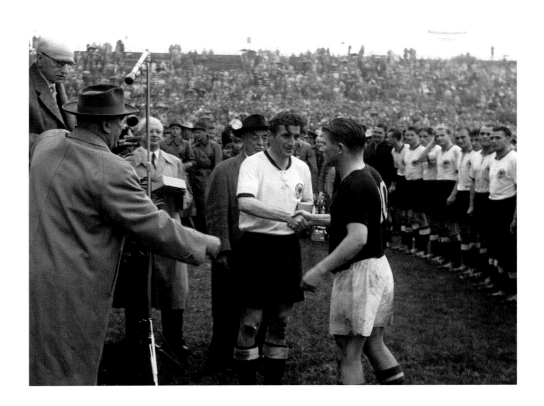

4 July 1954, Wankdorf Stadium, Bern
62,500 spectators endure a downpour
of rain before the final.

4 July 1954, Wankdorf Stadium, Bern
Hungarian legend Ferenc Puskas sportingly congratulates
West Germany's captain Fritz Walter after a shock 3-2 win
for the German team. Earlier in the tournament Hungary had
beaten West Germany 8-3, and still hold the record for the
highest number of goals in a single tournament (27).

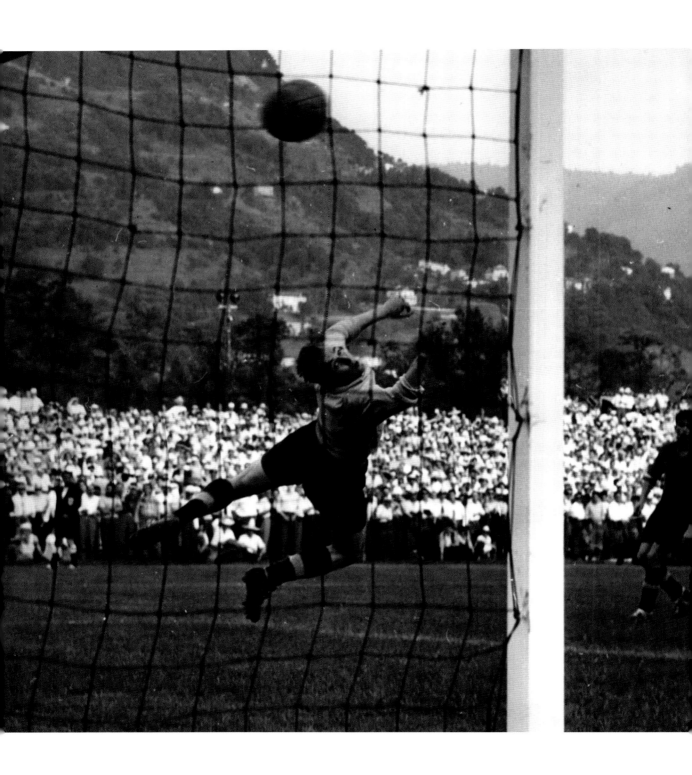

20 June 1954, Cornaredo Stadium, Lugano
To the backdrop of the Lugano mountains,
Italy score one of four goals they put past
Belgium in a 4-1 victory in the group stages.

STYRKA TILL LÅGT PRIS **OSCARIA SKO OCH**

TELEFUNKEN TV **ELEFUNKEN RADIO** **TELEFUN**

29 June 1958, Råsunda Stadium, Solna
Pelé scores one of the greatest goals in World Cup history,
and in the final against hosts Sweden. The 17-year-old had
flicked the ball over the head of one defender and as the
ball came down volleyed past the keeper.

1958
Sweden

1958 Sweden

Along with the 1992 European Championship, the 1958 World Cup is one of only two major football tournaments to have been held in Scandinavia. Wales and Northern Ireland were playing in their first World Cups, and for the Welsh it remains their one and only appearance. With England and Scotland also in Sweden, it stands as the only World Cup in which all four British nations qualified.

23 France were the tournament's top scoring team

England were out by the group stages and were depleted having lost players to tragedy in the Munich air crash of the same year, with Duncan Edwards the most high-profile casualty. As they later did in 2014, their worst World Cup performance, England wouldn't record a single win, although they like Wales were undefeated in the group stage having drawn all three games. The most high-profile absentees from 1958 were the former world champions Italy and Uruguay; the two teams together had won four out of the five World Cups played yet neither qualified for Sweden.

Going into the 1958 tournament Didi was the key player for Brazil and the poster boy of the team. He coined the phrase 'the beautiful game' before Pelé did so more famously years later, and in 1958 Didi lived up to his reputation and was awarded the Golden Ball, FIFA's prize for being the best player in the tournament. Also in the team was Garrincha, the 'Little Bird', and goals were expected in Brazil's group game against England. However, it became the first goalless draw in World Cup history and off the back of this result, Pelé was brought in, aged just 17. Wales had made it out of the group stage and faced Brazil in the quarter-final. It was 0-0 until the 66th minute and then Pelé scored his first World Cup goal. A hat-trick then followed in the next game against France, and Brazil were in the final and ready to make right the national disaster of 1950.

Host nation Sweden rode the wave of home advantage and recorded their best World Cup performance, finishing as runners-up. At one point they dreamt of glory as in the fourth minute of the final they took the lead with a great dribble and shot outside the box from Nils Liedholm. Sweden as world champions was a very realistic scenario at this moment in time. The dream lasted until the ninth minute as Brazil equalised with a close-range strike from Vavá. He would score one more, Pelé would get two,

13 Just Fontaine of France was top scorer

and future World Cup-winning manager Mário Zagallo also got on the score sheet in a 5-2 victory which still stands today as the highest scoring Final.

Pelé became the youngest player to compete – and score – in a World Cup Final, with a record that still stands. His first goal would go down in history as one of the best of all time; he flicked the ball over the head of a Swedish defender and struck a volley past the goalkeeper. A new standard had been set by Brazil and their teenage genius, and to be the best in the world you now had to overcome a level of football that had just set the bar far higher than anything that had preceded it.

In the previous five World Cups, the winners came from the continent in which the tournament was held. The triumph of the Brazilians of 1958 would be the first time that a country would win the World Cup outside their own, but it was an achievement that would not be repeated, as in the following years the South Americans won the World Cups held in the Americas, and vice-versa in Europe. It wasn't until 2014 that a European team would win the World Cup in the Americas, and since 1958 no South American country has won a European-held tournament.

Along with Pelé, the player most synonymous with 1958 is the French striker Just Fontaine, who up until 1974 held the record as the highest goalscorer in World Cup history. All of his 13 goals came in 1958, and in just six games. He never got the chance to play in another tournament due to injury and retired at the age of 27, otherwise he could have built up a tally of goals that was unassailable. While his overall record of highest scorer was to be overtaken by Gerd Müller, his 13 goals in one tournament stands as a record that no one has come close to. Fontaine, n his late 80s at the time of publication, remained fairly confident in his longevity as record holder and said, 'I don't think anyone will beat my 13 in a tournament. It's a record I will take to my grave.'

World Cup debutants: Wales, Northern Ireland, Soviet Union

Group 1

West Germany	3	1	Argentina	
Northern Ireland	1	0	Czechoslovakia	
West Germany	2	2	Czechoslovakia	
Argentina	3	1	Northern Ireland	
West Germany	2	2	Northern Ireland	
Czechoslovakia	6	1	Argentina	

	P	W	D	L	GD	Pts
West Germany	3	1	2	0	2	4
Northern Ireland	3	1	1	1	-1	3
Czechoslovakia	3	1	1	1	4	3
Argentina	3	1	0	2	-5	2

Play-off match

Northern Ireland	2*	1	Czechoslovakia

Group 2

France	7	3	Paraguay	
Yugoslavia	1	1	Scotland	
Yugoslavia	3	2	France	
Paraguay	3	2	Scotland	
France	2	1	Scotland	
Paraguay	3	3	Yugoslavia	

	P	W	D	L	GD	Pts
France	3	2	0	1	4	4
Yugoslavia	3	1	2	0	1	4
Paraguay	3	1	1	1	-3	3
Scotland	3	0	1	2	-2	1

Group 3

Sweden	3	0	Mexico	
Hungary	1	1	Wales	
Wales	1	1	Mexico	
Sweden	2	1	Hungary	
Sweden	0	0	Wales	
Hungary	4	0	Mexico	

	P	W	D	L	GD	Pts
Sweden	3	2	1	0	4	5
Wales	3	0	3	0	0	3
Hungary	3	1	1	1	3	3
Mexico	3	0	1	2	-7	1

Play-off match

Wales	2	1	Hungary

Group 4

Brazil	3	0	Austria	
Soviet Union	2	2	England	
Brazil	0	0	England	
Soviet Union	2	0	Austria	
Brazil	2	0	Soviet Union	
England	2	2	Austria	

	P	W	D	L	GD	Pts
Brazil	3	2	1	0	5	5
England	3	0	3	0	0	3
Soviet Union	3	1	1	1	0	3
Austria	3	0	1	2	-5	1

Play-off

Soviet Union	1	0	England

Quarter-Finals

Brazil	1
Wales	0
France	4
Northern Ireland	0
Sweden	2
Soviet Union	0
West Germany	1
Yugoslavia	0

Semi-Finals

Brazil	5
France	2
Sweden	3
West Germany	1

Final

Brazil	5
Sweden	2

Third Place Play-Off

France	6
West Germany	3

* After extra-time

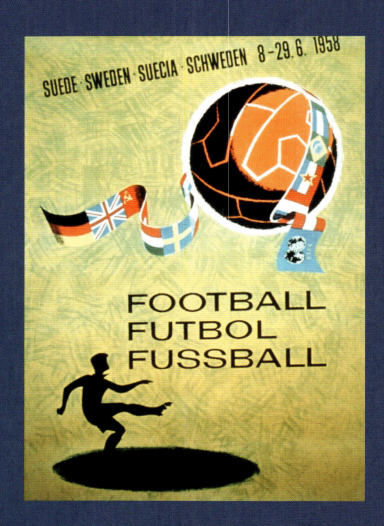

SUEDE · SWEDEN · SUECIA · SCHWEDEN 8–29. 6. 1958

FOOTBALL
FUTBOL
FUSSBALL

The official 1958 World Cup poster

29 June 1958, Råsunda Stadium, Solna
Brazilian players hug one another in the final,
as they become world champions for the first
time, as well as being the only country to win
the tournament outside their own continent.

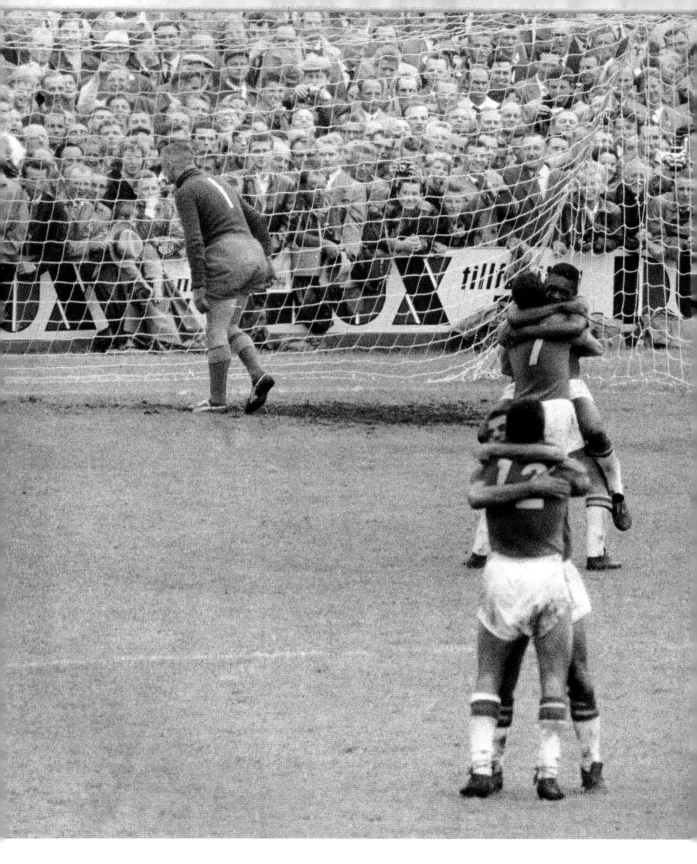

29 June 1958, Råsunda Stadium, Solna
At the Råsunda Stadium, some officials look in good spirits as they attempt
to dry the pitch before the World Cup Final between Sweden and Brazil.

19 July 1958, Ullevi Stadium, Gothenburg
Pele ends up in the back of the net along with
the ball. He has just scored his first ever World
Cup goal, which was enough to beat Wales 1-0
as Brazil progressed to the semi-final.

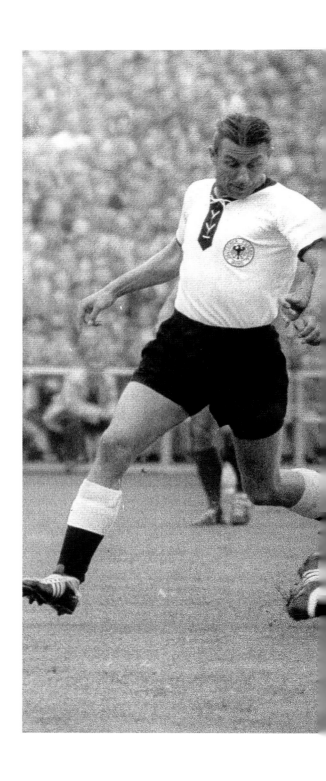

28 June 1958, Ullevi Stadium, Gothenburg
West Germany's Heinz Wewers (left) and
Karl-Heinz Schnellinger try to stop France's
Just Fontaine in the third-place play-off game.
France won 6-3 and Fontaine's overall tally of
13 goals in a single World Cup is still a record.

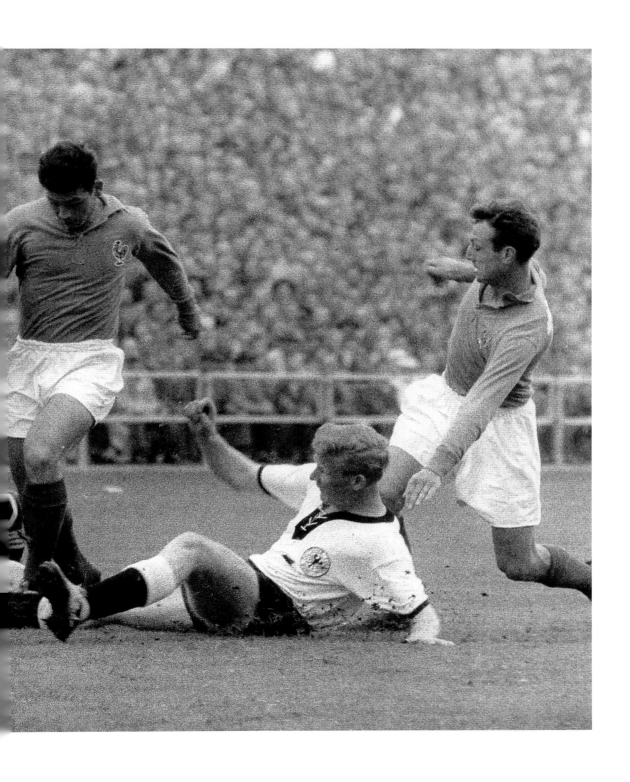

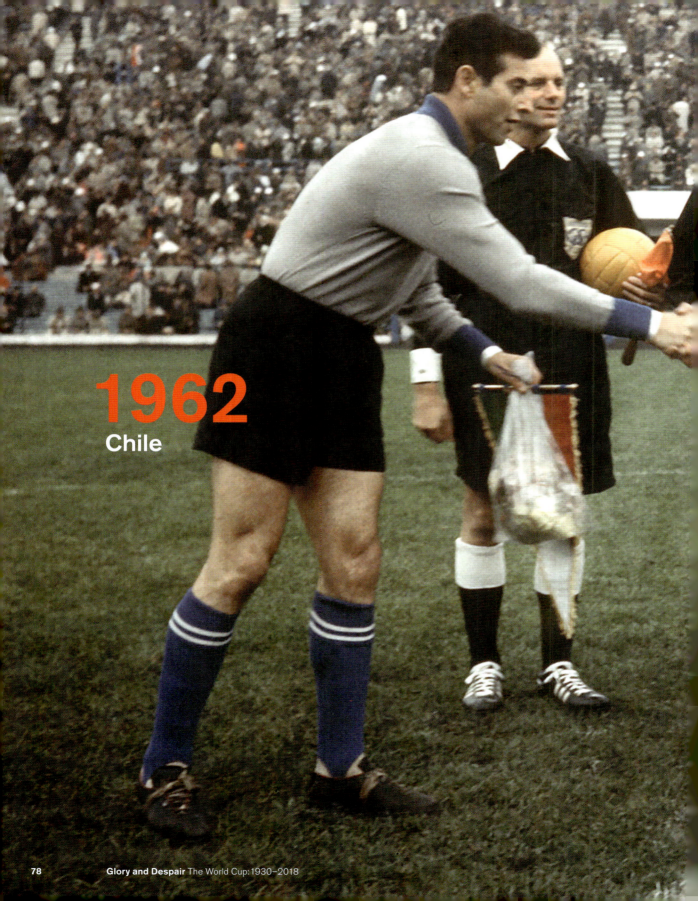

1962
Chile

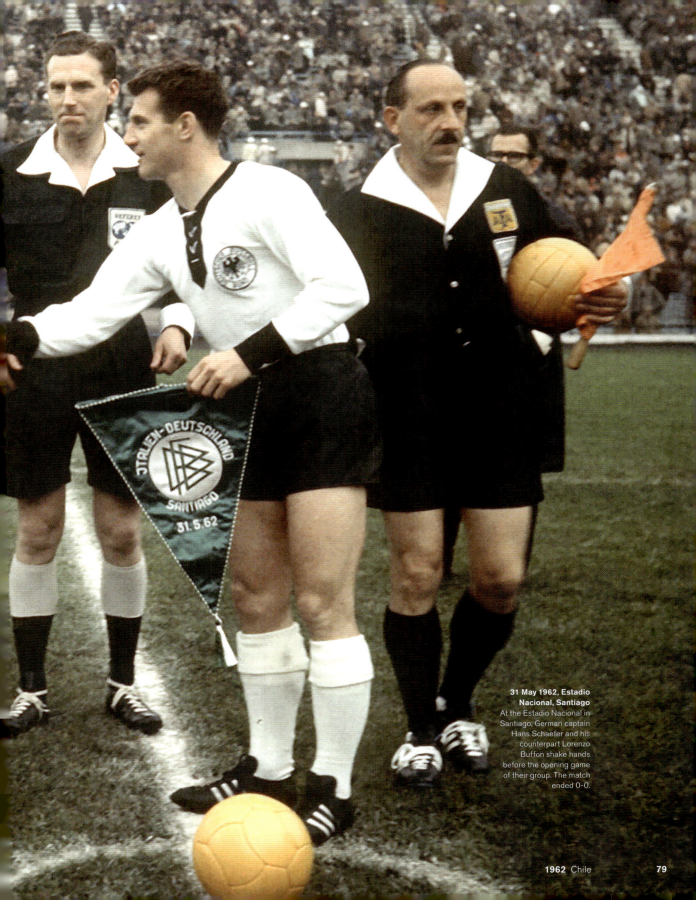

1962 Chile

Two years before the World Cup was due to be hosted in the longest country on the planet (from north to south), Chile was devastated by the Valdivia earthquake. It was the largest earthquake ever recorded and the resulting tsunamis reached as far as Australia. It put into doubt the country's ability to host the tournament, but Chile would downsize the number of venues used to stage games to just four, which made it second to only 1930 for the fewest number of stadiums used in a World Cup.

14 Brazil were the tournament's top scoring team

Perhaps the most standout and remembered moment from 1962 was the Battle of Santiago, between Italy and the hosts. Such was the amount of player fighting that this match resembled a boxing gym more than a game of football. So outraged was he by the level of thuggery on show, the BBC's David Coleman introduced highlights of the match by saying, 'The game you're about to see is the most stupid, appalling, disgusting, and disgraceful exhibition of football possibly in the history of the game. Chile versus Italy, this is the first time these countries have ever met, we hope it will be the last. The national motto of Chile reads "by reason or by force". Today the Chileans were prepared to be reasonable, the Italians only used force. The result was a disaster for the World Cup.'

A contender for dirtiest game ever played in a World Cup, our sensitive modern eyes would view this match with horror as punches, kicks and flying tackles came raining in throughout a game which required the police to enter the pitch on four separate occasions. The first foul occurred after 12 seconds. The backdrop to this bad-tempered game had been spats between Italian and Chilean journalists. Two Italian reporters had called Santiago a 'backwater dump' and described Chileans as 'miserable and backward'. The local press responded by calling the Italians fascists and oversexed. The two Italians had to leave the country for their own safety, and an Argentine reporter got beaten up instead in a case of mistaken identity.

In football today, a limp hand to a face can result in a sending off. In 1962's Battle of Santiago, Italy's Mario David repeatedly kicked Chile's Leonel Sánchez while he was on the ground. Instead of rolling around feigning injury, Sánchez got up and laid a clean left hook to David's face that Joe Frazier would have been proud of. The punishment was swift – a free kick was given and nothing more. Coleman in the commentary box huffed, 'That was one of the neatest left hooks I've ever seen.' For that line of commentary to be followed by no punishment just shows how much things have swung from one extreme to the other over the years. David responded minutes later by karate kicking Sánchez in the head. He was sent off and Italy were down to nine men.

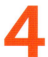 **4** Six players scorded four goals to finish as joint top scorers: Brazil's Garrincha and Vavá, along with Leonel Sánchez of Chile, Flórián Albert of Hungary, Valentin Ivanov of the Soviet Union and Dražan Jerković of Yugoslavia

In one brilliant moment, an Italian player was rugby-tackled to the floor, a fight ensued, and the referee ended up on the ground as he tried to break it up. 'We're getting a rugby match, and fight, and everything going in there. How can [Ken] Aston possibly keep this game going?' cried Coleman in the commentary box. The game did go the full 90; as for the score, Chile won 2-0 and shockingly ended the game with 11 men. Referee Ken Aston, of all people, would later come up with the idea for yellow and red cards, after approaching traffic lights and noticing the way amber turns to red.

Another standout moment from 1962 was Jimmy Greaves and a little dog who ran on to the pitch which put a temporary halt to England's quarter-final with Brazil. The little invader was caught by Greaves, who for his troubles got urinated on, much to the amusement of Brazil's Garrincha who later adopted the dog and named it after Greaves. With Pelé injured, Garrincha was Brazil's star man in their successful defence of the World Cup and the player most synonymous with the 1962 tournament. He scored two goals against England, and another two in the semi-final to help eliminate Chile. Czechoslovakia had made

World Cup debutants: Colombia, Bulgaria

it to their second World Cup Final and took the lead against Brazil in the 15th minute. However, it only took the world champions two minutes to level via an Amarildo shot which beat the out-of-position goalkeeper, who was expecting a cross, at his near post. As Pelé watched on from the front row, his team-mates Zito and Vavá scored in the second half and Brazil became the second team to have won the World Cup twice in a row, a feat that has not been repeated since. As for the Czechs, they equalled Hungary's record of two finals without winning one.

Group 1

Uruguay	2	1	Colombia
Soviet Union	2	0	Yugoslavia
Yugoslavia	3	1	Uruguay
Soviet Union	4	4	Colombia
Soviet Union	2	1	Uruguay
Yugoslavia	5	0	Colombia

	P	W	D	L	GD	Pts
Soviet Union	3	2	1	0	3	5
Yugoslavia	3	2	0	1	5	4
Uruguay	3	1	0	2	-2	2
Colombia	3	0	1	2	-6	1

Group 2

Chile	3	1	Switzerland
West Germany	0	0	Italy
Chile	2	0	Italy
West Germany	2	1	Switzerland
West Germany	2	0	Chile
Italy	3	0	Switzerland

	P	W	D	L	GD	Pts
West Germany	3	2	1	0	3	5
Chile	3	2	0	1	2	4
Italy	3	1	1	1	1	3
Switzerland	3	0	0	3	-6	0

Group 3

Brazil	2	0	Mexico
Czechoslovakia	1	0	Spain
Brazil	0	0	Czechoslovakia
Spain	1	0	Mexico
Brazil	2	1	Spain
Mexico	3	1	Czechoslovakia

	P	W	D	L	GD	Pts
Brazil	3	2	1	0	3	5
Czechoslovakia	3	1	1	1	-1	3
Mexico	3	1	0	2	-1	2
Spain	3	1	0	2	-1	2

Group 4

Argentina	1	0	Bulgaria
Hungary	2	1	England
England	3	1	Argentina
Hungary	6	1	Bulgaria
Hungary	0	0	Argentina
England	0	0	Bulgaria

	P	W	D	L	GD	Pts
Hungary	3	2	1	0	6	5
England	3	1	1	1	1	3
Argentina	3	1	1	1	-1	3
Bulgaria	3	0	1	2	-6	1

Quarter-Finals

Czechoslovakia	1
Hungary	0

Yugoslavia	1
West Germany	0

Brazil	3
England	1

Chile	2
Soviet Union	1

Semi-Finals

Czechoslovakia	3
Yugoslavia	1

Brazil	4
Chile	2

Final

Czechoslovakia	1
Brazil	3

Third Place Play-Off

Chile	1
Yugoslavia	0

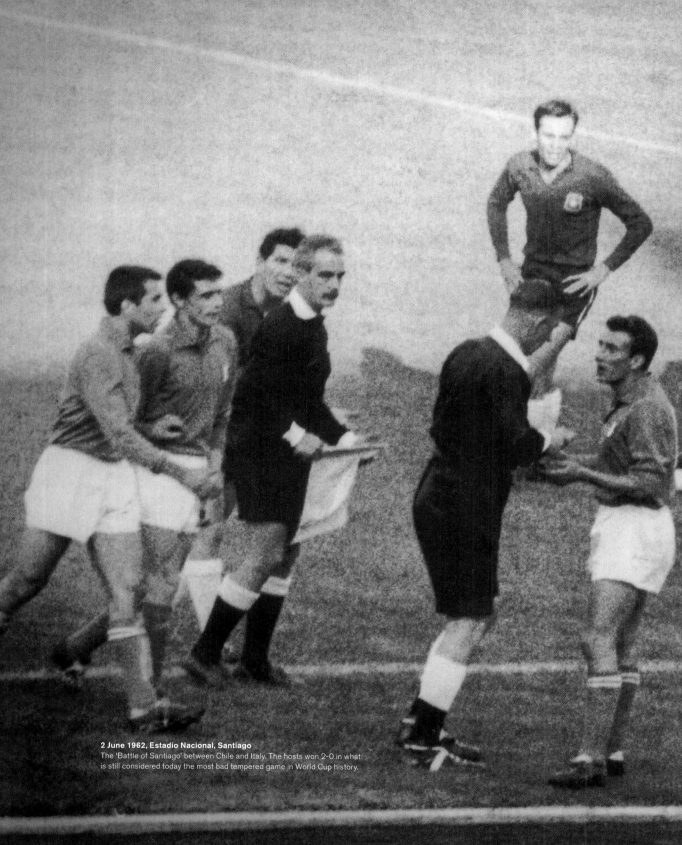

2 June 1962, Estadio Nacional, Santiago
The 'Battle of Santiago' between Chile and Italy. The hosts won 2–0 in what is still considered today the most bad tempered game in World Cup history.

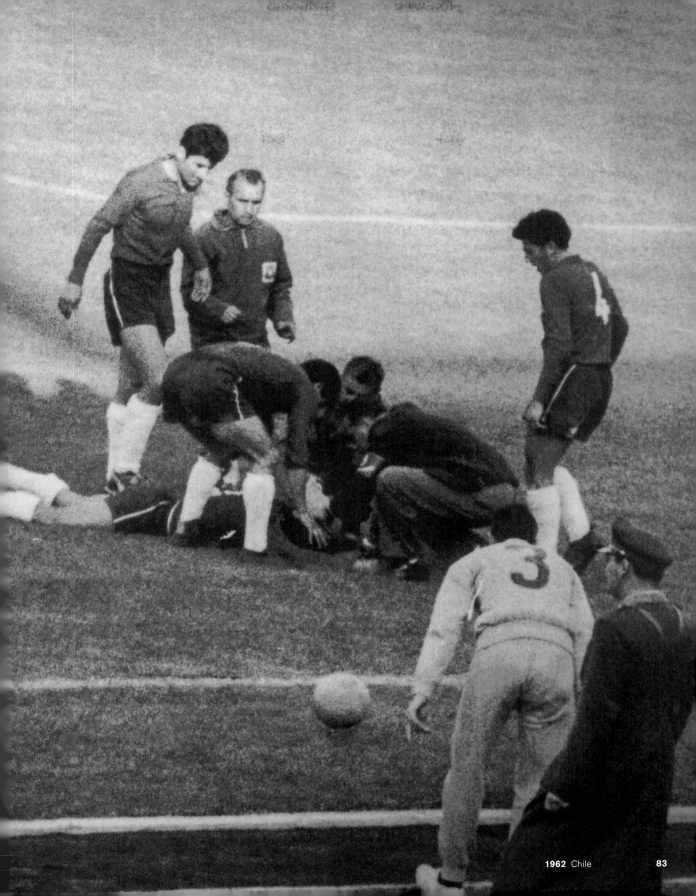

1962 Chile

83

17 June 1962, Estadio Nacional, Santiago
Legendary midfielder/forward Didi is a World
Cup winner for the second time in four years as
Brazil beat Czechoslovakia 3-1. No team since
1962 has successfully defended the World Cup.

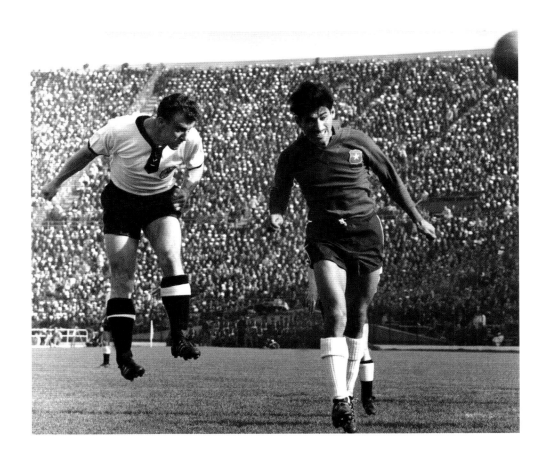

6 June 1962, Estadio Nacional, Santiago
German captain Hans Schaefer beats Chile's
Honorino Landa to the header as West Germany
beat the hosts 2-0 in the group stages.

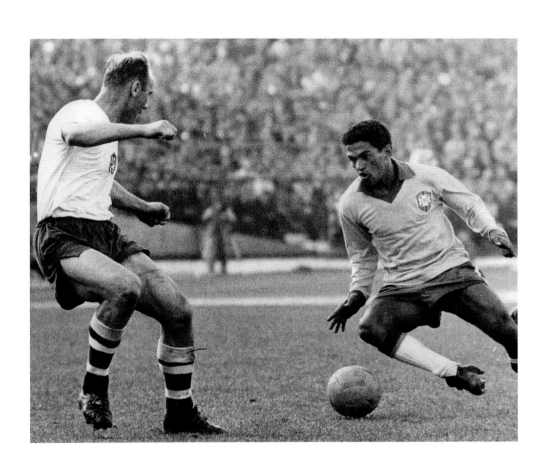

17 June 1962, Estadio Nacional, Santiago
Garrincha 'The Little Bird' was the standout
player of 1962. Here in the final he takes on
Czechoslovakia's Josef Masopust.

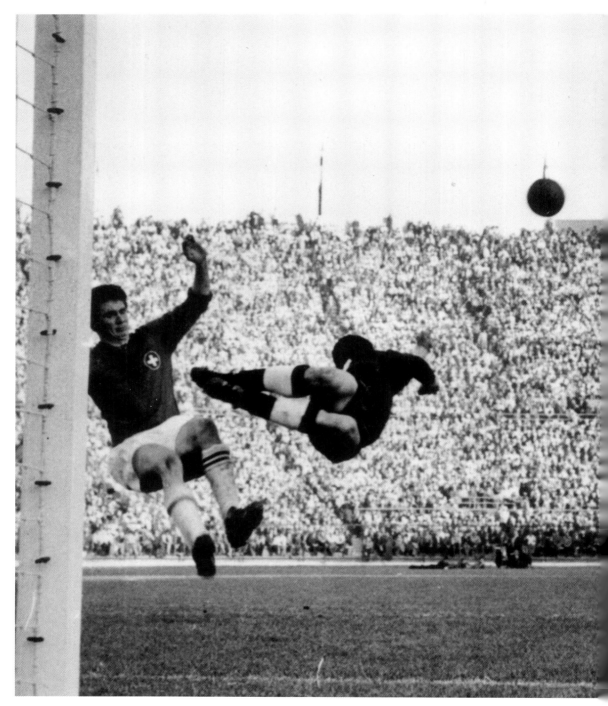

3 June 1962, Estadio Nacional, Santiago
German goalkeeper Wolfgang Fahrian punches the ball clear to deny Switzerland
during a group stage encounter. West Germany beat their European neighbours 2-1.

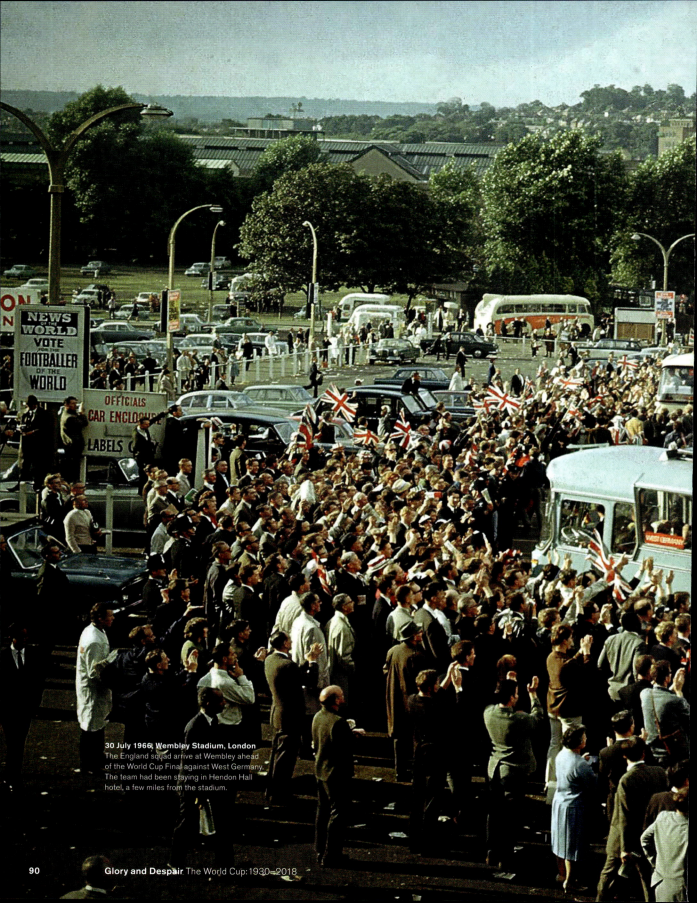

30 July 1966, Wembley Stadium, London
The England squad arrive at Wembley ahead
of the World Cup Final against West Germany.
The team had been staying in Hendon Hall
hotel, a few miles from the stadium.

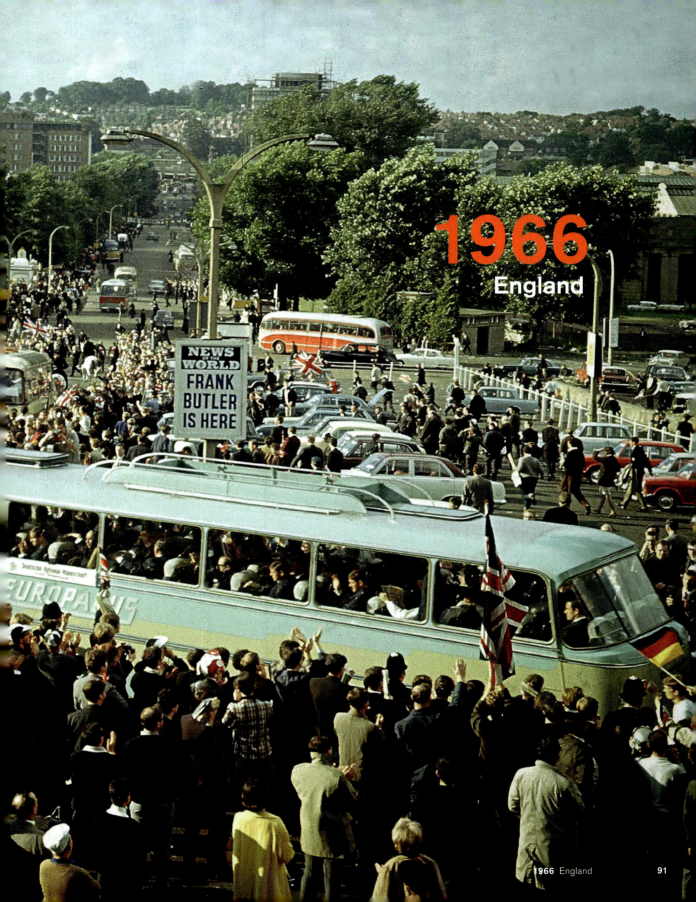

1966

England

1966 England

1966 was the last World Cup that didn't feature an African team. The Confederation of African Football (CAF) were frustrated that the overall winner of the African pool would still have to compete in a play-off against an Asian country. Thirty-one teams pulled out and a demand was made from CAF

17 Portugal were the tournament's top scoring team

that Africa should be guaranteed at least one entry to all future tournaments. Aside from North Korea, everyone else in 1966 was from Europe and Latin America and they would be competing in the birthplace of football. FIFA have in recent years claimed that football first started in China, even though the Chinese version was essentially a game of kick-ups where the ball was allowed to bounce. No opposition, target or purpose; just a person in a small grid doing a few keepy-uppies to take their mind off work! England and Scotland in the 1800s had formulated and structured football, and missionaries would promote this new sport all around the globe. Now the world was back where it began but were not in awe because up to this point in World Cup history the inventors had never been the masters.

The last time Brazil had lost a World Cup game was back in 1954 against Hungary. In England they lost twice in the space of four days, conceded six goals, and went out in the group stage. Beaten first by Portugal, and then Hungary it was Brazil's worst World Cup performance aside from 1934, when they were eliminated in their first match with no group stage in place. Pelé was the star attraction and looking to make up for the fact that he was injured in the final stages of the 1962 tournament. Instead, he was hacked out of the competition by Portuguese brutality. For Pelé it looked like the end of the road for his World Cup career as he hobbled off at Goodison Park.

In the same stadium, Portugal played North Korea in the quarter-final. In the group stage the Koreans had caused arguably the biggest upset in World Cup history by beating Italy at Ayresome Park, Middlesbrough. For the English public, the North Korean team were well liked and seen as a plucky underdog, but the establishment saw things differently. There were some Whitehall figures who wanted to ban them as they did not recognise the North as a legitimate state, but the FA, FIFA and even the prime minister, Harold Wilson, refused to consider kicking them out the tournament. Not prepared to

9 Eusébio of Portugal was top scorer

forget the matter, the Foreign Office made sure some measures were enforced, such as forbidding any North Korean symbols being on the World Cup Royal Mail stamps. Despite the fact that both teams were playing in their first World Cup, Portugal were strong favourites and had the world's second greatest player – the Mozambique-born Eusébio. Incredibly Korea went 3-0 up after just 25 minutes, but Eusébio scored four goals in the space of 32 minutes either side of half-time and the Portuguese won 5-3.

Portugal faced the hosts and lost 2-1 courtesy of two well-taken Bobby Charlton goals, and it would be another 20 years before they would be back at a

World Cup debutants: Portugal, North Korea

Group 1

Uruguay	0	0	England
France	1	1	Mexico
Uruguay	2	1	France
England	2	0	Mexico
Mexico	0	0	Uruguay
England	2	0	France

	P	W	D	L	GD	Pts
England	3	2	1	0	4	5
Uruguay	3	1	2	0	1	4
Mexico	3	0	2	1	-2	2
France	3	0	1	2	-3	1

Group 2

West Germany	5	0	Switzerland
Argentina	2	1	Spain
Spain	2	1	Switzerland
West Germany	0	0	Argentina
Argentina	2	0	Switzerland
West Germany	2	1	Spain

	P	W	D	L	GD	Pts
West Germany	3	2	1	0	6	5
Argentina	3	2	1	0	3	5
Spain	3	1	0	2	-1	2
Switzerland	3	0	0	3	-8	0

World Cup. West Germany saw off a strong Soviet Union team in the semi-final to set up a showdown with England, in the city of the 1960s, and in the most famous stadium in world football. The Queen was there, the Beatles were there, and Muhammad Ali also showed up to remind everybody who was number one.

The two most elite players on the pitch, Franz Beckenbauer and Bobby Charlton, had subdued afternoons as their managers gave them an instruction to mark the other one out of the game. Charlton would express disappointment in later years, but he also understood that it was for the good of the team. England had been a growing force as the 1960s rolled on and manager Alf Ramsey had predicted that his team would win the World Cup on home soil. With one minute to go they were 2-1 ahead but a contentious free kick was awarded to West Germany and from the resulting rebound Wolfgang Weber equalised and sent the game into extra time. 'You've won it once, go and win it again,' Ramsey told his players.

What followed was the most disputed goal in World Cup history, in that the English say it was a goal while everyone else viewed the camera shot from the side angle and said, 'No way!' England had used up all their refereeing favours at World Cups for the following 50 years and beyond. In the final seconds Geoff Hurst was through on goal, and blasted the ball into the roof of the net even though he was aiming for the stands in order to waste time. Hurst's hat-trick had meant England's greatest moment had arrived with the greatest commentary to go with it, 'Some people are on the pitch, they think it's all over. It is now.'

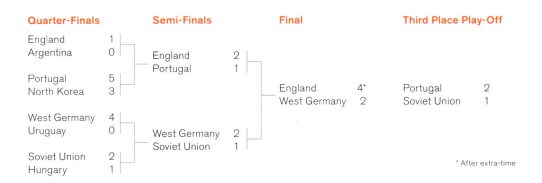

Group 3

Brazil	2	0	Bulgaria		
Portugal	3	1	Hungary		
Hungary	3	1	Brazil		
Portugal	3	0	Bulgaria		
Portugal	3	1	Brazil		
Hungary	3	1	Bulgaria		

	P	W	D	L	GD	Pts
Portugal	3	3	0	0	7	6
Hungary	3	2	0	1	2	4
Brazil	3	1	0	2	-2	2
Bulgaria	3	0	0	3	-7	0

Group 4

Soviet Union	3	0	North Korea		
Italy	2	0	Chile		
Chile	1	1	North Korea		
Soviet Union	1	0	Italy		
North Korea	1	0	Italy		
Soviet Union	2	1	Chile		

	P	W	D	L	GD	Pts
Soviet Union	3	3	0	0	5	6
North Korea	3	1	1	1	-2	3
Italy	3	1	0	2	0	2
Chile	3	0	1	2	-3	1

Quarter-Finals

England	1
Argentina	0
Portugal	5
North Korea	3
West Germany	4
Uruguay	0
Soviet Union	2
Hungary	1

Semi-Finals

England	2
Portugal	1
West Germany	2
Soviet Union	1

Final

England	4*
West Germany	2

Third Place Play-Off

Portugal	2
Soviet Union	1

* After extra-time

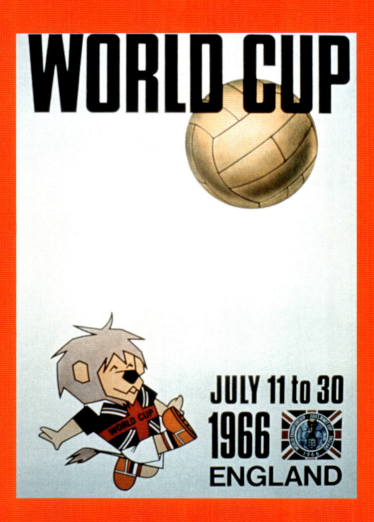

The 1966 World Cup poster featuring the cartoon lion World Cup Willie.

12 July 1966, Ayresome Park, Middlesbrough Soviet Union captain Albert Shesterniev and his North Korean counterpart Shin Yung Kyoo await the result of a coin toss by the referee before the game. The Soviets won 3–0.

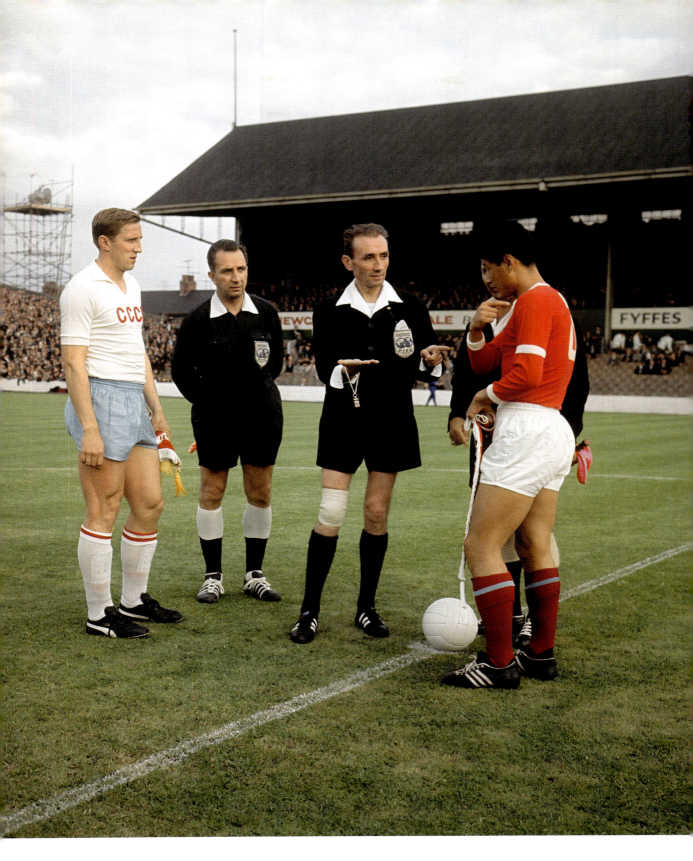

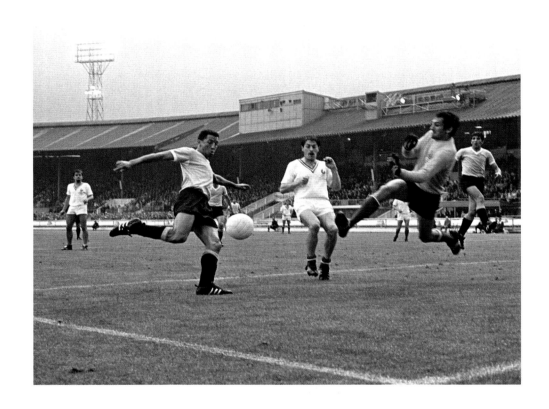

15 July 1966, White City Stadium, London
Uruguay take on France in West London, a stadium
that got demolished in 1984. Uruguay came out 2-1
winners and would progress to the last eight.

17 July 1966, Bolton, England
Pele and his Brazilian team-mates warm up before a training session. The defending world champions and glamour team of the age were supposed to have trained at Bolton Wanderers' Burnden Park stadium. However, the club officials said the facilities were not ready, therefore Brazil had to make do with a nearby recreation field, giving locals the chance to see the world champions up close.

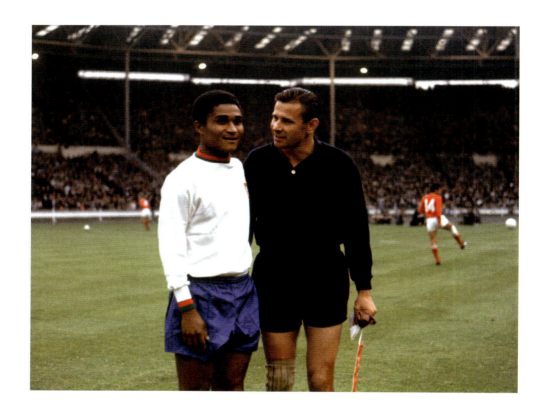

28 July 1966, Wembley Stadium, London
The meeting of two legends. Soviet Union goalkeeper Lev Yashin and Portugal's Eusebio embrace before the third-place play-off at Wembley. Portugal won 2-1.

19 July 1966, Goodison Park, Liverpool
Eusebio shows compassion towards his fellow great Pele, as the Brazilian was kicked out of the game by an aggressive Portugal side. The European team won 3-1 and Brazil were eliminated in the group stage.

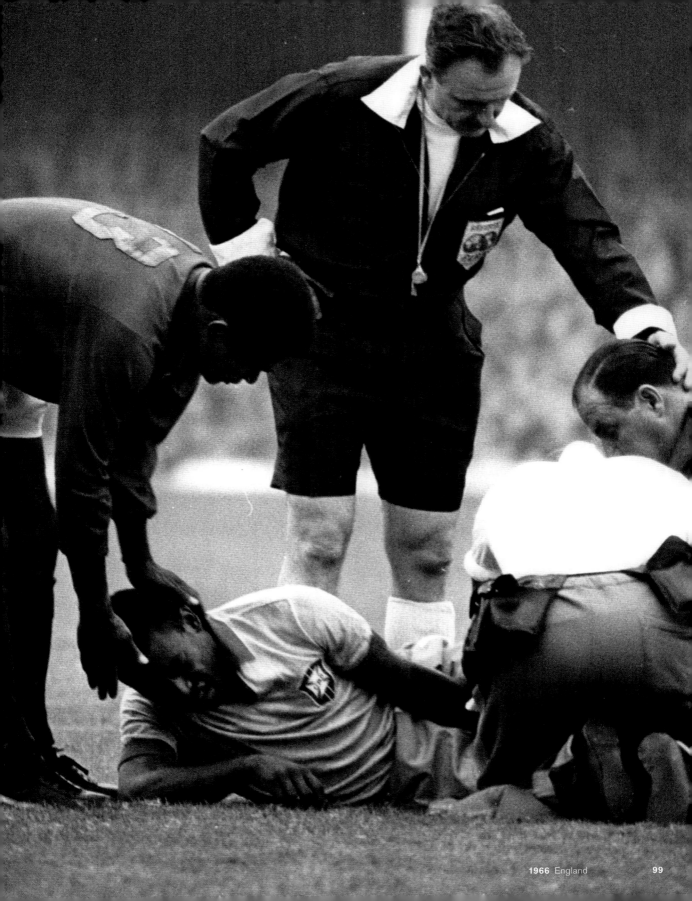

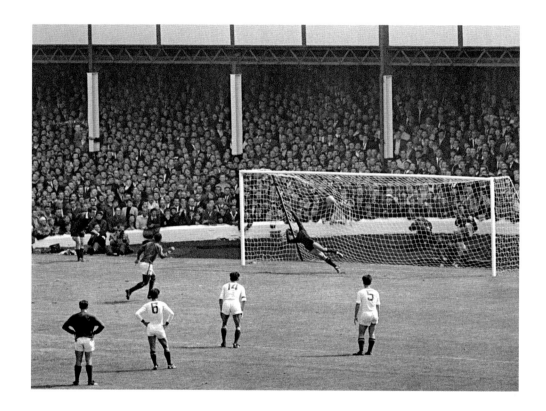

23 July 1966, Goodison Park, Liverpool
Eusebio leads his team to a comeback after trailing
3-0 to North Korea on Merseyside. This penalty was
one of four goals scored by Eusebio in a 5-3 win that
took Portugal to the semi-final in what was their first
ever appearance in a World Cup.

19 July 1966, Ayresome Park, Middlesbrough
North Korea celebrate a 1-0 win against Italy in what
some will still consider the greatest upset in the history
of the competition. In the final group game, Pak-Doo-ik
scored the only goal as the Italians were eliminated
whilst North Korea advanced to the quarter-final.

30 July 1966, Wembley Stadium, London
England and West Germany fans watch the game together in
the same unsegregated terrace at Wembley for the final.

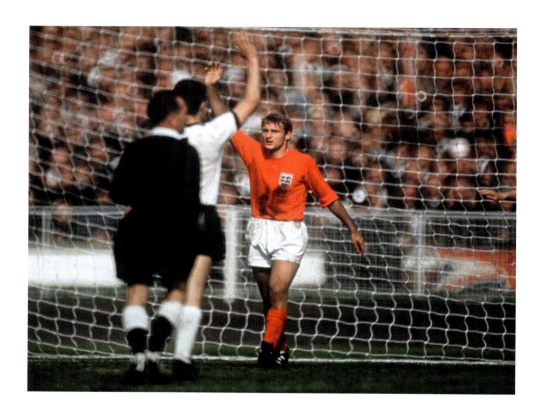

30 July 1966, Wembley Stadium, London
A pivotal moment. Instead of going for the rebound, Roger Hunt turns away from the goal and claims that Geoff Hurst's shot had gone over the line after bouncing down from the crossbar. When asked about his goal in the years to come, Hurst always cited Hunt's reaction as to why he thought the ball did cross the line.

Bobby Moore holds the Jules Rimet trophy, which was handed to him by the Queen in the Royal Box after beating West Germany 4-2.

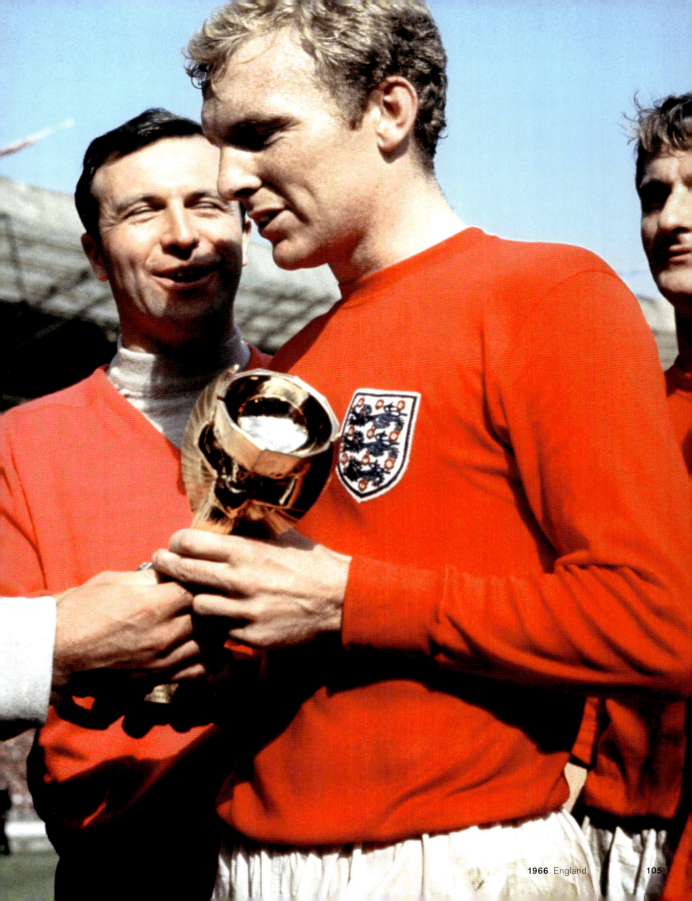

1970
Mexico

7 June 1970, Estadio Jalisco, Guadalajara
Gordon Banks commands his goal area during a tight
encounter between England and Brazil in Guadalajara.
Brazil won 1-0 via a second half goal from Jairzinho.

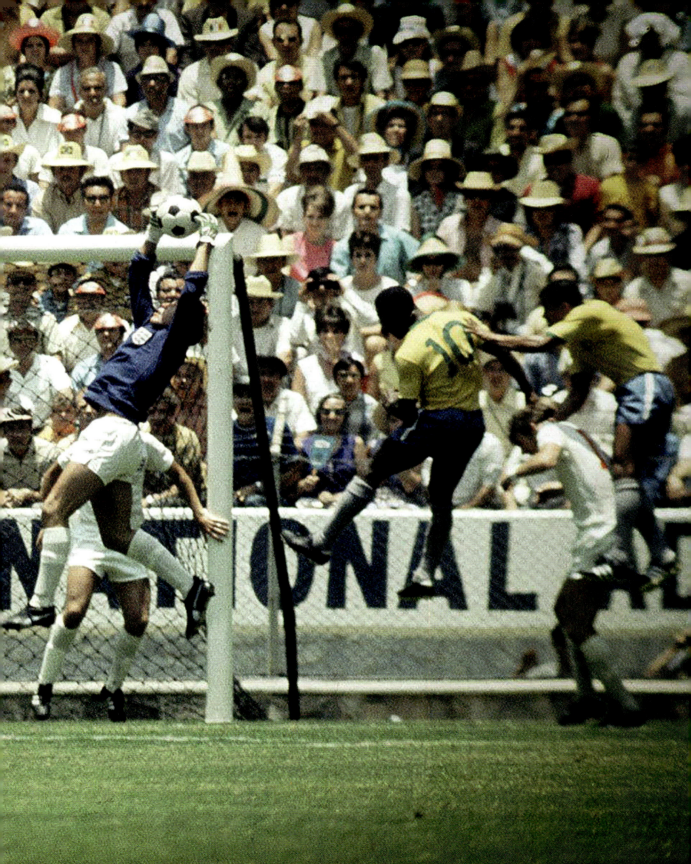

1970 Mexico

As great World Cups go, Mexico '70 is high up on the list; and as far as great teams go the winners Brazil over the years have been placed at the very top. Featuring Gérson, Rivellino, Tostão, Jairzinho, Carlos Alberto and a rejuvenated Pelé, they became the standard-bearer and measuring stick as to what a great team should aspire to be. If a team is average or poor then 'They're not exactly Brazil 1970' is a phrase that you could possibly hear.

19 Brazil were the tournament's top scoring team

The tournament was a series of firsts: the first World Cup to be held outside of South America and Europe; the first World Cup to be broadcast in colour; the first World Cup to feature the iconic chess board-patterned black and white ball known as the Adidas Telstar – the pattern that would go on to become the universal symbol of what a football looks like; the first World Cup to have substitutes as well as yellow and red cards; the first World Cup to feature a Panini sticker album; the first World Cup that had to allocate a mandatory place to an African team (in this case Morocco); the first and so far only World Cup where England came in as defending world champions and they were considered better than the team who won four years earlier.

England were drawn in Group 3 with Brazil, and the meeting between the two became celebrated as a pivotal match that produced a standard of play that raised football to a new level. The only goal was scored in the second half by Jairzinho who would create another first – the only player to score in every match including the final. Bobby Moore's one-footed tackle on Pelé, who was charging down on goal, became as celebrated as Pelé's header which was tipped past the post by Gordon Banks. The great Brazilian scored three goals in 1970 but his misses stand out more. He nearly scored against Uruguay in what would have gone down as the most audacious and cheekiest goal in history, as he rounded the keeper without touching the ball, then put his shot just wide, as a defender rushed back to cover the goal. Against the Czechs, Pelé was in his own half when he spotted the keeper off his line. He blasted the ball upwards, and the length and power were to perfection but it went narrowly wide of the left-hand post; so close to the greatest goal ever scored.

With no night games due to TV scheduling, no World Cup has ever looked hotter (with the exception of Mexico '86). Despite the conditions, it didn't prevent a great football spectacle, especially in the later rounds. The final was a memorable game for the way in which Brazil comprehensively took apart the European champions Italy 4-1.

Perhaps the Italians were exhausted from a semi-final with West Germany that would be hailed as one of the greatest ever World Cup games. The Germans had looked like going out in the quarter-finals after trailing England 2-0 with just 22 minutes to go. Bobby Charlton was substituted and in one of the great comebacks West Germany put three goals past Peter Bonetti, who was standing in as goalkeeper due to Banks being sidelined with food poisoning. Against Italy it looked too late for a comeback as the Germans were a goal down in injury time, but in the second minute of stoppage time Karl-Heinz Schnellinger volleyed in from a cross. Gerd Müller put West Germany ahead five minutes into

Group 1

Mexico	0	0	Soviet Union
Belgium	3	0	El Salvador
Soviet Union	4	1	Belgium
Mexico	4	0	El Salvador
Soviet Union	2	0	El Salvador
Mexico	1	0	Belgium

	P	W	D	L	GD	Pts
Soviet Union	3	2	1	0	5	5
Mexico	3	2	1	0	5	5
Belgium	3	1	0	2	-1	2
El Salvador	3	0	0	3	-9	0

Group 2

Uruguay	2	0	Israel
Italy	1	0	Sweden
Uruguay	0	0	Italy
Sweden	1	1	Israel
Sweden	1	0	Uruguay
Italy	0	0	Israel

	P	W	D	L	GD	Pts
Italy	3	1	2	0	1	4
Uruguay	3	1	1	1	1	3
Sweden	3	1	1	1	0	3
Israel	3	0	2	1	-2	2

World Cup debutants: Israel, Morocco, El Salvador

extra time and Italy at this point must have felt deflated. They had gone from being in a World Cup Final to being 2-1 down in the space of a few minutes. West Germany were resilient but so were the Italians, who trailed for just four minutes in the entire game. Tarcisio Burgnich quickly equalised, then Gigi Riva made it 3-2. Müller equalised in the second half of extra time and it looked like there was no separating the two sides. Directly from the kick-off Italy went down the other end and Rivera scored the final goal in what undoubtedly is the greatest ever period of extra time in World Cup history.

The winners of that semi-final were destined to be runners-up in the final; nobody had the beating of Brazil in 1970. The Italians had fallen behind to Pelé in the 16th minute and levelled through Roberto Boninsegna in the 37th, but Brazil won the World Cup in the most flamboyant style in the competition's history. Gérson scored from outside the box, then Jairzinho made it 3-1 and the game was over, though the best was yet to come.

10 Gerd Müller of West Germany was top scorer

If Diego Maradona is credited with the greatest ever solo goal in 1986, then Brazil get credited for the greatest team goal. They had played the ball around their own half before midfielder Clodoaldo got hold of it and dribbled around four Italian players as the English commentator Kenneth Wolstenholme said, 'Ah, this is great stuff.' The ball was played up the field to Jairzinho, who took on a couple of defenders and found Pelé who was just outside the box. The greatest player in the world never took glory for himself, and instead passed to his captain Carlos Alberto who was charging in on the right-hand side. Alberto blasted in the fourth as Wolstenholme famously reacted, 'And that was sheer delightful football.'

Pelé had sealed his legacy as the greatest player of all time, and Brazil got to keep the Jules Rimet Trophy for their achievement of being the first nation to win a hat-trick of World Cups.

Group 3

England	1	0	Romania
Brazil	4	1	Czechoslovakia
Romania	2	1	Czechoslovakia
Brazil	1	0	England
Brazil	3	2	Romania
England	1	0	Czechoslovakia

	P	W	D	L	GD	Pts
Brazil	3	3	0	0	5	6
England	3	2	0	1	1	4
Romania	3	1	0	2	-1	2
Czechoslovakia	3	0	0	3	-5	0

Group 4

Peru	3	2	Bulgaria
West Germany	2	1	Morocco
Peru	3	0	Morocco
West Germany	5	2	Bulgaria
West Germany	3	1	Peru
Bulgaria	1	1	Morocco

	P	W	D	L	GD	Pts
West Germany	3	3	0	0	6	6
Peru	3	2	0	1	2	4
Bulgaria	3	0	1	2	-4	1
Morocco	3	0	1	2	-4	1

Quarter-Finals

Uruguay	1*
Soviet Union	0

Brazil	4
Peru	2

Italy	4
Mexico	1

West Germany	3*
England	2

Semi-Finals

Brazil	3
Uruguay	1

Italy	4*
West Germany	3

Final

Brazil	4
Italy	1

Third Place Play-Off

West Germany	1
Uruguay	0

* After extra-time

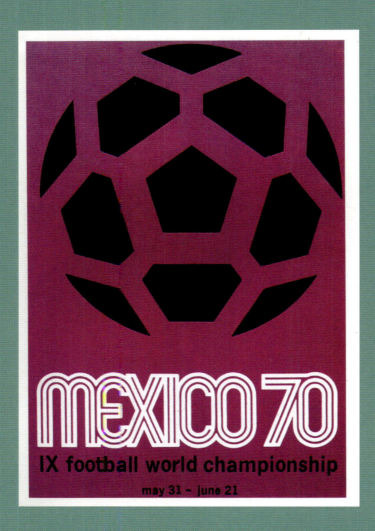

The official poster for Mexico 1970.

31 May 1970, Estadio Azteca, Mexico City
The opening ceremony at the iconic Azteca
Stadium in Mexico City.

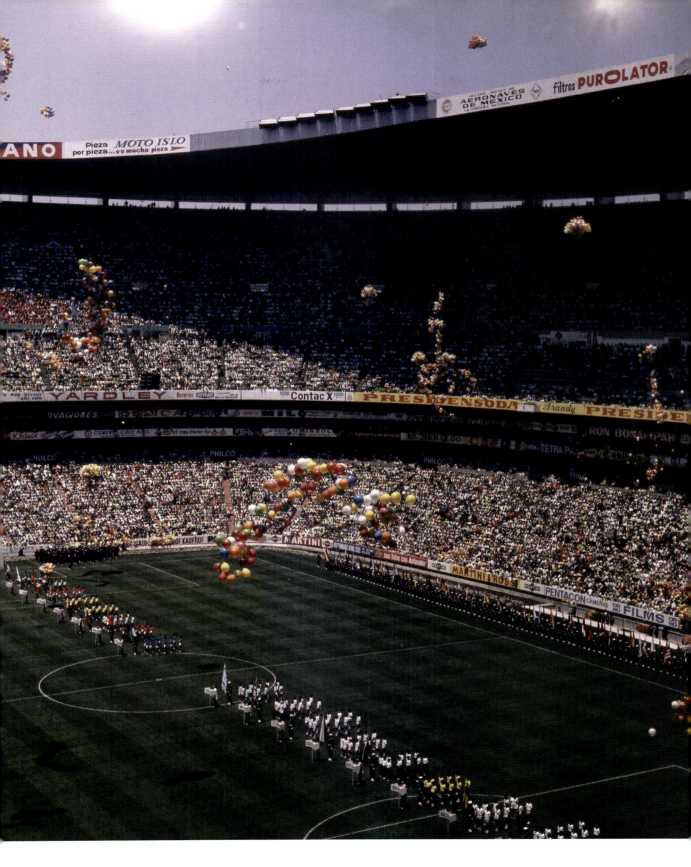

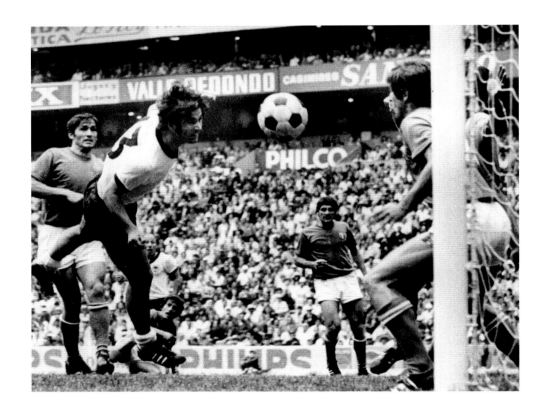

17 June 1970, Estadio Jalisco, Guadalajara
Gerd Muller heads into the bottom corner to make it
3-3 in an epic semi-final against Italy. Muller ended
the tournament as top scorer with 10 goals.

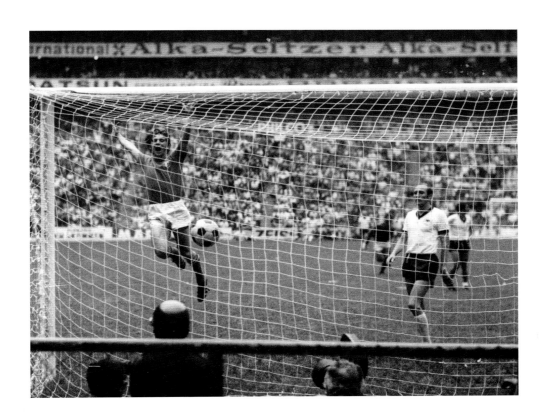

17 June 1970, Estadio Jalisco, Guadalajara
Luigi Riva scores and Italy go 3-2 ahead against West
Germany, having been behind 2-1. The game ended 4-3 to
Italy with the winning goal coming from Giovanni Rivera.

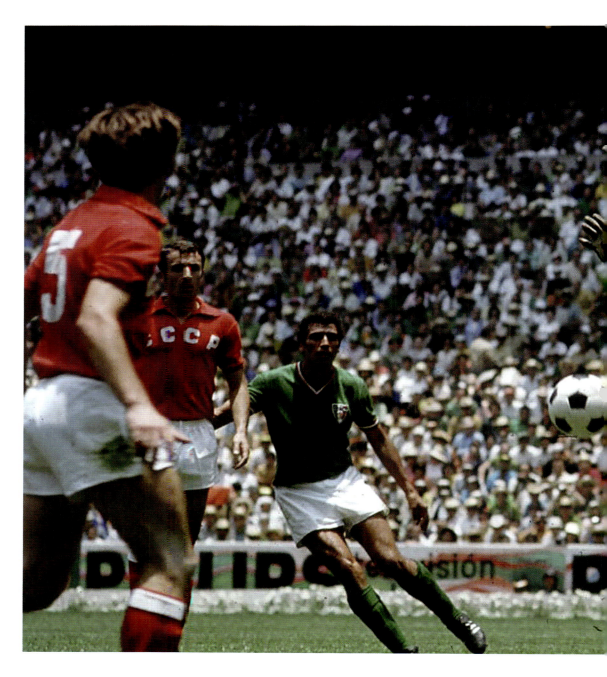

31 May 1970, Estadio Azteca, Mexico City
The opening game of 1970, was the hosts Mexico versus the Soviet Union in a 0-0 draw. Both teams would progress to the quarter-finals.

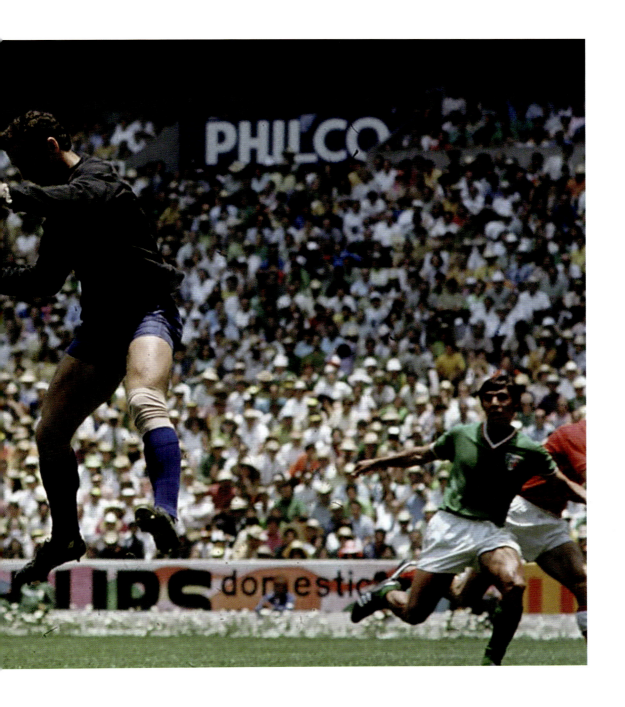

Glory and Despair The World Cup: 1930–2018

7 June 1970, Estadio Jalisco, Guadalajara
Legendary captains Bobby Moore and Carlos
Alberto await the result of a coin toss before
England versus Brazil.

May 1970, Mexico
Defending world champions England casually walk the streets of Mexico. To the far
left is Jimmy Greaves who wasn't part of the squad. However, Greavsie took part in a
road race to Mexico in what was billed as a 'World Cup Rally Championship'.

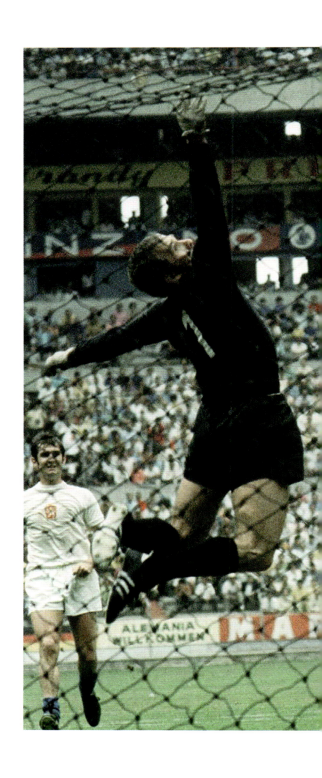

3 June 1970, Estadio Jalisco, Guadalajara
Czech goalkeeper Ivo Viktor pushes the ball
over the bar during an encounter with Brazil.
However, Viktor would have to pick the ball out
of the net four times as Brazil won 4-1.

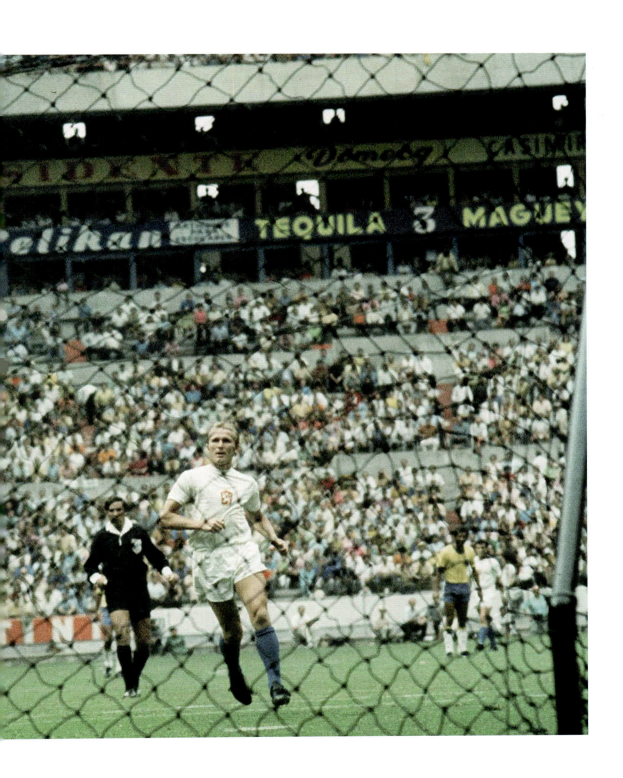

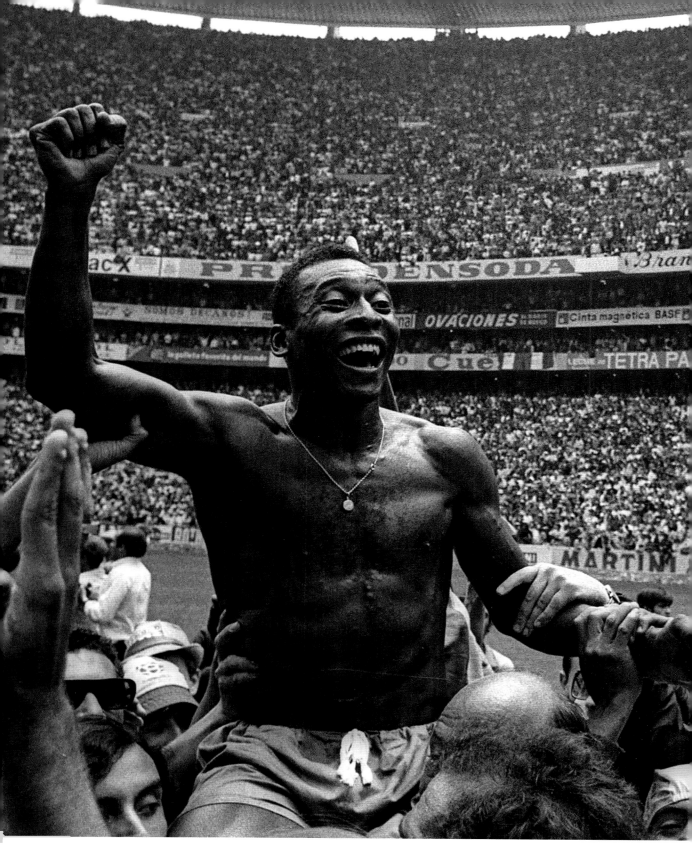

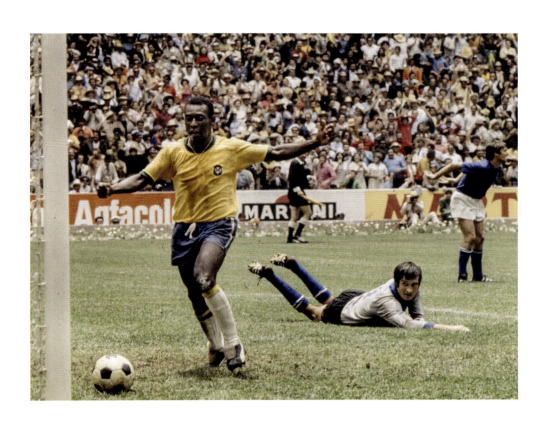

21 June 1970, Estadio Azteca, Mexico City
Pele is raised victorious as Brazil thrash Italy
4-1 in the final.

Seconds after captain Carlos Alberto smashed home the fourth
goal, Pele celebrates by kicking the ball back into the net.

VOLKSPARKSTADION HAMBURG
DDR – BR DEUTSCHLAND

22 June 1974, Volksparkstadion, Hamburg
A unique moment in football history as East Germany
meet West Germany in the group stages. In a major
upset East beat West 1-0.

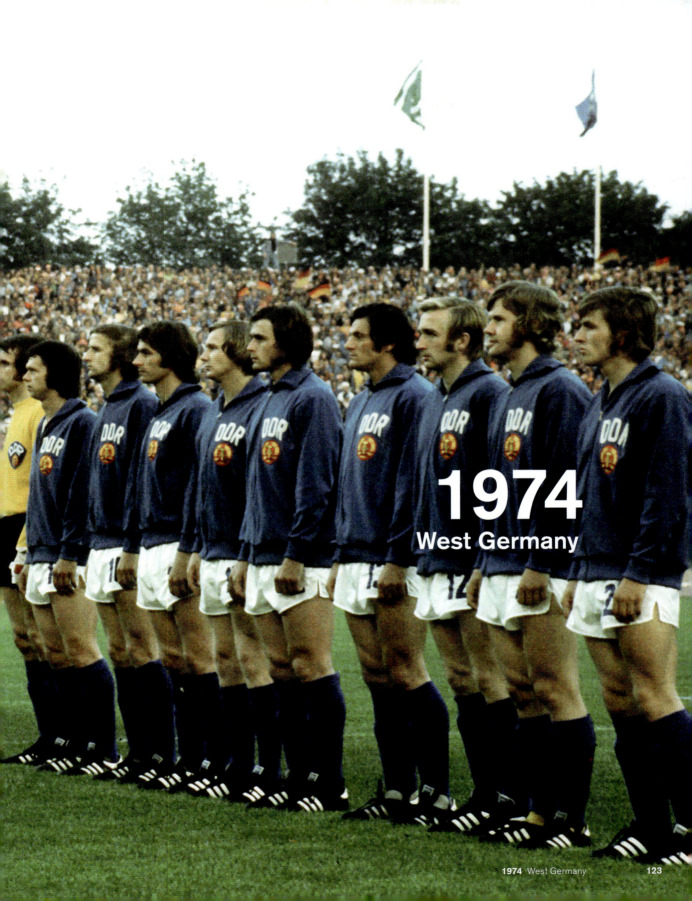

1974
West Germany

1974 West Germany

In previous World Cups the hosts were in the opening game but 1974 started a new tradition where the defending champions kicked things off, as Brazil and Yugoslavia played out a goalless draw. With the Jules Rimet Trophy in the hands of the Brazilians forever (or until 1983 when thieves stole it from a museum in Rio and melted it down) a new prize was created, known simply as the FIFA World Cup Trophy. It's 18-carat gold, has two strips of green malachite, and features human figures lifting up a globe. What Tutankhamun is to mummification this stunning new World Cup was to sports trophies.

16 Poland were the tournament's top scoring team

Germany – West and unified – have won this version of the prize three times, which is a record, and their first triumph came in the tournament hosted on home soil. But in the group stage they first had to dispose of East Germany. It was the only time that the East Germans qualified for the World Cup, but the politics of the day would mean that most people in East Germany couldn't travel to watch them and the Berlin Wall would remain standing for another 15 years. Incredibly, and against all odds, East triumphed over West in a 1-0 win. Both Germanys however advanced to the next round which saw a change of format from being a straight knockout, and for the first time since 1950 it reverted back to a second group phase.

Unlike in 1950, when the winner of the second phase became champions, in 1974 the winners of Group A and B would progress to the final. West Germany beat Yugoslavia, Poland and Sweden to get to their third World Cup Final. East Germany were in the group topped by the Netherlands, whose 1974 vintage is always in the conversation as the greatest team to not win the World Cup. Some people say Brazil in 1982, others Hungary in 1954, but perhaps most would say this Dutch group.

'Total Football' was a Dutch philosophy that centred around players being comfortable in any position, and in Johan Cruyff they had the best player in world football. The Netherlands' comprehensive beating of Brazil in the all-important deciding game of Group B looked like a coming of age for the soon-to-be world champions.

Only 30 years had passed since the war and occupation, and feelings were still strong with Dutch midfielder Willem van Hanegem saying, 'They murdered my father, sister, and two brothers. I am full of angst. I hate them.' In the final the Netherlands went 1-0 up after just 90 seconds via a Johan Neeskens penalty. At this point in time not many people would have predicted another 1954 miracle, but this time the Germans were on home soil and had superstars of their own. Paul Breitner converted a penalty after Bernd Hölzenbein was fouled in the box. Then two minutes before half-time Gerd Müller scored the most significant goal of his illustrious career, as he turned and placed the ball into the far corner of the net. It won Germany the World Cup and it broke Just Fontaine's record as the all-time leading scorer in the finals. Müller's record tally of 14 would last until 2006.

7 Grzegorz Lato of Poland was top scorer

Little Haiti did something that England and Spain couldn't do and that was qualify for West Germany. Zaire (now known as Democratic Republic of Congo), who were run by the dictator President Mobutu, also qualified in

First Round Group 1

West Germany	1	0	Chile
East Germany	2	0	Australia
West Germany	3	0	Australia
Chile	1	1	East Germany
Australia	0	0	Chile
East Germany	1	0	West Germany

	P	W	D	L	GD	Pts
East Germany	3	2	1	0	3	5
West Germany	3	2	0	1	3	4
Chile	3	0	2	1	-1	2
Australia	3	0	1	2	-5	1

First Round Group 2

Brazil	0	0	Yugoslavia
Scotland	2	0	Zaire
Brazil	0	0	Scotland
Yugoslavia	9	0	Zaire
Scotland	1	1	Yugoslavia
Brazil	3	0	Zaire

	P	W	D	L	GD	Pts
Yugoslavia	3	1	2	0	9	4
Brazil	3	1	2	0	3	4
Scotland	3	1	2	0	2	4
Zaire	3	0	0	3	-14	0

World Cup debutants: Zaire, Australia, East Germany, Haiti

1974, and in the very same year that their country was centre stage for one of the biggest events in sporting history – the 'Rumble in the Jungle' between Muhammad Ali and George Foreman. In West Germany they got thumped 9-0 by Yugoslavia, in what stands as the second biggest win in the competition's history.

Most famously, however, Zaire in 1974 will be remembered for a bizarre incident involving a Brazilian free kick from 25 yards out. With the likes of Rivellino and Jairzinho hovering to take the kick – the defending world champions were feared dead-ball specialists – Zaire's players lined up in the wall fearing the worst. The referee blew the whistle and Zaire's Mwepu Ilunga had a brainstorm – if I just boot the ball away then they can't score. With all his power Ilunga launched the ball away from danger as the bemused Brazilians protested to the referee, who booked the right-back.

Despite seemingly being out of their depth, Zaire would be pioneers for African football. Some have blamed their poor showing against Yugoslavia on player unrest which was due to a dispute over their own officials stealing player payments, and they would end up being compensated by FIFA just so they would agree to play the game. It was also said that players had been warned by Mobutu that they could not return home if they lost to Brazil by more than three goals, which might explain Mwepu's sense of desperation, as the score at that time was 2-0. Despite their appearance not going as they planned, 'the leopards' from Zaire go down in history as the first sub-Saharan African team to play in a World Cup.

First Round Group 3

Netherlands	2	0	Uruguay
Sweden	0	0	Bulgaria
Bulgaria	1	1	Uruguay
Netherlands	0	0	Sweden
Netherlands	4	1	Bulgaria
Sweden	3	0	Uruguay

	P	W	D	L	GD	Pts
Netherlands	3	2	1	0	5	5
Sweden	3	1	2	0	3	4
Bulgaria	3	0	2	1	-3	2
Uruguay	3	0	1	2	-5	1

First Round Group 4

Italy	3	1	Haiti
Poland	3	2	Argentina
Argentina	1	1	Italy
Poland	7	0	Haiti
Argentina	4	1	Haiti
Poland	2	1	Italy

	P	W	D	L	GD	Pts
Poland	3	3	0	0	9	6
Argentina	3	1	1	1	2	3
Italy	3	1	1	1	1	3
Haiti	3	0	0	3	-12	0

Second Round Group A

Netherlands	4	0	Argentina
Brazil	1	0	East Germany
Brazil	2	1	Argentina
Netherlands	2	0	East Germany
Argentina	1	1	East Germany
Netherlands	2	0	Brazil

	P	W	D	L	GD	Pts
Netherlands	3	3	0	0	8	6
Brazil	3	2	0	1	0	4
East Germany	3	0	1	2	-3	1
Argentina	3	0	1	2	-5	1

Second Round Group B

West Germany	2	0	Yugoslavia
Poland	1	0	Sweden
Poland	2	1	Yugoslavia
West Germany	4	2	Sweden
West Germany	1	0	Poland
Sweden	2	1	Yugoslavia

	P	W	D	L	GD	Pts
West Germany	3	3	0	0	5	6
Poland	3	2	0	1	1	4
Sweden	3	1	0	2	-2	2
Yugoslavia	3	0	0	3	-4	0

Final

| West Germany | 2 | 1 | Netherlands |

Third Place Play-Off

| Poland | 1 | 0 | Brazil |

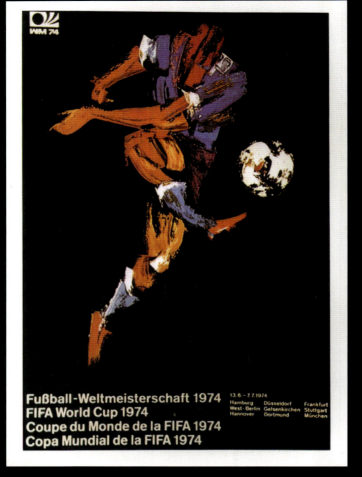

The 1974 official World Cup poster.

23 June 1974, Westfalenstadion, Dortmund
The stadium in Dortmund is full to capacity as the Netherlands beat Bulgaria 4-1 in the group stage.

22 June 1974, Parkstadion, Gelsenkirchen
A bizarre moment, as Zaire's Mwepu Ilunga is booked in the 78th minute after disrupting a free kick before it was taken. As the Brazilians were preparing to take the kick, Mwepu left the wall and booted the ball down the other end of the field.

30 June 1974, Parkstadion, Gelsenkirchen
East Germany and the Netherlands play out a tie
in the second group phase during a rain storm in
Hanover. The Netherlands won 2-0.

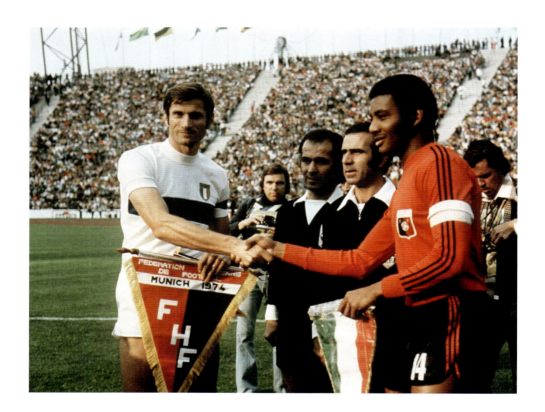

15 June 1974, Olympiastadion, Munich
Haiti meet two-time winners Italy in a David versus Goliath
match-up. Haiti were only the second team from the Caribbean
to appear at a World Cup and they took the lead in the 46th
minute. Italy faced another 1966 North Korea scenario,
however they came back to win the game 3-1.

23 June 1974, Westfalenstadion, Dortmund
Johannes Neeskens (out of shot) smashes
home a penalty for the Netherlands in a 4-1
victory over Bulgaria.

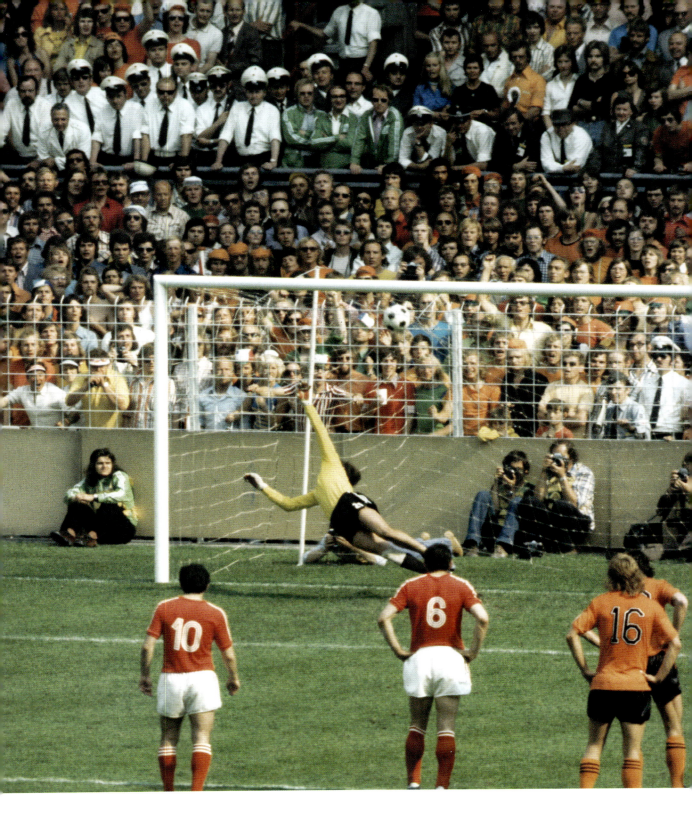

18 June 1974, Waldstadion, Frankfurt
Defending world champions Brazil take on Scotland in Frankfurt.
The game ended 0-0 and unfortunately for Scotland they went
out in the group stage despite not losing a game.

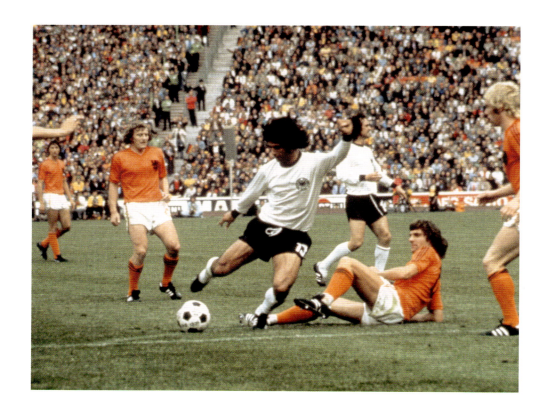

7 July 1974, Olympiastadion, Munich
Gerd Muller turns and shoots to put West Germany
2-1 ahead in the final against Netherlands.

West German goalkeeper Sepp Maier
attempts to punch the ball clear of danger.

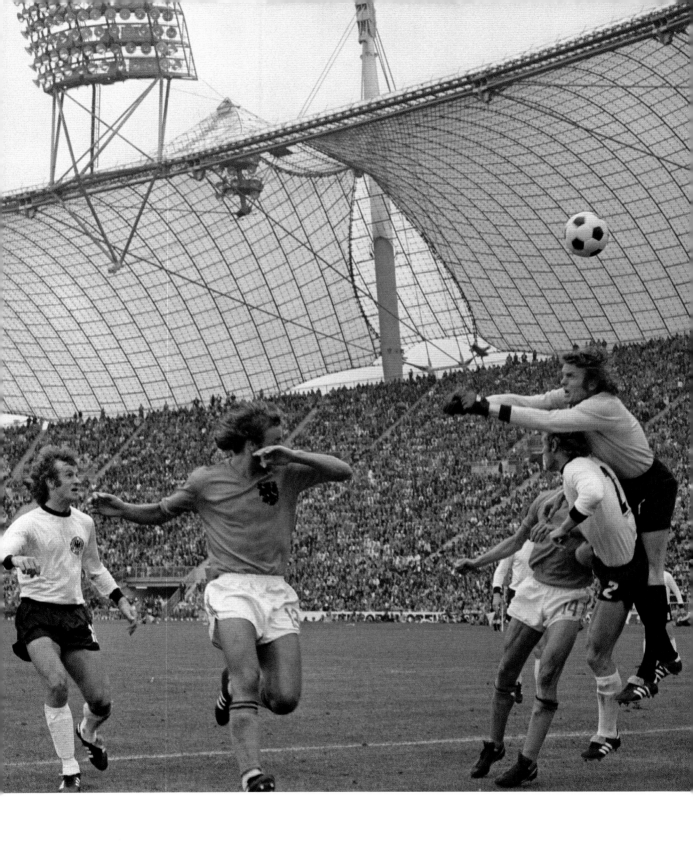

1978
Argentina

25 June 1978, Estadio Monumental, Buenos Aires
In the final, Argentina go 2-1 ahead against the Netherlands in extra time. Goalscorer Mario Kempes (centre) holds out his arms in ecstasy.

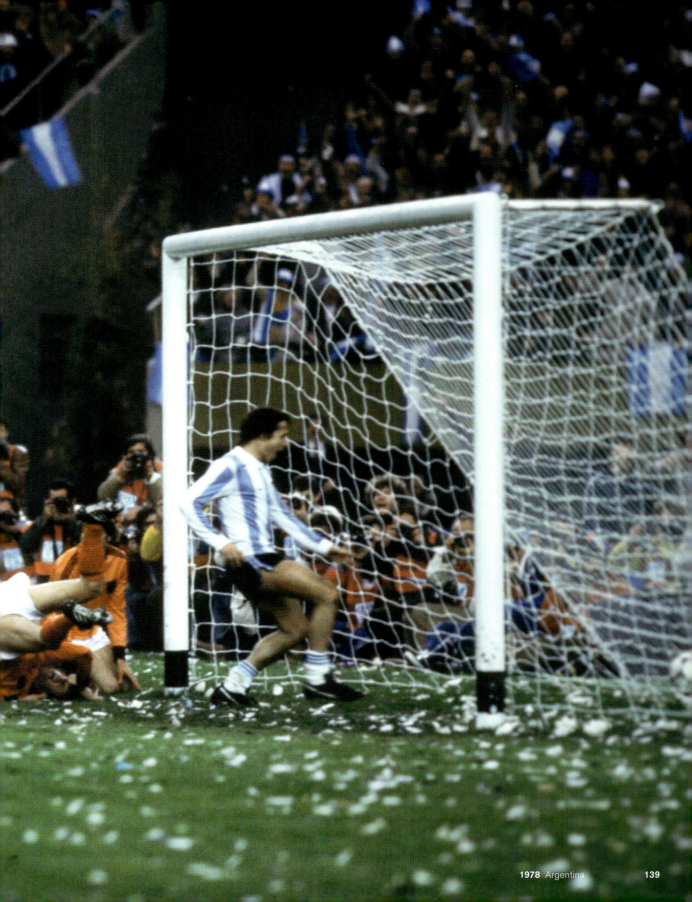

1978 Argentina

By 2026, the World Cup faces expansion from 32 teams to 48, in a move which many fans feel puts money before the quality and prestige of the competition. In 1978 FIFA's stance was the opposite, and they hadn't woken up to the idea that the tournament's structure was too small and outdated. After nearly 50 years of World Cup competition there were still only 16 teams participating. As a result, qualification was tighter than a can of sardines, to the point where even the champions of Europe, Czechoslovakia, didn't qualify.

15 Netherlands and Argentina were the tournament's top scoring teams

In 1978 Argentina were not considered an elite World Cup nation in the way that they are today. Since appearing in the inaugural final in 1930, their World Cup history had been unremarkable with a bad-tempered quarter-final exit against England in 1966 the furthest they had gone in that time.

In 1978 the emerging Diego Maradona was lurking in the background, but Argentina had a strong team and didn't feel they required the services of the 17-year-old, despite him making his national team debut in 1977. Up to this point the hosts had a history of winning the trophy, but the fact that Argentina was allowed to continue to hold the finals was very questionable as the country had been taken over by a military dictatorship in 1976. Nearly 6,000 people had 'gone missing' since the coup and it would later emerge that many of them died in football stadiums that were used as detention centres.

Given the dictatorship and its influence in how the host nation progressed, no World Cup has ever been as controversial as 1978. There were throwbacks to Mussolini and the 1934 finals with allegations of influencing referees and bribes. Argentina had been pitted in a 'group of death' with Italy, France and Hungary and faced the possibility of going out in the first round. During the France game it's alleged that the referee was on the side of the home team, which was something that the Hungarian manager Lajos Baróti had also cited by saying, 'Everything, even the air, is in favour of Argentina.' Due to the win against France, Argentina progressed, but looked like going out in the second group phase which included Brazil, Poland and Peru. Brazil's wins over Peru and Poland meant that in the final game for Argentina, they had to beat Peru by four goals or more. They won 6-0, Brazil cried foul play, and in the years to follow no game in World Cup history would face as much accusation of corruption, though no conclusive evidence has ever come to the forefront.

Brazil had another reason to feel utterly aggrieved during 1978; they had to participate in a game with notorious Welsh referee Clive Thomas. In one of the most controversial moments of any World Cup, Thomas denied the Brazilians a last-second winner against Sweden by blowing the full-time whistle as the ball was headed into the net by Zico. The disallowed goal had come via a corner and Brazil were in no particular rush, as an unwritten rule in football is that the referee never blows for time when a corner is taken. Thomas, on the other hand, never read unwritten rules and blew the whistle just as Zico's head connected with the ball. That decision changed the outcome of the second group phase as the Brazilians would have qualified for Group A, which could have resulted in an Argentina–Brazil final.

First Round Group 1

Italy	2	1	France
Argentina	2	1	Hungary
Italy	3	1	Hungary
Argentina	2	1	France
France	3	1	Hungary
Italy	1	0	Argentina

	P	W	D	L	GD	Pts
Italy	3	3	0	0	4	6
Argentina	3	2	0	1	1	4
France	3	1	0	2	0	2
Hungary	3	0	0	3	-5	0

First Round Group 2

West Germany	0	0	Poland
Tunisia	3	1	Mexico
West Germany	6	0	Mexico
Poland	1	0	Tunisia
West Germany	0	0	Tunisia
Poland	3	1	Mexico

	P	W	D	L	GD	Pts
Poland	3	2	1	0	3	5
West Germany	3	1	2	0	6	4
Tunisia	3	1	1	1	1	3
Mexico	3	0	0	3	-10	0

World Cup debutants: Iran, Tunisia

Scotland were strong – or were supposed to have been. With star players such as Kenny Dalglish and Graeme Souness there were even suggestions that they could win the World Cup, with manager Ally Macleod suggesting they were capable. Thousands of Scots made the journey to Argentina, which in those days wasn't a tourist destination and came at a very high cost, with one man even selling his business in order to pay for his transport. He probably wished he hadn't. Scotland lost their first game 3-1 against Peru, and then drew 1-1 with Iran as hundreds of angry fans lined up near the players' tunnel to jeer the team off the field, with one throwing his tartan scarf at them in fury. Despite Scotland going out in the first round, Archie Gemmill gave the Tartan Army something to cheer as he produced one of the great World Cup goals during a 3-2 win over the Netherlands.

Whether allegations of corruption are true or not, one thing is for sure, Argentina being in a final on home soil produced one of the greatest spectacles in the history of the World Cup courtesy of the home fans. Before the game, ticker tape and confetti were thrown from the stands in an incredible show of pageantry. The Dutch were in their second final in a row, despite missing Johan Cruyff who had decided not to make the journey to South America. The star of the show was Mario Kempes, who had scored two of Argentina's goals against Peru. His opening goal was cancelled out by Dick Nanninga in the 82nd minute. However, the home team would score twice in extra time and 48 years after losing to Uruguay, Argentina could now call themselves world champions.

6 Mario Kempes of Argentina was top scorer

First Round Group 3

Austria	2	1	Spain
Brazil	1	1	Sweden
Austria	1	0	Sweden
Brazil	0	0	Spain
Spain	1	0	Sweden
Brazil	1	0	Austria

	P	W	D	L	GD	Pts
Austria	3	2	0	1	1	4
Brazil	3	1	2	0	1	4
Spain	3	1	1	1	0	3
Sweden	3	0	1	2	-2	1

First Round Group 4

Peru	3	1	Scotland
Netherlands	3	0	Iran
Netherlands	0	0	Peru
Scotland	1	1	Iran
Peru	4	1	Iran
Scotland	3	2	Netherlands

	P	W	D	L	GD	Pts
Peru	3	2	1	0	5	5
Netherlands	3	1	1	1	2	3
Scotland	3	1	1	1	-1	3
Iran	3	0	1	2	-6	1

Second Round Group A

Netherlands	5	1	Austria
Italy	0	0	West Germany
Netherlands	2	2	West Germany
Italy	1	0	Austria
Austria	3	2	West Germany
Netherlands	2	1	Italy

	P	W	D	L	GD	Pts
Netherlands	3	2	1	0	5	5
Italy	3	1	1	1	0	3
West Germany	3	0	2	1	-1	2
Austria	3	1	0	2	-4	2

Second Round Group B

Brazil	3	0	Peru
Argentina	2	0	Poland
Poland	1	0	Peru
Argentina	0	0	Brazil
Brazil	3	1	Poland
Argentina	6	0	Peru

	P	W	D	L	GD	Pts
Argentina	3	2	1	0	8	5
Brazil	3	2	1	0	5	5
Poland	3	1	0	2	-3	2
Peru	3	0	0	3	-10	0

Final

Argentina	3*	1	Netherlands

Third Place Play-Off

Brazil	2	1	Italy

* After extra-time

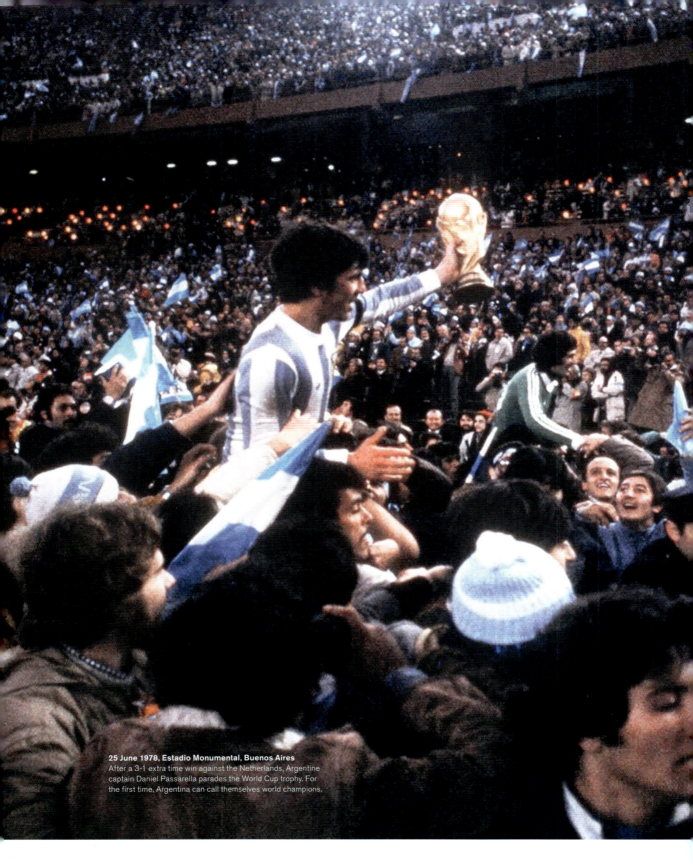

25 June 1978, Estadio Monumental, Buenos Aires
After a 3-1 extra time win against the Netherlands, Argentine captain Daniel Passarella parades the World Cup trophy. For the first time, Argentina can call themselves world champions.

The official 1978 World Cup poster.

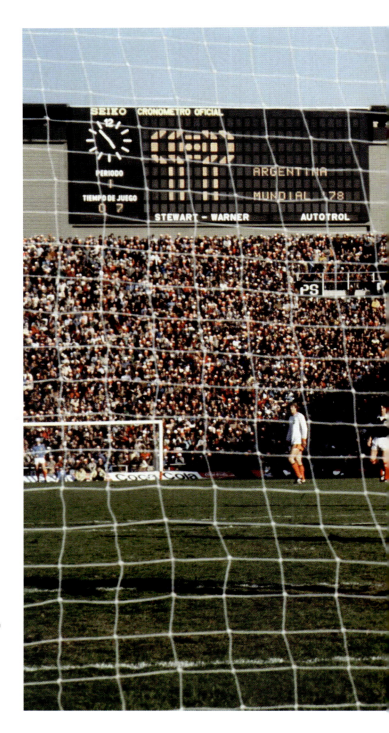

11 June 1974, Estadio Cuidad de Mendoza, Mendoza
Scotland take on the Netherlands. The Scots needed to win by three goals in order to progress to the next phase and they went 3-1 ahead in the 68th minute through a famous Archie Gemmill solo goal. However, the Dutch regrouped and three minutes later scored a goal from Johnny Rep and the game ended 3-2. A great win for Scotland, but not enough to progress to the second group phase.

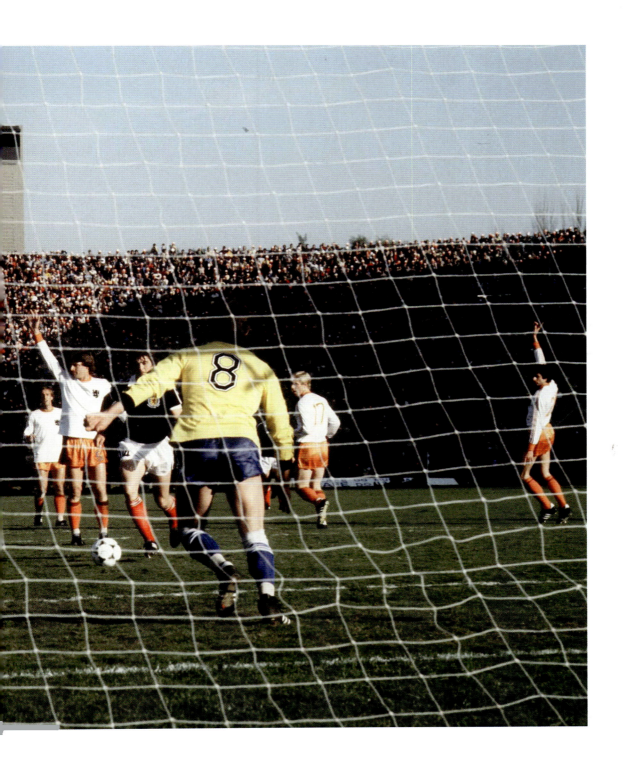

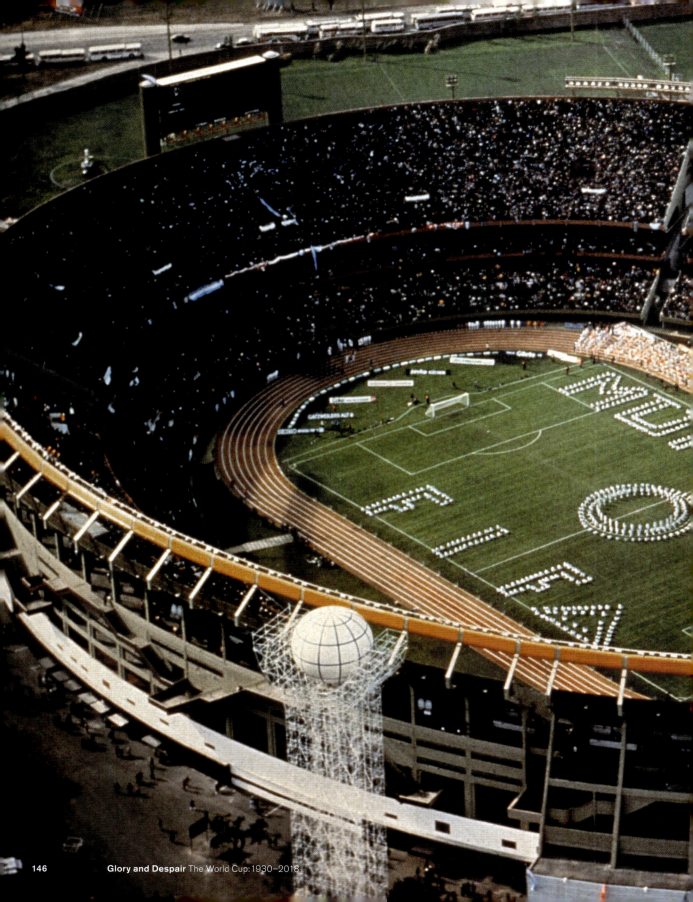

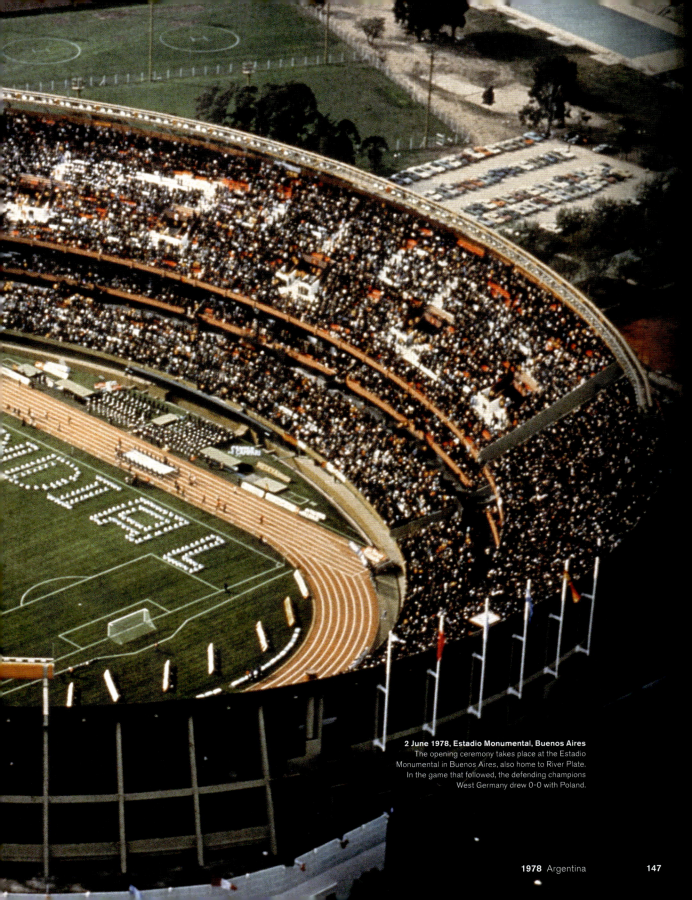

2 June 1978, Estadio Monumental, Buenos Aires
The opening ceremony takes place at the Estadio
Monumental in Buenos Aires, also home to River Plate.
In the game that followed, the defending champions
West Germany drew 0-0 with Poland.

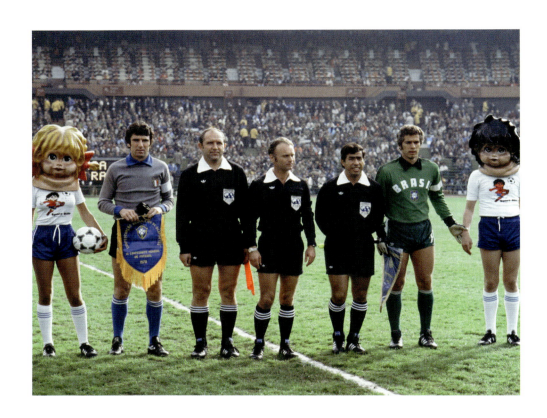

24 June 1978, Estadio Monumental, Buenos Aires
In between the officials, goalkeepers Dino Zoff (left) and Leao (right)
are captains for both Italy and Brazil for the third-place play-off game.
Next to them are two women who for some reason have been asked
to wear bizarre face masks. Brazil won the game 2-1.

7 June 1978, Estadio Chateau Carreras, Córdoba
Not a good time to be a Scotland player. A 1-1 draw
with Iran has put the Scots on the verge of elimination
and their fans gather by the tunnel to vent their fury as
the players leave the pitch.

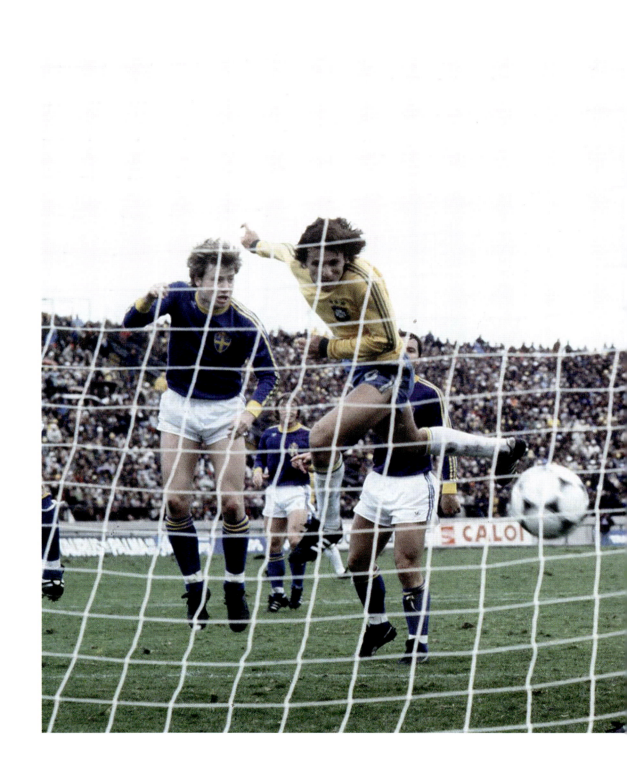

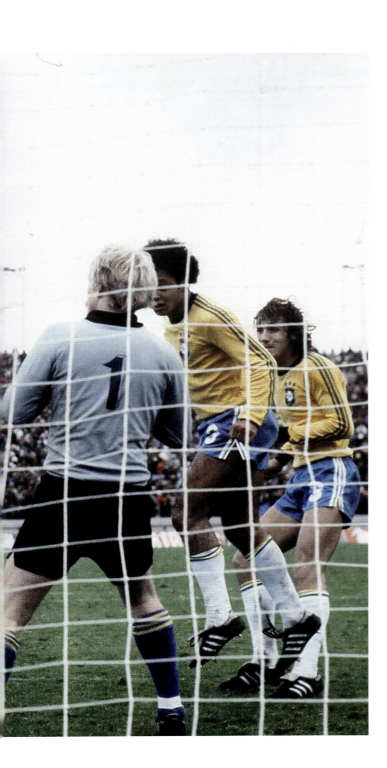

3 June 1978, José Amalfitani Stadium, Buenos Aires
Zico thinks he has scored the winner against Sweden in the dying seconds as he heads home from a corner. However, in one of the most infamous moments in World Cup history, the referee Clive Thomas had blown the final whistle just after the corner was taken and so the goal was not given.

25 June 1978, Estadio Monumental, Buenos Aires
In the final, Argentina fans celebrate below a classic 1970s scoreboard.

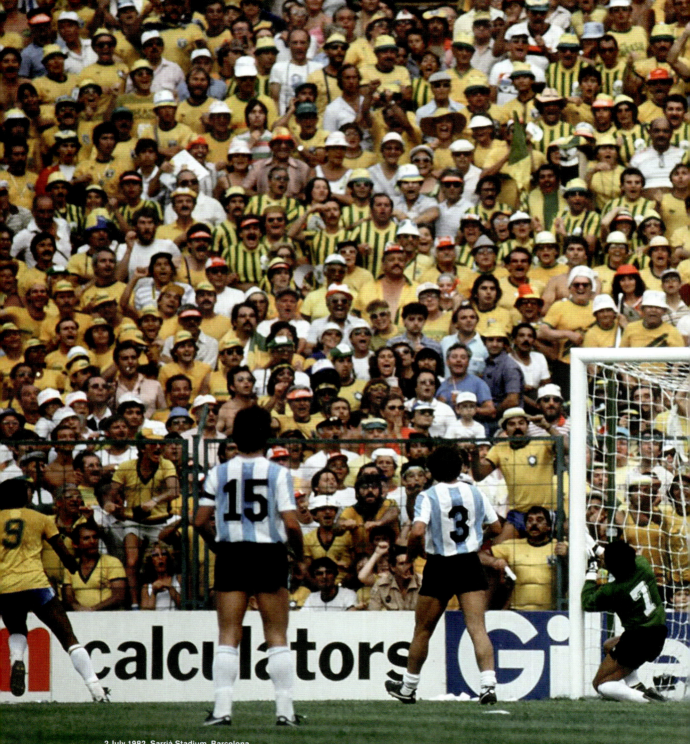

2 July 1982, Sarrià Stadium, Barcelona
Brazilian fans on the terraces watch on as Serginho heads
home a cross to make it 2-0 against defending world
champions Argentina. Spain 1982 was the last World Cup
to have open terracing.

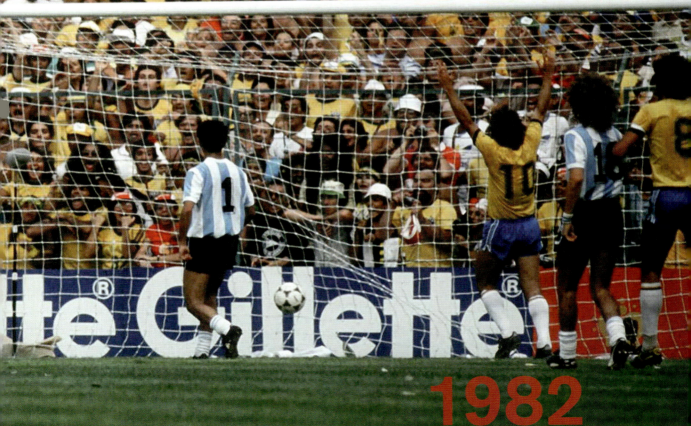

1982

Spain

1982 Spain

Perhaps the greatest football show on earth was in Spain '82, and at the forefront were Brazil who lit up the tournament with a style of play that put them in the conversation as the greatest team not to have won a World Cup.

16 France were the tournament's top scoring team

With the charismatic Zico and Sócrates, they cruised through the group stage and swept aside Argentina in the first game in the second group phase. This set up a decider with Italy in which the winner would progress to the semi-final. Twenty-four teams were now involved in the tournament, up from 16, and this would be the last World Cup in which there was a second group stage instead of a straight knockout.

Against Brazil, Paolo Rossi (back from a recent ban for alleged match-fixing), put the Italians 1-0 up. The response outlined why the Brazilians were favourites, as an exquisite turn and through-ball from Zico set up Sócrates who scored from a tight angle. It was a goal that English commentator John Motson described as summing up the philosophy of Brazilian football. However, in a classic encounter, Rossi would score two more in a 3-2 victory and Brazil were out. Up to this point, Rossi had not registered a goal in the tournament and was the villain of the Italian media. His hat-trick made him an overnight hero and Italy would beat Poland in the semi-final for a chance to win the World Cup for the first time since Mussolini was in power.

France, led by Michel Platini, were the other flair team in 1982 who would have felt that they should have gone all the way. In their semi-final with West Germany they were 3-1 up in the second half of extra time, yet threw away the lead and lost what was the first World Cup penalty shoot-out. West Germany had got to the final with an average side, and with perhaps the biggest villain in the history of the finals. In the second half, with the score 1-1, goalkeeper Harald Schumacher charged out of his goal as Patrick Battiston

6 Paolo Rossi of Italy was top scorer

chased a through ball. The force with which Schumacher collided with the Frenchman resulted in Battiston being knocked out, losing two teeth, damaging a vertebra, and requiring an oxygen mask to breathe. The outcome of the incident was a goal kick to Germany.

Many accused Schumacher of deliberate thuggery and not going for the ball, and he won no friends by saying, 'If that is all that's wrong with him I'll pay for the crowns,' after learning that the Frenchman had lost two teeth. The goalkeeper also received criticism for not even bothering to check on Battiston during the whole time he was laid out motionless on the pitch. Not many neutrals were disappointed when Italy beat West Germany 3-1 in the final, as Marco Tardelli produced the most famous and emotional goal celebration in history after blasting in the second.

Another controversy in 1982 involving West Germany was their infamous 1-0 win against Austria in the first group stage. It was a scoreline that suited both nations and put West Germany top of the group, and Austria second, at the expense of Algeria who like the rest of the world called foul play regarding the manner in which the game played out once the Germans scored after ten minutes. Both teams had clearly settled for the convenient scoreline and the crux of the problem was that Algeria had played earlier in the day, meaning that West Germany and Austria knew what margins were enough to take both teams through. Had the matches been played simultaneously then a different scenario could have transpired, and off the back of this incident FIFA introduced a ruling in which the last round of group games must kick off at the same time. Poor Algeria, they won two out of three group games, including a 2-1 victory over West Germany, and yet they still went home early – while the winners Italy didn't even win a single game in the first group stage, yet still qualified.

And while we can feel sorry for Algeria, no one can feel sorry for Sheik Fahad Al-Ahmad, the head of the Kuwait FA and brother of the ruling sheik. Acting like a rich man who insisted on everything his way, he disputed France's fourth goal, and from the stands waved the Kuwait team off the field. He only agreed to

World Cup debutants: Algeria, Kuwait, New Zealand, Cameroon, Honduras

First Round Group 1

Italy	0	0	Poland
Peru	0	0	Cameroon
Italy	1	1	Peru
Poland	0	0	Cameroon
Poland	5	1	Peru
Italy	1	1	Cameroon

	P	W	D	L	GD	Pts
Poland	3	1	2	0	4	4
Italy	3	0	3	0	0	3
Cameroon	3	0	3	0	0	3
Peru	3	0	2	1	-4	2

First Round Group 2

Algeria	2	1	West Germany
Austria	1	0	Chile
West Germany	4	1	Chile
Austria	2	0	Algeria
Algeria	3	2	Chile
West Germany	1	0	Austria

	P	W	D	L	GD	Pts
West Germany	3	2	0	1	3	4
Austria	3	2	0	1	2	4
Algeria	3	2	0	1	0	4
Chile	3	0	0	3	-5	0

First Round Group 3

Belgium	1	0	Argentina
Hungary	10	1	El Salvador
Argentina	4	1	Hungary
Belgium	1	0	El Salvador
Belgium	1	1	Hungary
Argentina	2	0	El Salvador

	P	W	D	L	GD	Pts
Belgium	3	2	1	0	2	5
Argentina	3	2	0	1	4	4
Hungary	3	1	1	1	6	3
El Salvador	3	0	0	3	-12	0

First Round Group 4

England	3	1	France
Czechoslovakia	1	1	Kuwait
England	2	0	Czechoslovakia
France	4	1	Kuwait
France	1	1	Czechoslovakia
England	1	0	Kuwait

	P	W	D	L	GD	Pts
England	3	3	0	0	5	6
France	3	1	1	1	1	3
Czechoslovakia	3	0	2	1	-2	2
Kuwait	3	0	1	2	-4	1

First Round Group 5

Spain	1	1	Honduras
Yugoslavia	0	0	Northern Ireland
Spain	2	1	Yugoslavia
Honduras	1	1	Northern Ireland
Yugoslavia	1	0	Honduras
Northern Ireland	1	0	Spain

	P	W	D	L	GD	Pts
Northern Ireland	3	1	2	0	1	4
Spain	3	1	1	1	0	3
Yugoslavia	3	1	1	1	0	3
Honduras	3	0	2	1	-1	2

First Round Group 6

Brazil	2	1	Soviet Union
Scotland	5	2	New Zealand
Brazil	4	1	Scotland
Soviet Union	3	0	New Zealand
Soviet Union	2	2	Scotland
Brazil	4	0	New Zealand

	P	W	D	L	GD	Pts
Brazil	3	3	0	0	8	6
Soviet Union	3	1	1	1	2	3
Scotland	3	1	1	1	0	3
New Zealand	3	0	0	3	-10	0

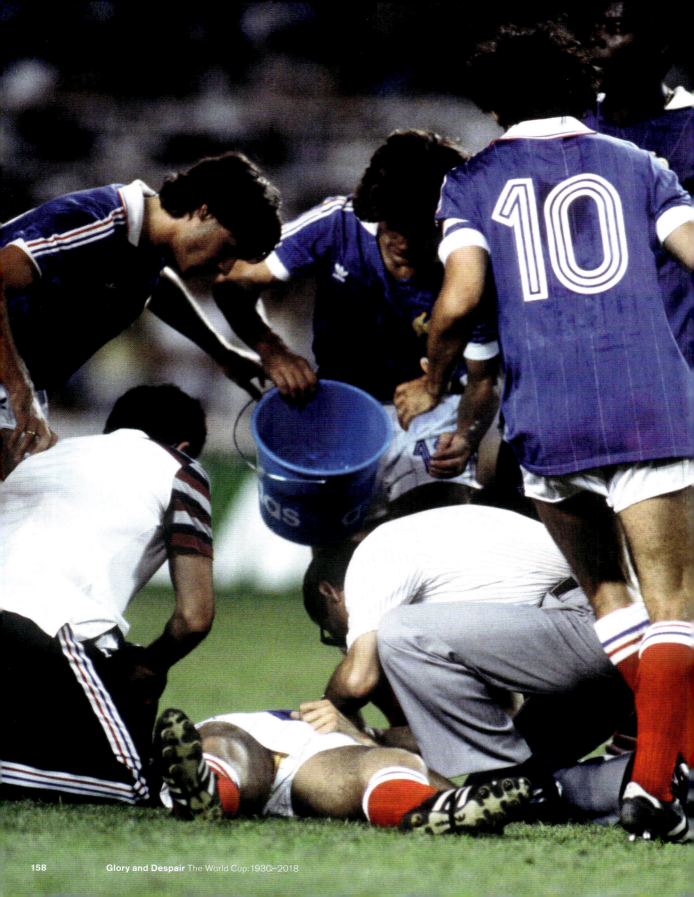

let them back on if the goal was disallowed, which it shamefully was. A cowardly decision from the referee, matched by FIFA's pathetic fine of £8,000 to the sheik.

England managed to get eliminated despite not losing a game. A lack of goals cost them in the second group phase as two 0-0 draws against Spain and West Germany wasn't enough for a semi-final berth. However, in England's first game they seemed to indicate that scoring was easy as they beat France 3-1, with Bryan Robson netting after just 27 seconds. It was seemingly a World Cup record and Robson was awarded a commemorative gold watch from FIFA. Unfortunately for Robson, several years later someone dug up old TV footage of a Václav Mašek goal for Czechoslovakia in the 1962 World Cup after just 16 seconds. On the bright side for Robson, he still kept the watch.

Second Round Group A

Poland	3	0	Belgium
Soviet Union	1	0	Belgium
Poland	0	0	Soviet Union

	P	W	D	L	GD	Pts
Poland	2	1	1	0	3	3
Soviet Union	2	1	1	0	1	3
Belgium	2	0	0	2	-4	0

Second Round Group B

West Germany	0	0	England
West Germany	2	1	Spain
Spain	0	0	England

	P	W	D	L	GD	Pts
West Germany	2	1	1	0	1	3
England	2	0	2	0	0	2
Spain	2	0	1	1	-1	1

Second Round Group C

Italy	2	1	Argentina
Brazil	3	1	Argentina
Italy	3	2	Brazil

	P	W	D	L	GD	Pts
Italy	2	2	0	0	2	4
Brazil	2	1	0	1	1	2
Argentina	2	0	0	2	-3	0

Second Round Group D

France	1	0	Austria
Austria	2	2	Northern Ireland
France	4	1	Northern Ireland

	P	W	D	L	GD	Pts
France	2	2	0	0	4	4
Austria	2	0	1	1	-1	1
Northern Ireland	2	0	1	1	-3	1

Semi-Final 1

Italy	2	0	Poland

Semi-Final 2

West Germany	3	3	France

West Germany win 5-4 on penalties

Final

Italy	3	1	West Germany

Third Place Play-Off

Poland	3	2	France

8 July 1982, Ramón Sánchez Pizjuán, Seville
One of the most shocking incidents in World Cup history. France's Patrick Battiston is motionless after being charged into by West German goalkeeper Harald Schumacher. His injuries included three cracked ribs, damaged vertebrae, and two missing teeth. No foul was given and Schumacher didn't even approach the felled player whilst he lay unconscious.

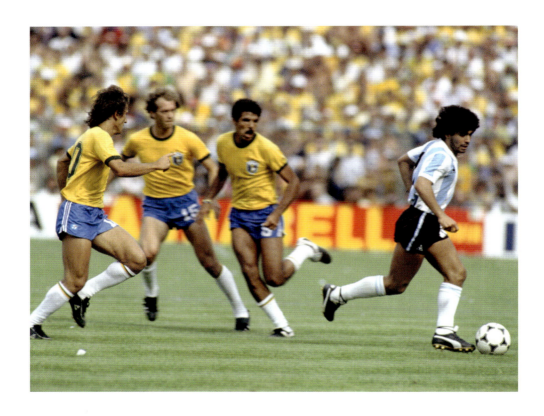

2 July 1982, Sarrià Stadium, Barcelona
Spain 1982 was a nightmare for the young Diego Maradona, and he was on the end of rough treatment from defenders throughout the tournament. In this game against Brazil, which Argentina lost 3-1, his temper got the better of him and he was sent off for a violent kick to the stomach in the 85th minute.

23 June 1982, Balaídos, Vigo
Italy's Fulvio Collovati tackles Cameroon's Roger Milla in a game that ended 1-1. In the group stage both teams drew all three games and were also equal on goal difference. Italy however had scored one goal more, and that was the margin that eliminated Cameroon whilst Italy progressed and would go on to win the tournament.

20 June 1982, Estadio Luis Casanova, Valencia
Fans of host nation Spain create a partisan atmosphere ahead of
their group game with Yugoslavia which they went on to win 2-1.

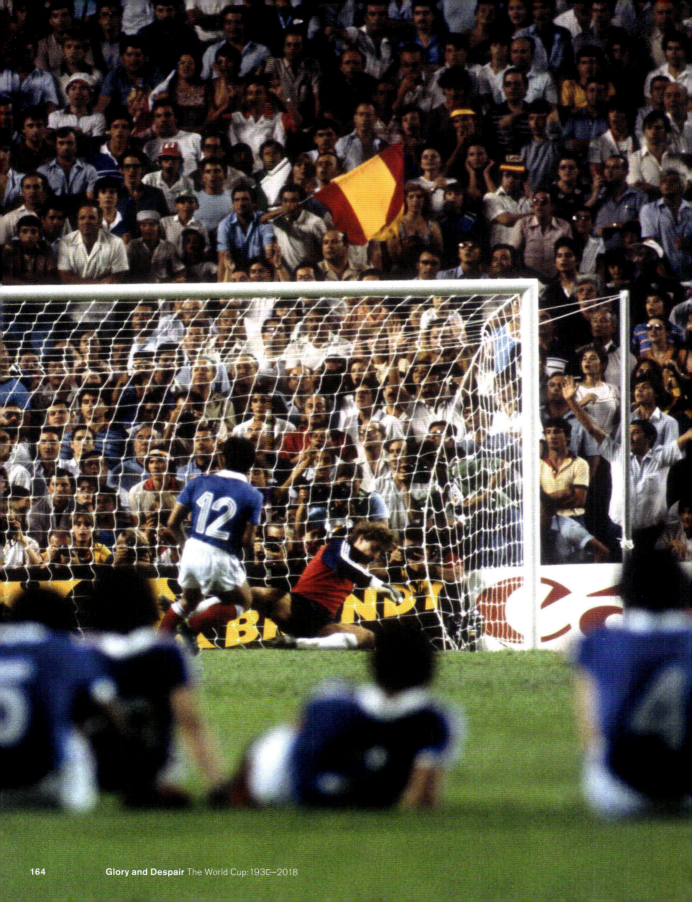

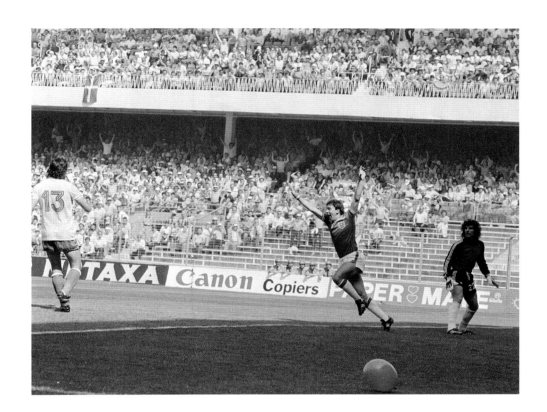

8 July 1982, Ramón Sánchez Pizjuán, Seville
The first ever World Cup penalty shoot-out.
France's Alain Giresse converts his penalty,
however West Germany would triumph 5-4 and go
through to meet Italy in the final.

16 June 1982, San Mamés Stadium, Bilbao
In England's opening group game, Bryan Robson scores against France after
just 27 seconds in Bilbao. It was seemingly a record, however in later years
someone timed Vaclav Masek's goal from the 1962 World Cup at just 16
seconds. Robson's goal at the time of writing is the third fastest on record.

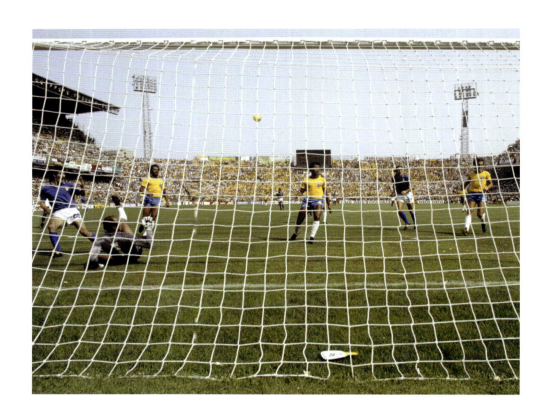

5 July 1982, Sarrià Stadium, Barcelona
Italy's Paolo Rossi scores a hat-trick as
favourites Brazil are knocked out in one of the
all-time classic encounters.

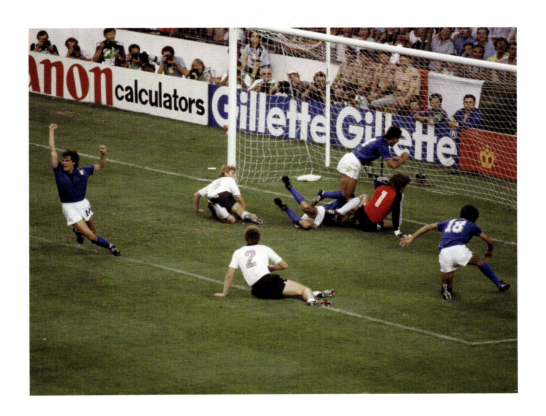

11 July 1982, Santiago Bernabéu, Madrid
Paolo Rossi heads the opening goal of the World Cup Final
past Harald Schumacher and Italy go on to triumph 3-1 to
equal Brazil's record of three overall World Cup victories.

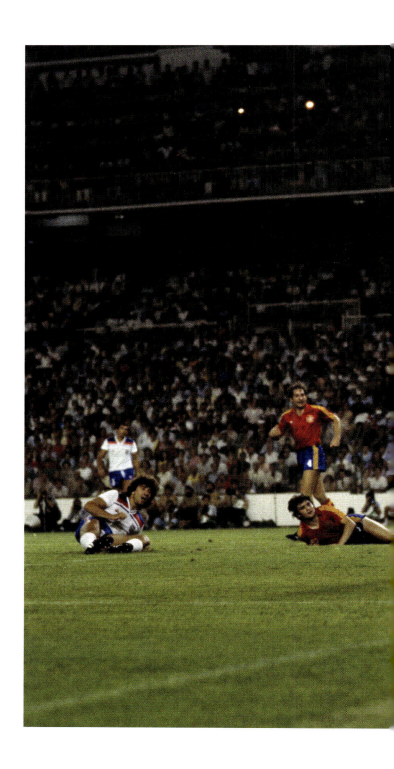

5 July 1982, Santiago Bernabéu, Madrid
Kevin Keegan sees his diving header narrowly
miss as England go out in the second group
phase after a 0-0 draw. England needed to win
2-0 or more to progress to the semi-final having
also drawn 0-0 with eventual group winners
West Germany. The hosts Spain had already
been eliminated after a 2-1 loss to the Germans
and were playing for pride.

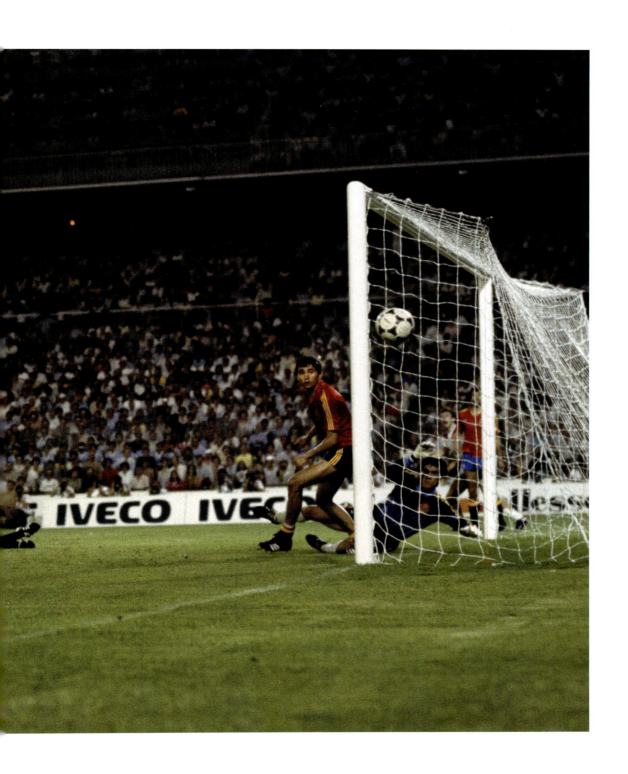

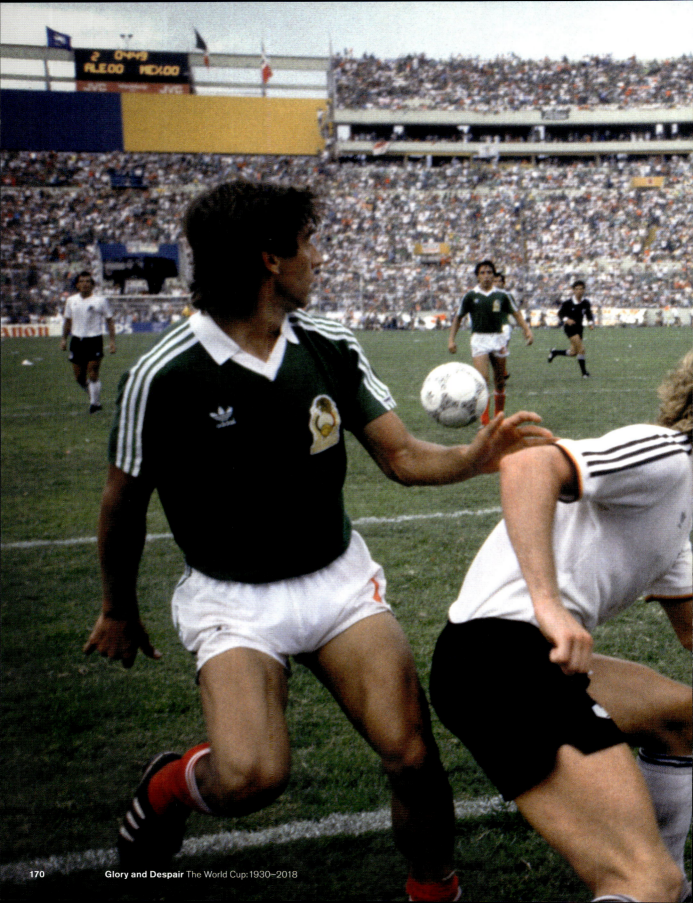

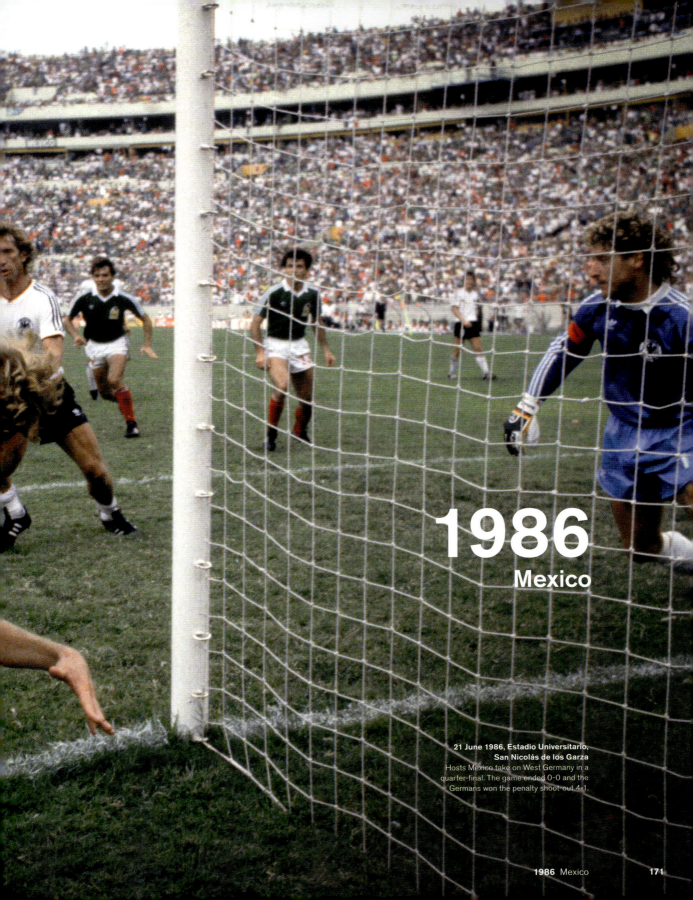

1986
Mexico

21 June 1986, Estadio Universitario, San Nicolás de los Garza
Hosts Mexico take on West Germany in a quarter-final. The game ended 0-0 and the Germans won the penalty shoot-out 4-1.

1986 Mexico

When Mexico co-hosts the 2026 World Cup, it will be the first nation to have hosted the tournament three times. When the 1986 World Cup was held in Mexico it was the first time a country had been awarded two tournaments, and Italy, France, Germany and Brazil would in later years also claim that honour.

14 Argentina were the tournament's top scoring team

It was not meant to be that way, as initially Colombia was awarded the 1986 finals. However, the number of teams had risen from 16 to 24 since it was named as hosts, meaning that a higher cost on infrastructure would be needed, and so Colombia pulled out unable to meet the bill; it was back to the Azteca Stadium which was so synonymous with 1970 and Pelé.

A year before the 1986 World Cup there was doubt cast as to whether Mexico could host it as Mexico City had been devastated by one of the worst earthquakes in the country's history. In an appalling tragedy, tens of thousands of people died. Mexico had eight months to recover, and did so in time for the opening game – Bulgaria versus defending champions Italy, which ended 1-1. Seeding was directly linked to how teams had performed in the previous World Cup, so Poland being semi-finalists in 1982 meant that they were seeded higher than stronger teams such as Spain, England, Belgium, Denmark and the eventual winners Argentina.

The structure introduced in 1986 is the one that has been used in all World Cups since: teams playing three group games each, followed by four rounds of straight knockout competition. As in 1970, a notable element of this World Cup was no floodlit night matches. The games were scheduled in the daytime to accommodate time zones east of the Atlantic, which meant matches being played in scorching heat. Argentina's Jorge Valdano complained, 'TV companies made teams play in Mexico City at midday and with an altitude of 2,500 metres and high levels of smog and humidity. It was inhuman. They sold a bad football product to the world. You have to care for the game and protect it from the outside aggression of commercialisation.'

Despite Valdano's justifiable anger with the scheduling, there were still some classic games. Perhaps the match of the tournament was in the second round when Belgium beat a strong Soviet Union side 4-3 after extra time. The big shock also came in the second round when Spain beat Denmark 5-1. The Spanish were considered one of the stronger teams, but Denmark in 1986 were fancied by some to win the World Cup, and the one-sided nature of Spain's win was surprising.

No World Cup is as synonymous with one player as 1986 is with Diego Maradona. Many will say that he won the World Cup single-handedly; Argentina were a good team, but certainly not worthy of winning outright had it not been for the presence of Maradona. In contrast, many will say that as great as Pelé was

6 Gary Lineker of England was top scorer

in 1970, Brazil were still good enough to have won the World Cup without him. In the 1986 quarter-final against England Maradona produced the most controversial moment – as well as the greatest in the space of just four minutes. His 'Hand of God' goal was followed by what some people describe as the best goal in the history of the World Cup. When Maradona punched the ball into the net his offence was so blatant that Ray Charles would have disallowed it, yet the goal stood. Moments before Maradona got the ball for his second, Glenn Hoddle had been hacked down, and if the foul had been given then the world would never have seen the greatest goal ever scored. Not content with dribbling past the England midfield and defence, Diego also rounded Peter Shilton as legendary English commentator Peter Jones admitted, 'And that is why Maradona is the greatest player in the world.'

The 1986 FIFA World Cup's official film was called *Hero*, and is perhaps the most iconic and brilliant of all the productions, which dated back to 1966. Narrated by Michael Caine, it was heavily focused on Maradona to the point where it felt like a documentary about him with everyone else in supporting roles.

World Cup debutants: Canada, Denmark, Iraq

First Round Group A

Bulgaria	1	1	Italy
Argentina	3	1	South Korea
Italy	1	1	Argentina
South Korea	1	1	Bulgaria
Italy	3	2	South Korea
Argentina	2	0	Bulgaria

	P	W	D	L	GD	Pts
Argentina	3	2	1	0	4	5
Italy	3	1	2	0	1	4
Bulgaria	3	0	2	1	-2	2
South Korea	3	0	1	2	-3	1

First Round Group B

Mexico	2	1	Belgium
Paraguay	1	0	Iraq
Paraguay	1	1	Mexico
Belgium	2	1	Iraq
Belgium	2	2	Paraguay
Mexico	1	0	Iraq

	P	W	D	L	GD	Pts
Mexico	3	2	1	0	2	5
Paraguay	3	1	2	0	1	4
Belgium	3	1	1	1	0	3
Iraq	3	0	0	3	-3	0

First Round Group C

France	1	0	Canada
Soviet Union	6	0	Hungary
France	1	1	Soviet Union
Hungary	2	0	Canada
France	3	0	Hungary
Soviet Union	2	0	Canada

	P	W	D	L	GD	Pts
Soviet Union	3	2	1	0	8	5
France	3	2	1	0	4	5
Hungary	3	1	0	2	-7	2
Canada	3	0	0	3	-5	0

First Round Group D

Brazil	1	0	Spain
Algeria	1	1	Northern Ireland
Brazil	1	0	Algeria
Spain	2	1	Northern Ireland
Brazil	3	0	Northern Ireland
Spain	3	0	Algeria

	P	W	D	L	GD	Pts
Brazil	3	3	0	0	5	6
Spain	3	2	0	1	3	4
Northern Ireland	3	0	1	2	-4	1
Algeria	3	0	1	2	-4	1

First Round Group E

Uruguay	1	1	West Germany
Denmark	1	0	Scotland
West Germany	2	1	Scotland
Denmark	6	1	Uruguay
Denmark	2	0	West Germany
Scotland	0	0	Uruguay

	P	W	D	L	GD	Pts
Denmark	3	3	0	0	8	6
West Germany	3	1	1	1	-1	3
Uruguay	3	0	2	1	-5	2
Scotland	3	0	1	2	-2	1

First Round Group F

Morocco	0	0	Poland
Portugal	1	0	England
England	0	0	Morocco
Poland	1	0	Portugal
England	3	0	Poland
Morocco	3	1	Portugal

	P	W	D	L	GD	Pts
Morocco	3	1	2	0	2	4
England	3	1	1	1	2	3
Poland	3	1	1	1	-2	3
Portugal	3	1	0	2	-2	2

Despite 1986 being so heavily associated with one player, the tournament was certainly not lacking in footballing legends; they just all got overshadowed. Real Madrid and Mexico's Hugo Sánchez was the epitome of a footballing superstar and worshipped by the host nation. Michel Platini of France, Karl-Heinz Rummenigge of West Germany, plus Brazilian duo Zico and Sócrates were in the twilights of their great careers and playing in their last World Cups. Younger stars included Michael Laudrup (Denmark), Lothar Matthäus (West Germany), Careca (Brazil), Enzo Scifo (Belgium), Enzo Francescoli (Uruguay), Emilio Butragueño (Spain) and Gary Lineker, who became the first Englishman to win the Golden Boot.

The final itself was a memorable one, and arguably the last to go down as a classic. Argentina were 2-0 up with just 16 minutes to go when West Germany scored two goals in the space of six minutes. Although Maradona did not score in the final, his contribution was significant. With just a few minutes remaining he played a perfect though ball to Burruchaga to score the winning goal. Maradona had emulated Pelé from the 1970 World Cup and in the same venue, the Azteca Stadium.

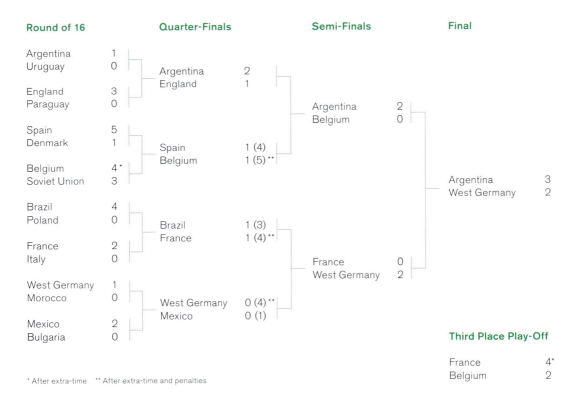

Round of 16		Quarter-Finals		Semi-Finals		Final	
Argentina	1						
Uruguay	0	Argentina	2				
England	3	England	1				
Paraguay	0			Argentina	2		
				Belgium	0		
Spain	5						
Denmark	1	Spain	1 (4)			Argentina	3
Belgium	4*	Belgium	1 (5)**			West Germany	2
Soviet Union	3						
Brazil	4						
Poland	0	Brazil	1 (3)				
France	2	France	1 (4)**				
Italy	0			France	0		
				West Germany	2		
West Germany	1						
Morocco	0	West Germany	0 (4)**				
Mexico	2	Mexico	0 (1)				
Bulgaria	0						

* After extra-time ** After extra-time and penalties

Third Place Play-Off

France	4*
Belgium	2

29 June 1986, Azteca Stadium, Mexico City
Scenes of pandemonium as Argentina have just
beaten West Germany 3-2 in a classic final encounter.

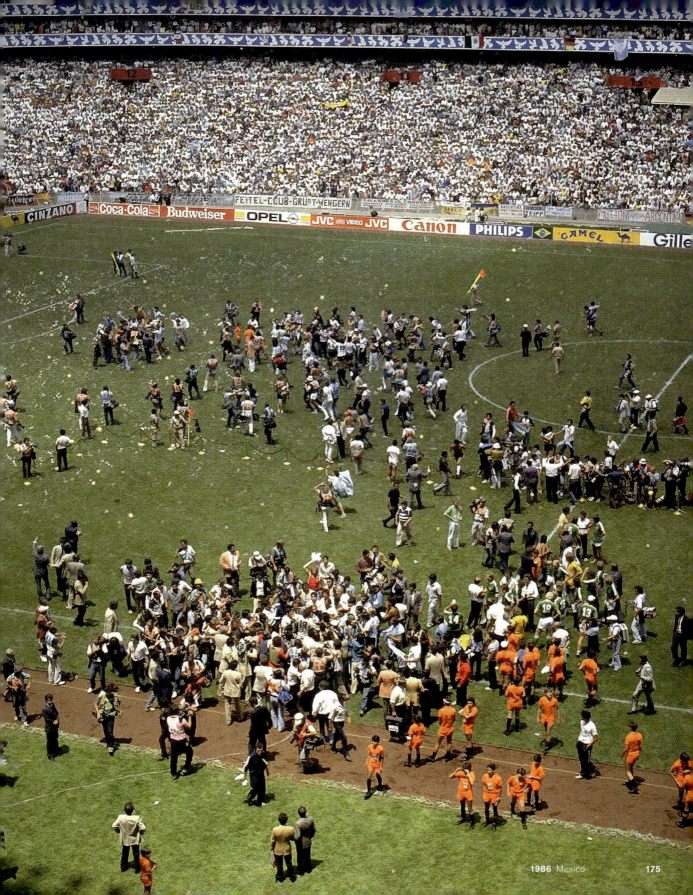

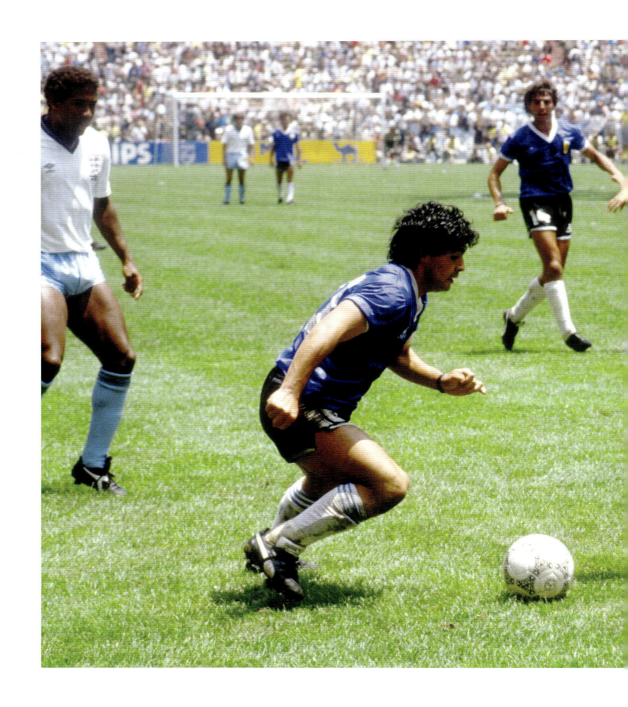

22 June 1986, Azteca Stadium, Mexico City
Maradona takes on England's Terry Butcher and Kenny Sansom in the quarter-final.

Glory and Despair The World Cup: 1930–2018

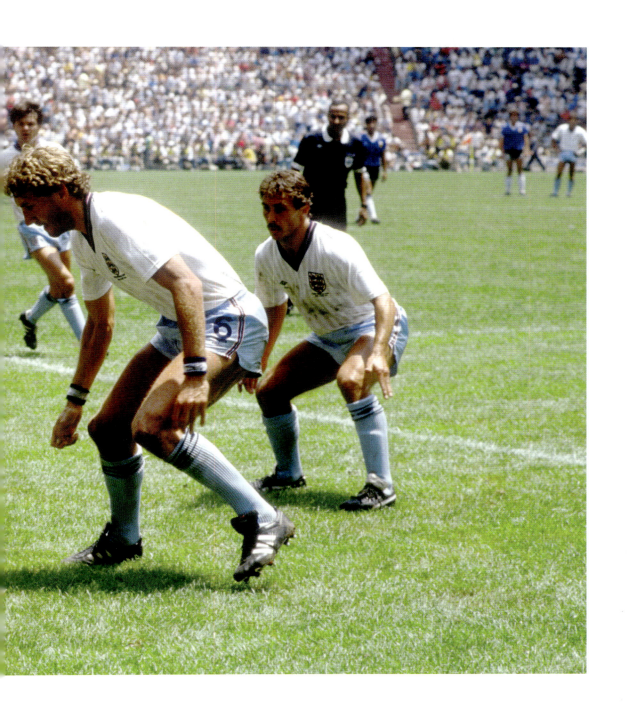

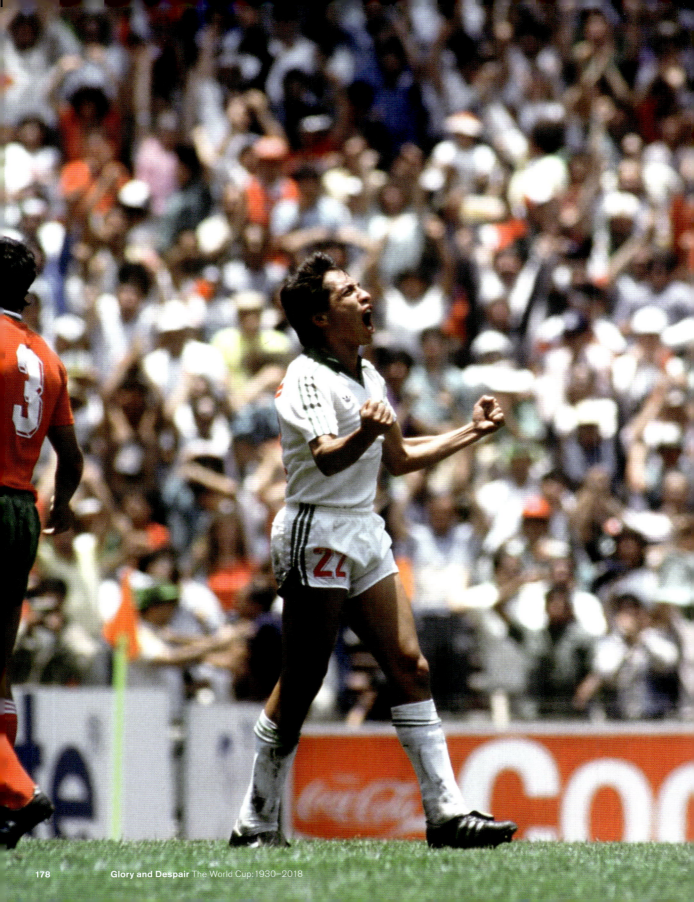

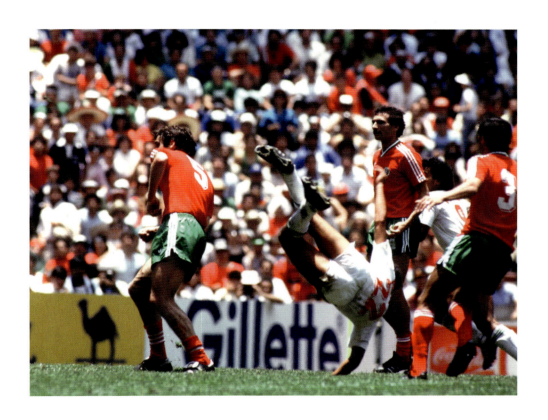

15 June 1986, Azteca Stadium, Mexico City
Mexico's Manuel Negrete scores one of the greatest
goals in the history of the competition as the hosts
beat Bulgaria 2-0 in the round of 16.

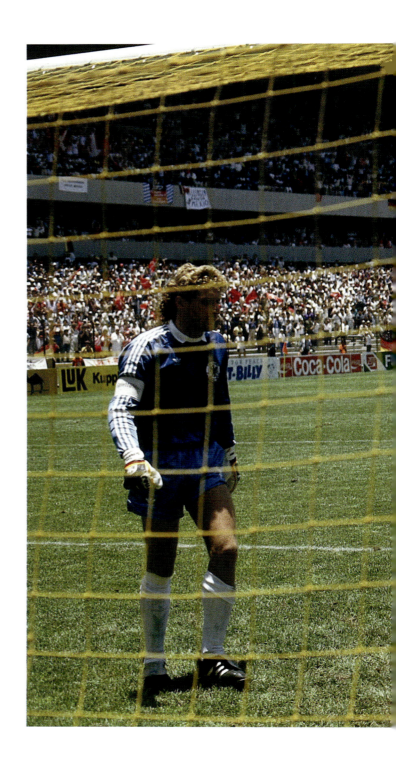

13 June 1986, Estadio La Corregidora, Querétaro
Denmark record a 2–0 win against West Germany
as Michael Laudrup celebrates in front of Harald
Schumacher. Denmark at this point were uttered
among the favourites to win the tournament.

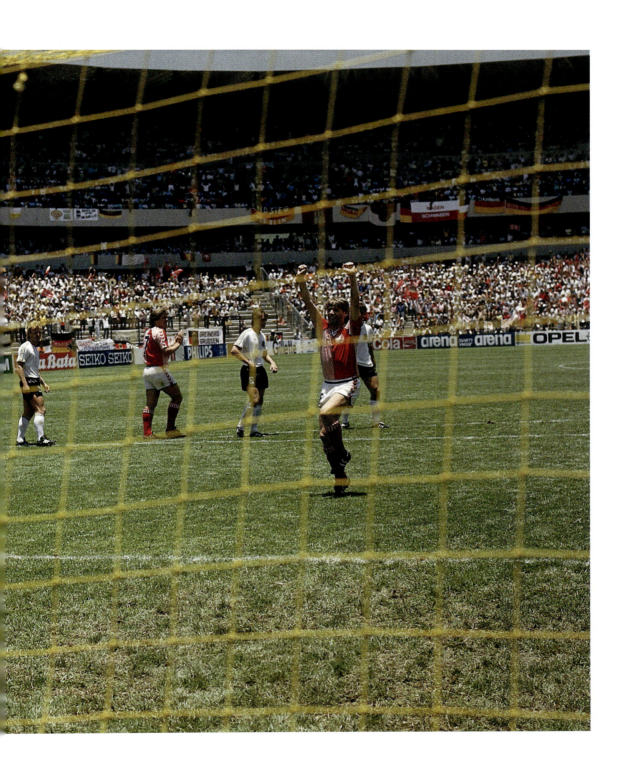

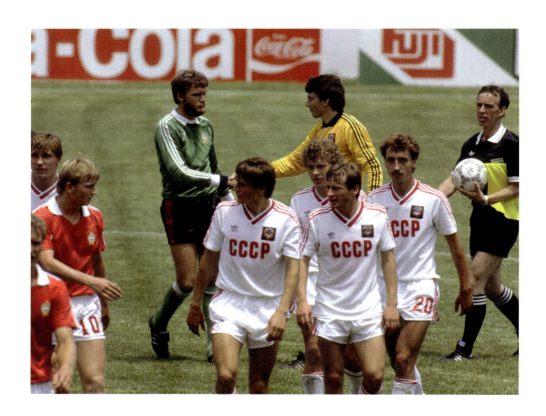

2 June 1986, Estadio Sergio León Chavez, Irapuato
A strong Soviet Union team have just destroyed Hungary
6-0 in the group stages. The Soviets had a strong
Ukrainian presence with 9 of the 13 players used in this
game coming from the Ukraine.

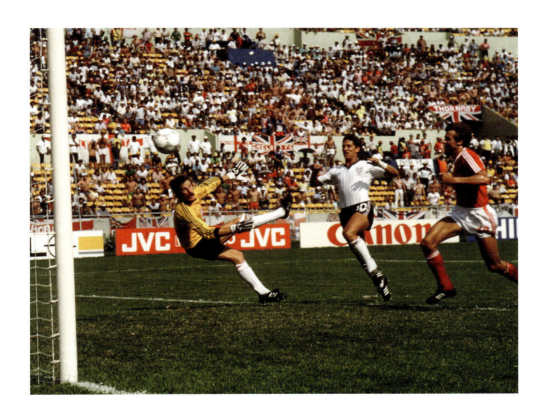

11 June 1986, Estadio Universitario, San Nicolás de los Garza
England had a terrible start to Mexico 1986 and needed a win
against Poland to progress to the round of 16. Gary Lineker here
scores the second of his three goals in a 3-0 win as England finally
find their form.

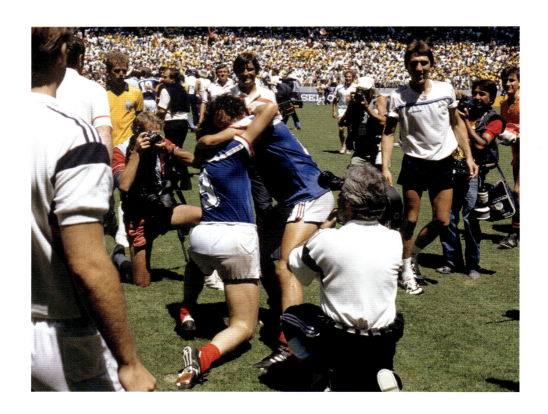

21 June 1986, Estadio Jalisco, Guadalajara
France's Michel Platini (right) and Luis Fernandez (left) celebrate beating Brazil on penalties in a thrilling and gruelling encounter.

A pivotal moment as Julio Cesar fires a penalty against the post in the shoot-out. Luis Fernandez scored the next penalty for France to win the shoot-out 4-3.

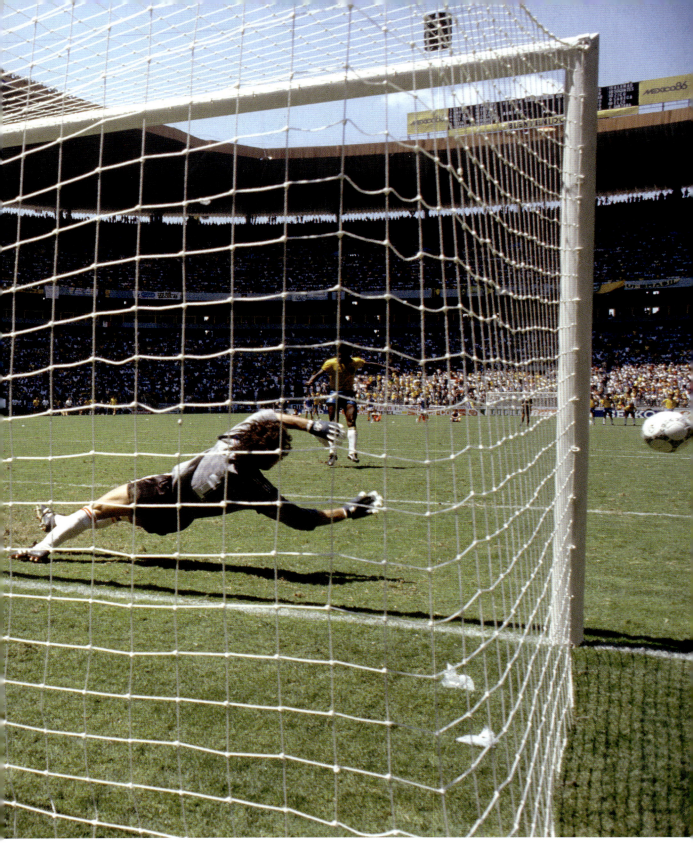

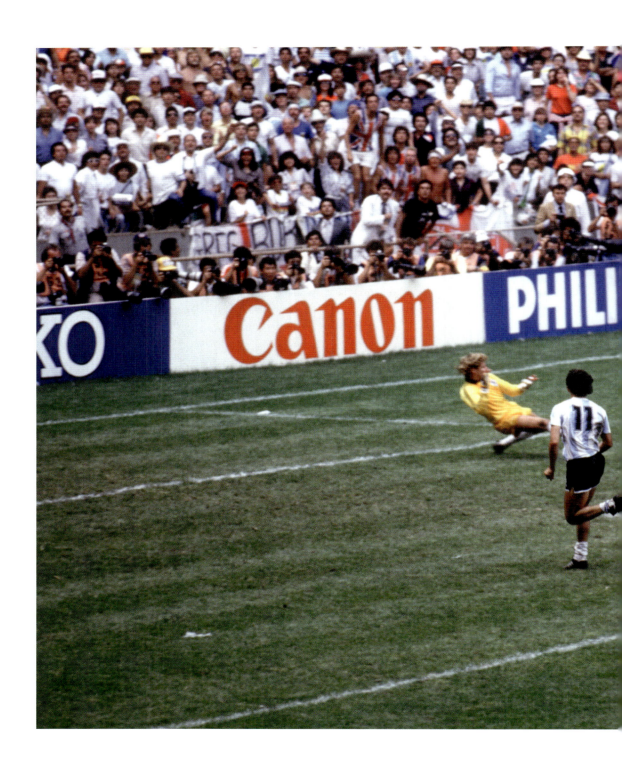

Glory and Despair The World Cup: 1930–2018

29 June 1986, Azteca Stadium, Mexico City
With 83 minutes on the clock, Maradona plays through Jorge Burruchaga who slides the ball past Schumacher to win the final 3-2. In a classic encounter the Germans had been 2-0 down with just 16 minutes to go, and had levelled the score by the 80th minute.

1990

Italy

4 July 1990, Stadio delle Alpi, Turin
An epic semi-final between England and West Germany.
Andreas Brehme fires in a free kick that deflects off Paul Parker
(12), and over goalkeeper Peter Shilton to make it 1-0.

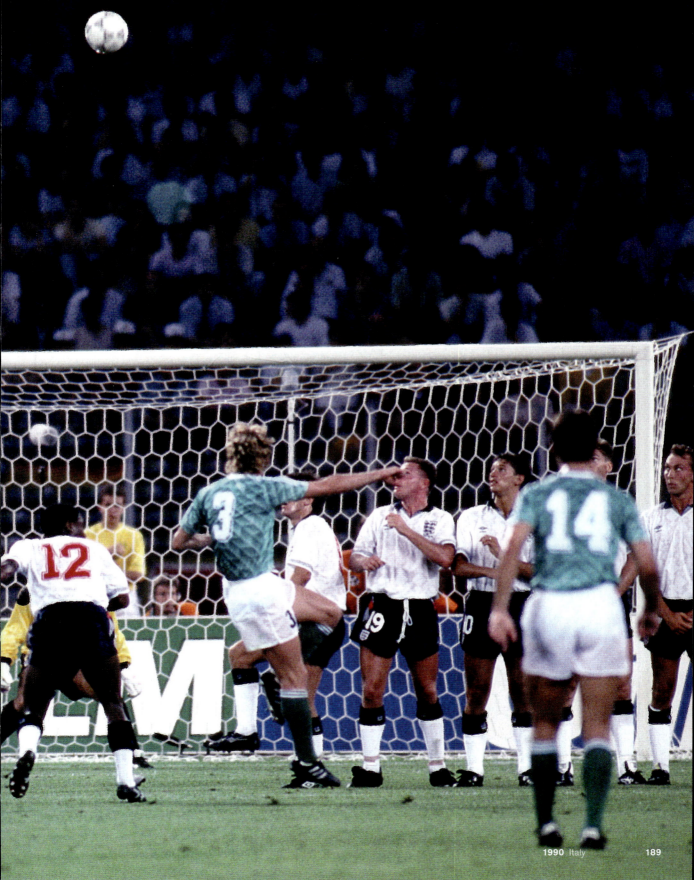

1990 Italy

Noticeable absentees from 1990 were Mexico, the hosts of the previous World Cup, as they had been suspended for using overage players in an under-20s tournament. France, who were so strong in 1982 and '86, would also miss out for the first time since 1974. The borders of the world were changing and Yugoslavia, Czechoslovakia and the Soviet Union would be competing in their last World Cups before the break-up of their countries, as multiple independent states would soon emerge. A year earlier, the Berlin Wall came down, Germany would be unified, and 1990 was the last time in which they would compete as West Germany. Some old friends returned: the USA were back for the first time since 1950 and Colombia since 1962. The Netherlands also returned after missing out in 1982 and '86. The stage was set for the perfect World Cup location; in contrast to the 2022 tournament being handed to Qatar, Italy was a football-obsessed nation with a strong team, and Serie A in 1990 was far in a way the greatest league in the world.

15 West Germany were the tournament's top scoring team

Third seeds Brazil were a huge disappointment and went out in the last 16 courtesy of Argentina. In the 81st minute Maradona produced the one moment in the tournament where he lived up to his reputation as the best player in the world, as he set up Claudio Caniggia to score the winner. Two penalty shoot-outs later and Argentina were in the final yet again, although many would say that they were the luckiest team to ever do so. With Maradona out of form, and the team lacking flair and goals, nobody would have predicted another final, especially after they lost the opening game of the tournament to Cameroon in one of the great World Cup upsets. In the four knockout matches they only scored two goals; however, they had a penalty-saving master in goalkeeper Sergio Goycochea.

Teams without luck were the losing semi-finalists England and Italy. The backstory to Argentina v Italy was that Maradona helped defeat the host nation in Naples, in the very same stadium where he played his club football. To fuel the fire before the game, Maradona had suggested that the people of Naples were

6 Salvatore Schillaci of Italy was top scorer

disrespected by the rest of Italy and that they should support Argentina. England and West Germany played out a thrilling semi-final which became famous for Gazza's tears. England would dwell on the disappointment of that result for years; it was their best chance to win a second World Cup. They had matched the Germans throughout the 120 minutes and knew that they would have stood a great chance against Argentina in the final had the shoot-out gone in their favour. It was England's first penalty decider and it was the beginning of a losing trend that would continue for years to come. In contrast, the Germans were masters from the spot. After 1990 their record stood at three wins in three, and to this day they have never lost on penalties in a major tournament.

Germany were worthy winners of the tournament but the final was terrible, and up to that point perhaps the worst one yet. With just five minutes to go Rudi Völler was fouled in the box, and Andreas Brehme converted the penalty. Goycochea was great at saving penalties, but not against Germans. West Germany had equalled the three World Cup successes of Brazil and Italy, with the extra panache of having won the new version of the trophy twice.

Some people proclaimed Paul Gascoigne as the standout player of Italia '90, despite him not making it on to the scoresheet. One player who did manage to score was Italy's Salvatore 'Toto' Schillaci. Before the tournament he was unknown outside of Italy, unlike superstar Gianluca Vialli, who was the face of the host nation. Vialli had a nightmare few weeks and didn't score, but Toto netted six times to win the Golden Boot, as well as receiving the Golden Ball as the overall best player.

World Cup debutants: Republic of Ireland, Costa Rica, United Arab Emirates

First Round Group A

Italy	1	0	Austria
Czechoslovakia	5	1	USA
Italy	1	0	USA
Czechoslovakia	1	0	Austria
Italy	2	0	Czechoslovakia
Austria	2	1	USA

	P	W	D	L	GD	Pts
Italy	3	3	0	0	4	6
Czechoslovakia	3	2	0	1	3	4
Austria	3	1	0	2	-1	2
USA	3	0	0	3	-6	0

First Round Group B

Cameroon	1	0	Argentina
Romania	2	0	Soviet Union
Argentina	2	0	Soviet Union
Cameroon	2	1	Romania
Argentina	1	1	Romania
Soviet Union	4	0	Cameroon

	P	W	D	L	GD	Pts
Cameroon	3	2	0	1	-2	4
Romania	3	1	1	1	1	3
Argentina	3	1	1	1	1	3
Soviet Union	3	1	0	2	0	2

First Round Group C

Brazil	2	1	Sweden
Costa Rica	1	0	Scotland
Brazil	1	0	Costa Rica
Scotland	2	1	Sweden
Brazil	1	0	Scotland
Costa Rica	2	1	Sweden

	P	W	D	L	GD	Pts
Brazil	3	3	0	0	3	6
Costa Rica	3	2	0	1	1	4
Scotland	3	1	0	2	-1	2
Sweden	3	0	0	3	-3	0

First Round Group D

Colombia	2	0	United Arab Emirates
West Germany	4	1	Yugoslavia
Yugoslavia	1	0	Colombia
West Germany	5	1	United Arab Emirates
West Germany	1	1	Colombia
Yugoslavia	4	1	United Arab Emirates

	P	W	D	L	GD	Pts
West Germany	3	2	1	0	7	5
Yugoslavia	3	2	0	1	1	4
Colombia	3	1	1	1	1	3
UAE	3	0	0	3	-9	0

First Round Group E

Belgium	2	0	South Korea
Uruguay	0	0	Spain
Belgium	3	1	Uruguay
Spain	3	1	South Korea
Spain	2	1	Belgium
Uruguay	1	0	South Korea

	P	W	D	L	GD	Pts
Spain	3	2	1	0	3	5
Belgium	3	2	0	1	3	4
Uruguay	3	1	1	1	-1	3
South Korea	3	0	0	3	-5	0

First Round Group F

England	1	1	Ireland
Netherlands	1	1	Egypt
England	0	0	Netherlands
Ireland	0	0	Egypt
England	1	0	Egypt
Netherlands	1	1	Ireland

	P	W	D	L	GD	Pts
England	3	1	2	0	1	4
Ireland	3	0	3	0	0	3
Netherlands	3	0	3	0	0	3
Egypt	3	0	2	1	-1	2

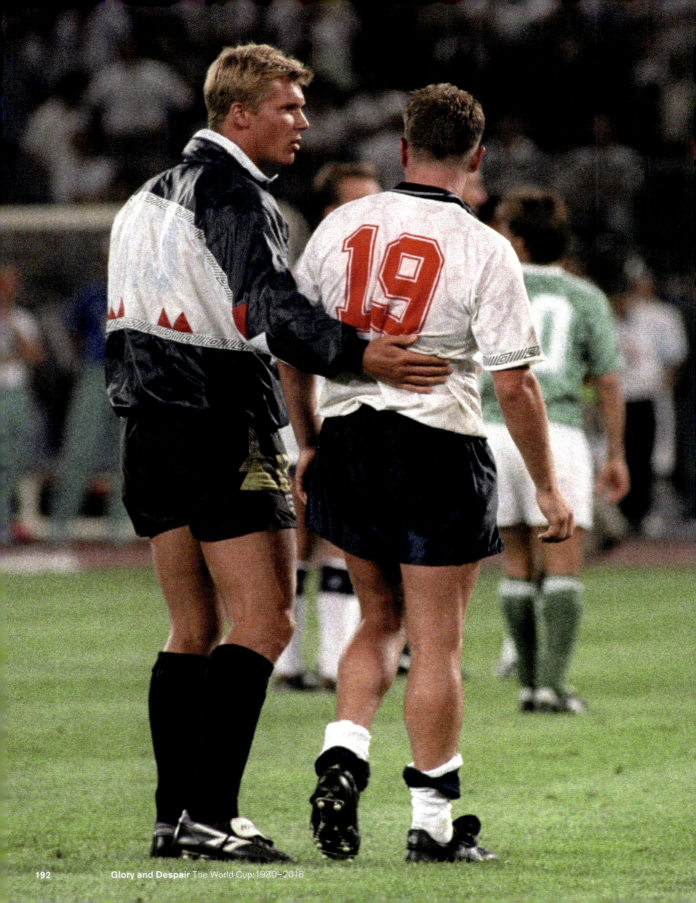

Like the World Cups that preceded it, Italia '90 had its own unique look and identity. It had always been this way; for example, the goal shapes in Argentina in 1978 were designed differently to the goals in West Germany four years previously. Mexico '86 looked totally different to Spain '82, and each tournament had its own personality. The stadiums in Italia '90 were very distinct in this respect and in many ways, it was the last World Cup to carry that individuality. Football in the future would be a lot more assimilated in appearance, mainly through the introduction of corporate culture and globalisation. Design plans for stadiums get passed around from country to country. The nets are all the same depth, the posts a certain number of metres away from the first row. Fewer partisan fans, more VIPs. Germany 2006 looked fairly identical to Russia 2018.

Italia '90 had a romance to it, which was summed up perfectly by Pavarotti's 'Nessun Dorma'. Despite being a low-scoring tournament, it remains iconic and loved, with perhaps one of the reasons being that it was the last World Cup to happen while football still had a credible claim as the 'people's game'.

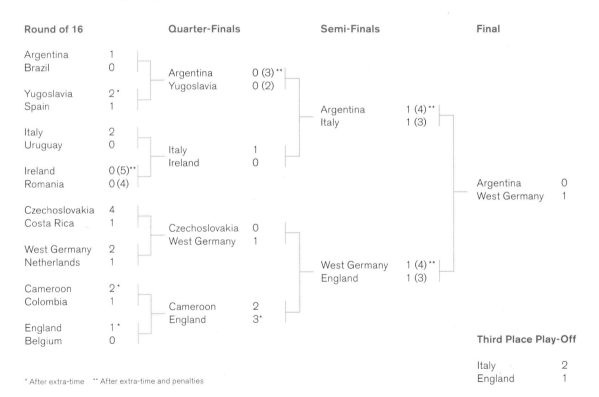

Round of 16		Quarter-Finals		Semi-Finals		Final	
Argentina	1						
Brazil	0	Argentina	0 (3)**				
		Yugoslavia	0 (2)				
Yugoslavia	2*			Argentina	1 (4)**		
Spain	1			Italy	1 (3)		
Italy	2						
Uruguay	0	Italy	1				
		Ireland	0				
Ireland	0 (5)**					Argentina	0
Romania	0 (4)					West Germany	1
Czechoslovakia	4						
Costa Rica	1	Czechoslovakia	0				
		West Germany	1				
West Germany	2			West Germany	1 (4)**		
Netherlands	1			England	1 (3)		
Cameroon	2*						
Colombia	1	Cameroon	2				
		England	3*				
England	1*						
Belgium	0						

Third Place Play-Off

Italy	2
England	1

* After extra-time ** After extra-time and penalties

4 July 1990, Stadio delle Alpi, Turin
A tearful Paul Gascoigne is consoled by reserve goalkeeper Chris Woods, as England are eliminated by West Germany in the semi-final after a penalty shoot-out. Famously, Gazza's tears had started whilst the game was still on after he was booked for a late tackle. This meant that he would have been suspended for the final had England got through.

16 June 1990, Stadio Sant'Elia, Cagliari
Italian police look to be on high alert during the group game between
England and Netherlands on the island of Cagliari. England had
dominated, but missed a number of clear-cut chances and the game
ended 0-0.

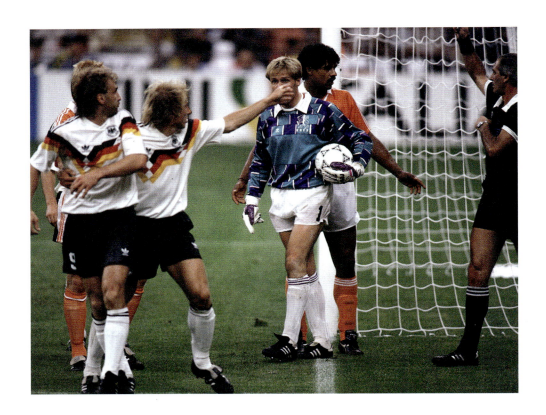

24 June 1990, San Siro, Milan
A controversial incident during a round of 16 clash between West Germany and the Netherlands at the San Siro in Milan. Dutch goalkeeper Hans Van Breukelen's massive overreaction to a Rudi Voeller challenge results in some pushing and shoving in which both Voeller and Frank Rijkaard received red cards.

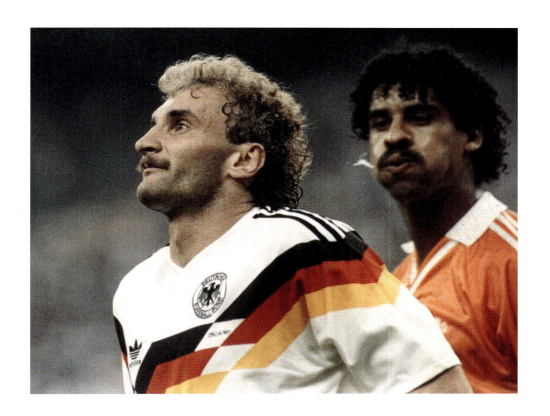

24 June 1990, San Siro, Milan
As both men walk off the pitch after being sent off,
Rijkaard spits into the mullet of Voeller. In the ITV
studio, Jack Charlton commented "If he'd have done
that to me I'd have chinned him!"

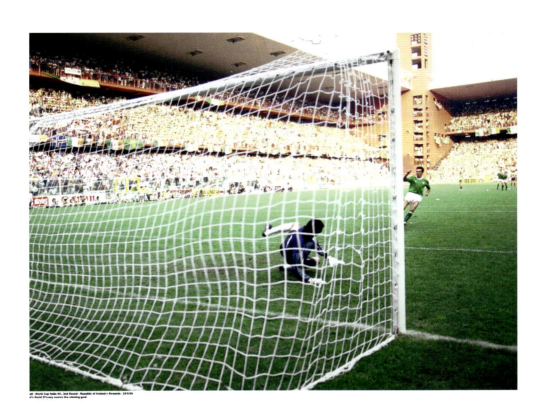

24 June 1990, Stadio delle Alpi, Turin
Maradona looks his old self, as he dribbles past the Brazilian defence, before playing a ball to Claudio Caniggia to open the scoring with just nine minutes remaining. Brazil had looked the better side, but Argentina would progress to the quarter-finals.

25 June 1990, Stadio Luigi Ferraris, Genoa
A memorable moment for the Republic of Ireland in their first ever World Cup. In a penalty shoot-out against Romania David O'Leary sends the Irish through to the quarter-final where they would face the hosts Italy in Rome.

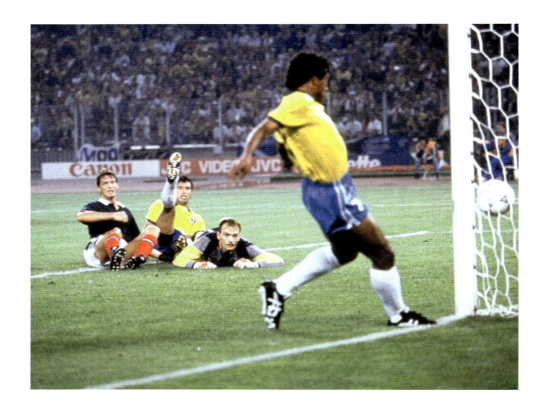

20 June 1990, Stadio delle Alpi, Turin
Agony for Scotland as Muller makes it 1-0 to
Brazil with just nine minutes left on the clock.
A 0-0 outcome would have seen Scotland
qualify for the round of 16.

23 June 1990, Stadio San Paolo, Naples
Colombia's Andres Escobar (2) collides with his own goalkeeper Rene
Higuita in a last 16 clash against Cameroon, as the Africans win 2-1. For
Cameroon's second goal Milla had intercepted Higuita who had tried to
dribble past him from 40 yards out. Milla was left with an open goal as
Cameroon progressed to face England in the quarter-final.

3 July 1990, Stadio San Paolo, Naples
In Naples, 'Toto' Schillaci is about to successfully convert his penalty in the shoot-out with Argentina. However, the Italians would miss two penalties and Maradona would be triumphant in the very same place where he played his club football for Napoli.

1 July 1990, Stadio San Paolo, Naples
Roger Milla was 38 years of age when he scored four goals at Italia 90 and shot to football superstardom. In this game against England, however, Cameroon would narrowly lose 3-2, courtesy of two Gary Lineker penalties.

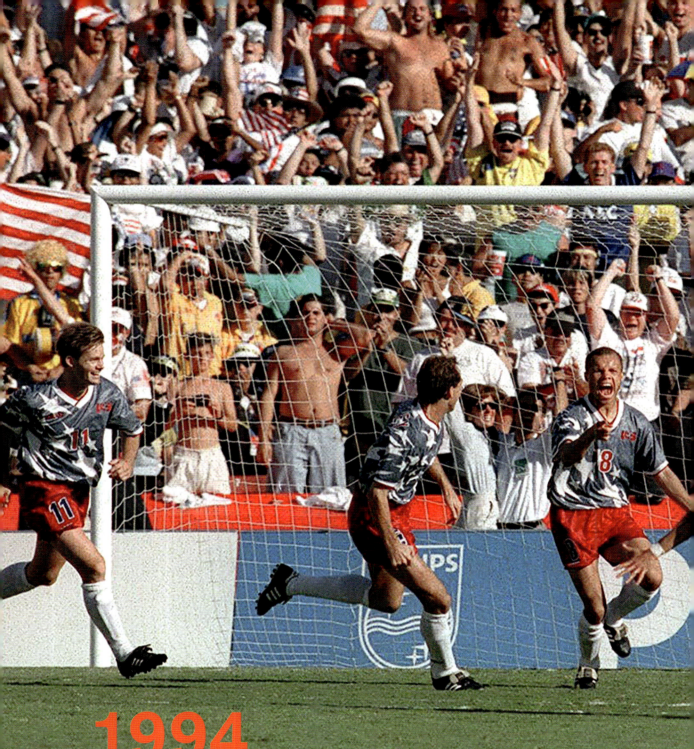

1994

United States of America

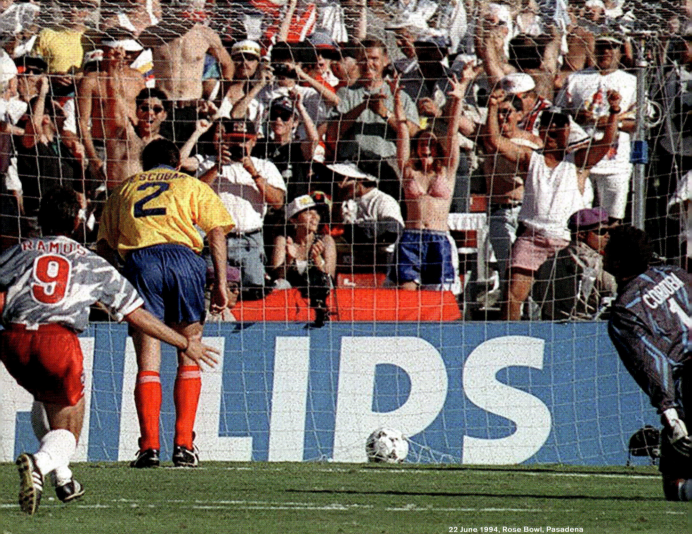

22 June 1994, Rose Bowl, Pasadena
The United States celebrate going 1-0 ahead against Colombia, due to an own goal from Andres Escobar. The 2-1 win for the hosts eliminated the South Americans and USA would progress to the knockout rounds for the first time since 1930.

1994 United States of America

Up to this point, all previous World Cups had been awarded to a host nation in which football was on a par with religion. For better or worse, 1994 broke that mould; football had a big following in the USA, but for the vast majority of the country the game wasn't remotely on their radar. It was a wholesale change to the idea that

15 Sweden were the tournament's top scoring team

you should give a World Cup to the people who love it the most. When the US was awarded the tournament in 1988 one of the conditions was that it had to have a national league for the sport. Major League Soccer – MLS – was formed in 1993 and owes its very existence to the World Cup.

One thing that the Americans certainly were masters at was stadiums worthy of a tournament. All over the country were high-capacity NFL grounds and attendance records would be set in 1994. On the whole, it was an entertaining tournament but FIFA would have been disappointed that the two most prestigious games were dull and uneventful, which wasn't a great advert for selling the sport to a sceptical American public. The opener between Germany and Bolivia and the final between Brazil and Italy produced just the one goal and very little in the way of compelling action. It all began and ended with a missed penalty kick. Firstly, in the opening ceremony Diana Ross put the ball wide of the post, then four weeks later Roberto Baggio skied the ball over the crossbar and finally Brazil got their hands on a fourth World Cup, which was the first time they won the current version of the trophy. Although Baggio would be stigmatised, Italy had already missed two penalties, and even if he had have scored Brazil would still have won if they had converted their final kick.

Winning a record fourth World Cup was a Brazilian obsession. They had won three out of four between 1958 and 1970, which put them in a frame of mind that they should win it every time; a mentality they still carry today. In 1990 they produced one of their most average sides but this time they had Romário, arguably the best player of the day. The man who used to carry that undisputed title was back in town: Diego Maradona was looking fit and ready to take on the world. Things began more than well as Argentina beat new boys Greece 4-0 and Maradona smashed a goal into the top corner from outside the box. As he ran towards the camera, eyes wide open, and roaring, it looked as if the old Maradona was back and more psyched up than before. One problem – performance-enhancing drugs were found in his system in a test after the next game against Nigeria, and Maradona was thrown out of the tournament and banned from football.

Noticeable absentees who failed to qualify were France, Uruguay, Portugal, Denmark, England and also Scotland, who unlike the others had qualified for the previous five World Cups, making this the first finals since 1938 that didn't include one British home nation. With the amount of Irish DNA in the UK

6 Oleg Salenko of Russia and Hristo Stoichkov of Bulgaria were joint top scorers

many would turn their support to the Republic of Ireland, who celebrated the standout moment in their footballing history by beating Italy 1-0 in New Jersey, home to so many Americans with Irish and Italian descent. The Irish team over the years had included many UK-born players and the scorer of the only goal in the match was Ray Houghton – who was originally from Glasgow.

Bulgaria beat Germany and were the surprise team of the tournament. They reached the semi-final, as did Sweden, who in contrast to their usual conservative and defensive image were the flair team of the tournament and top scorers.

The USA did well and qualified from the group stage for the first time since 1930, with their golden moment being a 2-1 win over Colombia, which unexpectedly eliminated the South Americans, who many had tipped to be contenders to win the tournament. What followed shocked football to the core. After the Colombian players returned home, their defender Andrés Escobar was verbally abused in a nightclub by figures from the underworld because he had scored an own goal in the loss to the USA. Escobar defended

World Cup debutants: Greece, Nigeria, Saudi Arabia, Russia

First Round Group A

USA	1	1	Switzerland
Romania	3	1	Colombia
Switzerland	4	1	Romania
USA	2	1	Colombia
Colombia	2	0	Switzerland
Romania	1	0	USA

	P	W	D	L	GD	Pts
Romania	3	2	0	1	0	6
Switzerland	3	1	1	1	1	4
USA	3	1	1	1	0	4
Colombia	3	1	0	2	-1	3

First Round Group B

Cameroon	2	2	Sweden
Brazil	2	0	Russia
Brazil	3	0	Cameroon
Sweden	3	1	Russia
Russia	6	1	Cameroon
Brazil	1	1	Sweden

	P	W	D	L	GD	Pts
Brazil	3	2	1	0	5	7
Sweden	3	1	2	0	2	5
Russia	3	1	0	2	1	3
Cameroon	3	0	1	2	-8	1

First Round Group C

Germany	1	0	Bolivia
Spain	2	2	South Korea
Germany	1	1	Spain
South Korea	0	0	Bolivia
Spain	3	1	Bolivia
Germany	3	2	South Korea

	P	W	D	L	GD	Pts
Germany	3	2	1	0	2	7
Spain	3	1	2	0	2	5
South Korea	3	0	2	1	-1	2
Bolivia	3	0	1	2	-3	1

First Round Group D

Argentina	4	0	Greece
Nigeria	3	0	Bulgaria
Argentina	2	1	Nigeria
Bulgaria	4	0	Greece
Bulgaria	2	0	Argentina
Nigeria	2	0	Greece

	P	W	D	L	GD	Pts
Nigeria	3	2	0	1	4	6
Bulgaria	3	2	0	1	3	6
Argentina	3	2	0	1	3	6
Greece	3	0	0	3	-10	0

First Round Group E

Ireland	1	0	Italy
Norway	1	0	Mexico
Italy	1	0	Norway
Mexico	2	1	Ireland
Italy	1	1	Mexico
Ireland	0	0	Norway

	P	W	D	L	GD	Pts
Mexico	3	1	1	1	0	4
Ireland	3	1	1	1	0	4
Italy	3	1	1	1	0	4
Norway	3	1	1	1	0	4

First Round Group F

Belgium	1	0	Morocco
Netherlands	2	1	Saudi Arabia
Saudi Arabia	2	1	Morocco
Belgium	1	0	Netherlands
Saudi Arabia	1	0	Belgium
Netherlands	2	1	Morocco

	P	W	D	L	GD	Pts
Netherlands	3	2	0	1	1	6
Saudi Arabia	3	2	0	1	1	6
Belgium	3	2	0	1	1	6
Morocco	3	0	0	3	-3	0

himself in the exchange and for that he was shot dead in the car park. A bodyguard was found guilty of the murder, though many believe his conviction was a cover for the real perpetrators.

Russia had an average side and went out in the group stages, but one player would create a record that still stands today – Oleg Salenko scored five goals in one game against Cameroon. Not to be outdone, Cameroon's Roger Milla also scored in that game, at the age of 42, and it made him the oldest scorer in the competition's history, beating his old record which he set in 1990. The goal of the tournament came from the most unlikely source. Belgium were expected to beat Saudi Arabia but in the fifth minute Saeed Al-Owairan picked up possession in his own half, took on four players, and blasted the ball in the back of the net, which made the Saudis only the second Asian team to progress past the group stage.

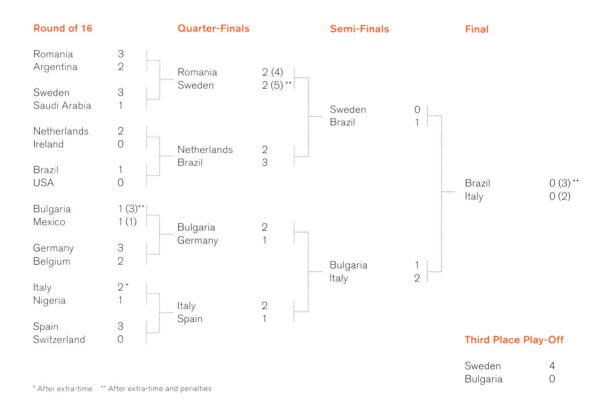

Round of 16		**Quarter-Finals**		**Semi-Finals**		**Final**	
Romania	3						
Argentina	2	Romania	2 (4)				
		Sweden	2 (5)**				
Sweden	3			Sweden	0		
Saudi Arabia	1			Brazil	1		
Netherlands	2						
Ireland	0	Netherlands	2				
		Brazil	3				
Brazil	1					Brazil	0 (3)**
USA	0					Italy	0 (2)
Bulgaria	1 (3)**						
Mexico	1 (1)	Bulgaria	2				
		Germany	1				
Germany	3			Bulgaria	1		
Belgium	2			Italy	2		
Italy	2*						
Nigeria	1	Italy	2				
		Spain	1				
Spain	3						
Switzerland	0						

Third Place Play-Off

Sweden	4
Bulgaria	0

* After extra-time ** After extra-time and penalties

22 June 1994, Rose Bowl, Pasadena
Andres Escobar has just scored an own goal against the USA which would have horrific ramifications. He was shot dead the following month at the age of just 27, by gang members in his home country who blamed him for Colombia's defeat.

17 July 1994, Rose Bowl, Pasadena
The final kick of the final game of USA 94. Roberto Baggio skies the ball
over the crossbar and Brazil win the World Cup for a record fourth time.

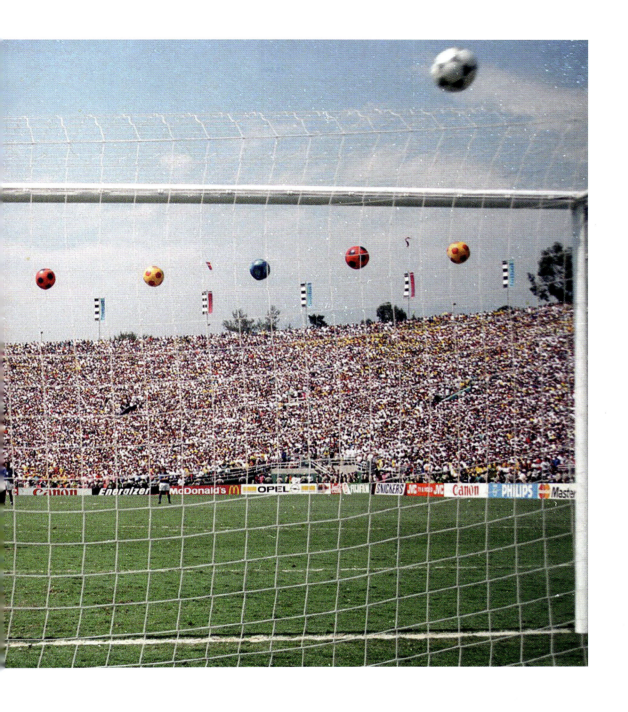

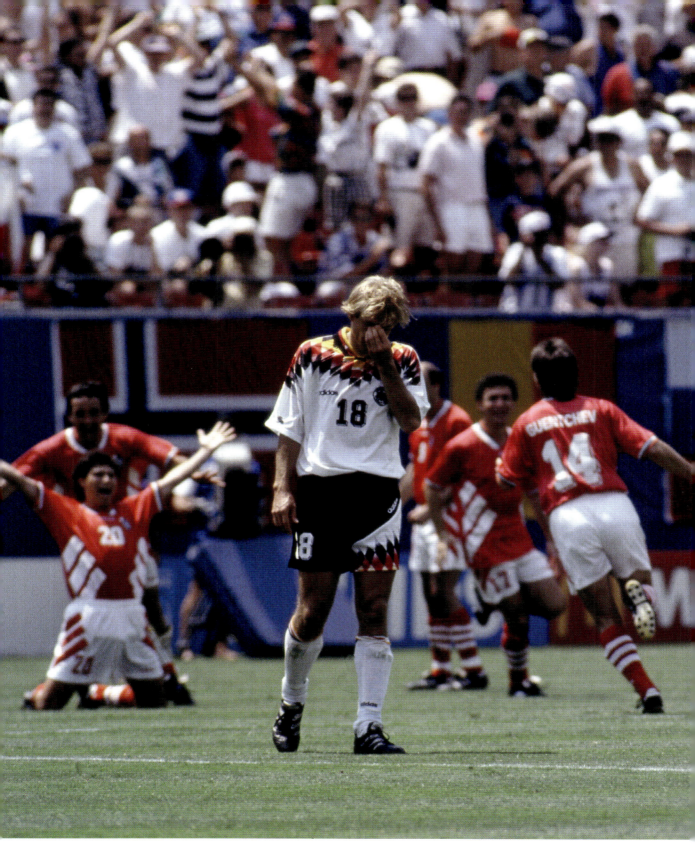

10 July 1994, Giants Stadium, East Rutherford
Germany's Jurgen Klinsmann can't believe what has happened. In the shock of the tournament, Bulgaria eliminate the world champions after a 2-1 win in New Jersey, to progress to the semi-final.

18 June 1994, Giants Stadium, East Rutherford
Jack Charlton soaks up the atmosphere before Ireland's group stage clash with Italy in New Jersey. Against the odds, the Irish won the game 1-0 thanks to a Ray Houghton strike from outside the box.

25 June 1994, Foxboro Stadium, Foxborough
All looks well and good for Diego Maradona as he walks off the pitch as his Argentina side
beat Nigeria 2-1 in Massachusetts. However, a storm is on the horizon as he would fail a
drugs test after the game and be thrown out of the tournament and banned from football.

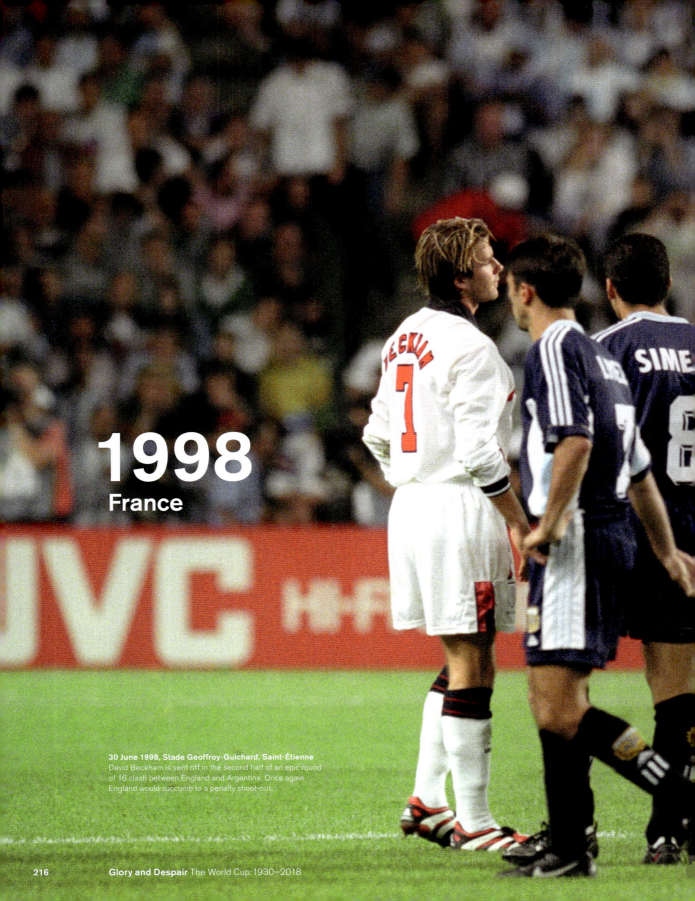

1998
France

30 June 1998, Stade Geoffroy-Guichard, Saint-Étienne
David Beckham is sent off in the second half of an epic round
of 16 clash between England and Argentina. Once again
England would succumb to a penalty shoot-out.

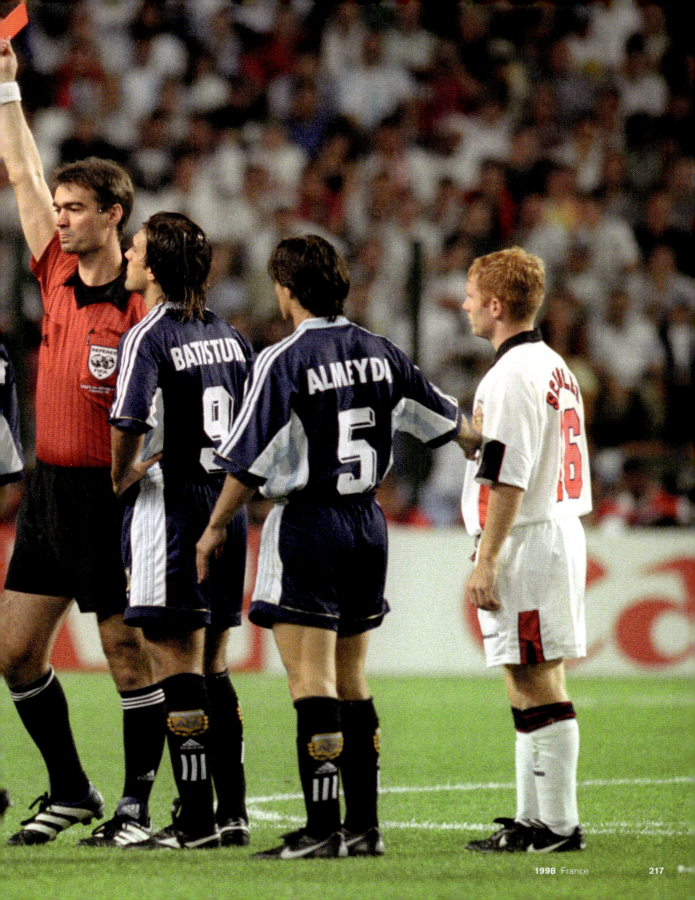

1998 France

By 1998 football had significantly changed off the pitch. The people who were getting into the stadiums for the big games were not necessarily the ones who had followed their team through thick and thin, but the chaps who worked for the likes of Coca-Cola and Adidas. The 1998 finals remains the only World Cup this author has been to and I was lucky enough to make it to four games, three of them by way of buying off ticket touts. I was able to see first-hand the corporate culture that had crept into the game with FIFA being the market leader for commercialism. In Toulouse, England played Romania. Thousands of fans had no tickets and black market prices were far too high for most. The disappointment of not getting a ticket turned to bitterness once fans saw the rows of coaches and buses for the people with free tickets. Working for a company that sponsors the tournament now meant more than being a loyal and passionate supporter, and this was the direction football chose as we entered a new millennium.

15 France were the tournament's top scoring team

The change in culture marred what otherwise was a brilliant World Cup. France was a perfect host nation, with wonderful cities, but despite a rich football history Les Bleus had still never made it to a World Cup Final, let alone being among the six nations who had won the tournament. They had failed to qualify for the previous World Cup and the French media were very sceptical of the team, despite the presence of Zinedine Zidane. Thierry Henry was also in the starting line-up, but in 1998 he was an emerging young player and virtually unheard of outside of France. He scored in the opening 3-0 win against new boys South Africa, and another two against Saudi Arabia in a 4-0 win in Paris, during which Zidane got sent off for

First Round Group A

Brazil	2	1	Scotland
Morocco	2	2	Norway
Scotland	1	1	Norway
Brazil	3	0	Morocco
Norway	2	1	Brazil
Morocco	3	0	Scotland

	P	W	D	L	GD	Pts
Brazil	3	2	0	1	3	6
Norway	3	1	2	0	1	5
Morocco	3	1	1	1	0	4
Scotland	3	0	1	2	-4	1

First Round Group B

Italy	2	2	Chile
Cameroon	1	1	Austria
Chile	1	1	Austria
Italy	3	0	Cameroon
Italy	2	1	Austria
Chile	1	1	Cameroon

	P	W	D	L	GD	Pts
Italy	3	2	1	0	4	7
Chile	3	0	3	0	0	3
Austria	3	0	2	1	-1	2
Cameroon	3	0	2	1	-3	2

First Round Group C

Denmark	1	0	Saudi Arabia
France	3	0	South Africa
South Africa	1	1	Denmark
France	4	0	Saudi Arabia
France	2	1	Denmark
South Africa	2	2	Saudi Arabia

	P	W	D	L	GD	Pts
France	3	3	0	0	8	9
Denmark	3	1	1	1	0	4
South Africa	3	0	2	1	-3	2
Saudi Arabia	3	0	1	2	-5	1

First Round Group D

Paraguay	0	0	Bulgaria
Nigeria	3	2	Spain
Nigeria	1	0	Bulgaria
Spain	0	0	Paraguay
Paraguay	3	1	Nigeria
Spain	6	1	Bulgaria

	P	W	D	L	GD	Pts
Nigeria	3	2	0	1	0	6
Paraguay	3	1	2	0	2	5
Spain	3	1	1	1	4	4
Bulgaria	3	0	1	2	-6	1

a stamp. I was in Toulouse that day and it was wonderful to see the local reaction as thousands of people celebrated in the streets with car horns going off all over the city. Despite the corporate takeover of the sport, the people proved that you don't have to be inside the stadium to create the kind of atmosphere and pageantry that makes being a host nation so special.

Unlike the previous three World Cups, no third-placed team with a good record would qualify from the group stage as there were now eight groups instead of six. The tournament had expanded from 24 to 32 teams and for Croatia it was their debut as an independent nation. They had caused an upset by beating Germany 3-0 in the quarter-final and faced the hosts in the semi-final. After Croatia went 1-0 up early in the second half, two goals from Lilian Thuram put France into the final to face Brazil, who had beaten the Netherlands on penalties.

6 Davor Šuker of Croatia was top scorer

The Dutch had made it that far courtesy of a brilliant Dennis Bergkamp strike in the final minute against Argentina in the previous round. Every England fan cheered Bergkamp's goal as their team had been beaten on penalties in the previous round by Argentina, in a contender for the game of the tournament. England had played with ten men since the early part of the second half and had a goal disallowed in extra time. Had it stood, it would have counted as a golden goal and ended the game in one of only two World Cups which incorporated the golden goal rule. It was supposed to encourage attacking play instead of sitting back for penalties but it also raised the stakes for not conceding; and so, as on many occasions throughout its history, the rule resulted in even more defensive tactics. Only one golden goal was scored in 1998, for France to beat Paraguay in the last 16.

First Round Group E

Mexico	3	1	South Korea
Netherlands	0	0	Belgium
Belgium	2	2	Mexico
Netherlands	5	0	South Korea
Belgium	1	1	South Korea
Netherlands	2	2	Mexico

	P	W	D	L	GD	Pts
Netherlands	3	1	2	0	5	5
Mexico	3	1	2	0	2	5
Belgium	3	0	3	0	0	3
South Korea	3	0	1	2	-7	1

First Round Group F

FR Yugoslavia	1	0	Iran
Germany	2	0	USA
Germany	2	2	FR Yugoslavia
Iran	2	1	USA
FR Yugoslavia	1	0	USA
Germany	2	0	Iran

	P	W	D	L	GD	Pts
Germany	3	2	1	0	4	7
FR Yugoslavia	3	2	1	0	2	7
Iran	3	1	0	2	-2	3
USA	3	0	0	3	-4	0

First Round Group G

England	2	0	Tunisia
Romania	1	0	Colombia
Colombia	1	0	Tunisia
Romania	2	1	England
England	2	0	Colombia
Romania	1	1	Tunisia

	P	W	D	L	GD	Pts
Romania	3	2	1	0	2	7
England	3	2	0	1	3	6
Colombia	3	1	0	2	-2	3
Tunisia	3	0	1	2	-3	1

First Round Group H

Argentina	1	0	Japan
Croatia	3	1	Jamaica
Croatia	1	0	Japan
Argentina	5	0	Jamaica
Argentina	1	0	Croatia
Jamaica	2	1	Japan

	P	W	D	L	GD	Pts
Argentina	3	3	0	0	7	9
Croatia	3	2	0	1	2	6
Jamaica	3	1	0	2	-6	3
Japan	3	0	0	3	-3	0

Zidane's World Cup had been subdued due to missing games through a red card, and he had yet to register a goal by the time of the final. Ronaldo on the other hand, had scored four goals, yet in the final, the fortunes of the two superstars would be reversed. Before the game it was reported that Ronaldo wasn't in the starting line-up, then moments later it was said that he would play. Around 72 minutes before kick off Ronaldo had suffered a convulsive fit, and was in no fit state to play the most important game of football on the planet. 'We lost the World Cup, but I won another cup, my life,' were Ronaldo's words in later years, and in an inquest, Brazil's doctor admitted that he was too scared of the outcry if he had insisted that the striker was not fit to play. Conspiracy theories also went around that Nike, the sponsor of the Brazilian team, had applied pressure for Ronaldo to play, but no conclusive proof has ever come to light.

Ronaldo was a pedestrian in the final, unlike Zidane who scored two headers in the first half. In injury time Patrick Vieira played a through ball to his Arsenal team-mate Emmanuel Petit, who made it 3-0. One English newspaper the next day carried a front page headline that Arsenal had won the World Cup.

In the 16th World Cup, France became the sixth host nation to lift the trophy. Up to this point over a third of all World Cups had been won by the home country. In the following years the hosts would not be among the elite of world football, apart from Germany in 2006, and with 2022 in Qatar, then 2026 in USA/Canada and Mexico, it's likely that France, for now, will remain the last host to lift the trophy.

World Cup debutants: Japan, Jamaica, Croatia, South Africa.

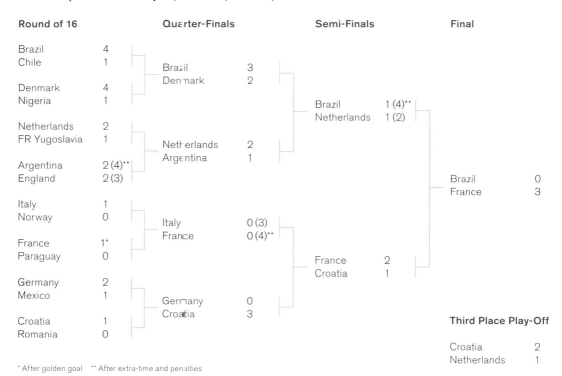

Round of 16		Quarter-Finals		Semi-Finals		Final	
Brazil	4						
Chile	1	Brazil	3				
		Denmark	2				
Denmark	4			Brazil	1 (4)**		
Nigeria	1			Netherlands	1 (2)		
Netherlands	2						
FR Yugoslavia	1	Netherlands	2				
		Argentina	1			Brazil	0
Argentina	2 (4)**					France	3
England	2 (3)						
Italy	1						
Norway	0	Italy	0 (3)				
		France	0 (4)**				
France	1*			France	2		
Paraguay	0			Croatia	1		
Germany	2						
Mexico	1	Germany	0				
		Croatia	3				
Croatia	1						
Romania	0						

Third Place Play-Off

Croatia	2
Netherlands	1

* After golden goal ** After extra-time and penalties

4 July 1998, Stade Vélodrome, Marseille
In the dying seconds in Marseille, and with the score at 1-1, Dennis Bergkamp scores one of the goals of the tournament to break Argentina hearts and send the Dutch through to the semi-finals.

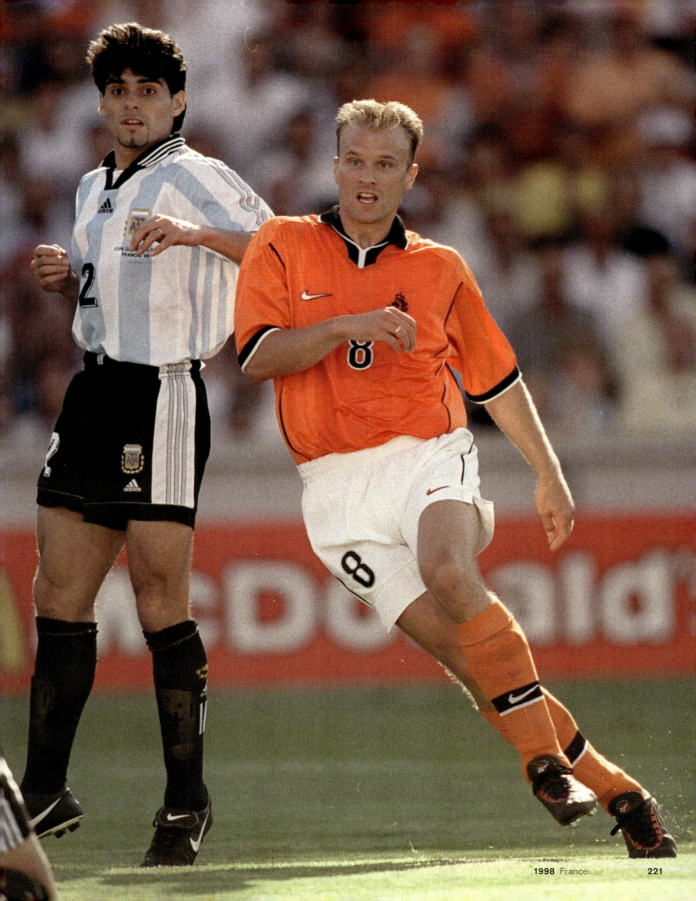

4 July 1998, Stade de Gerland, Lyon
Germany's Lothar Matthäus looks dejected as
Croatia celebrate a shock 3-0 quarter-final win
over the reigning European champions.

10 June 1998, Stade de France, Saint-Denis
Scotland's John Collins puts a penalty past Brazil's Taffarel to
make it 1-1 in the opening game. However the defending world
champions would win the game 2-1.

12 July 1998, Stade de France, Saint-Denis
In the final between France and Brazil, Zinedine Zidane heads home the opening goal from a corner in a 3-0 victory for the hosts.

Didier Deschamps has the medal, the trophy and the flag, as France become the seventh nation to be able to call themselves world champions.

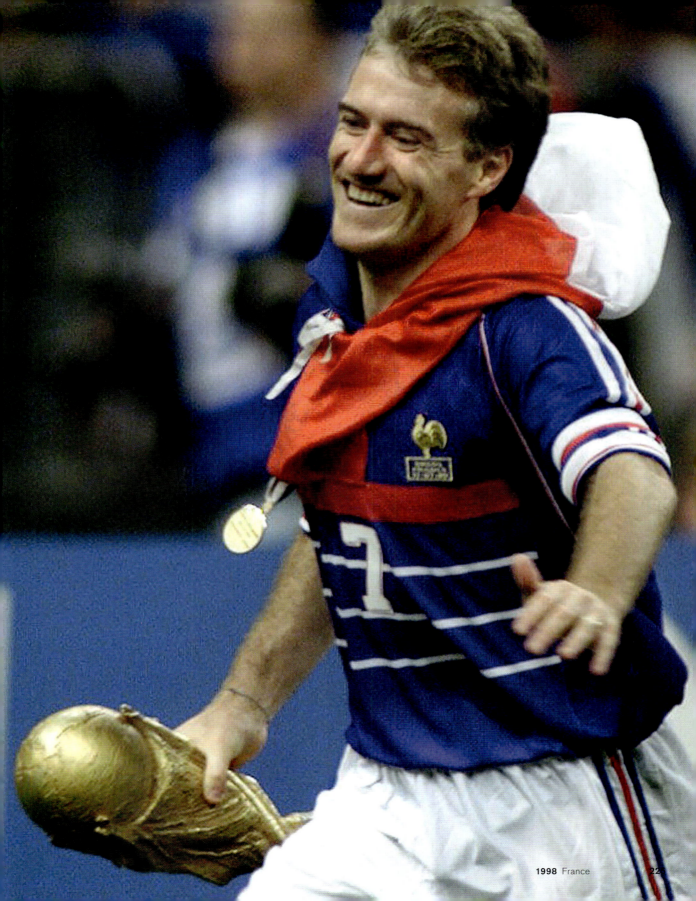

21 June 1998, Stade de Gerland, Lyon
Jubilant Iran players celebrate going 1-0 ahead against the USA in a match that carried significant off-the-pitch importance given the political tensions between the two countries over the years. Before the game, the players of both teams posed for a joint group photo in a show of harmony and friendship. Iran won the game 2-1.

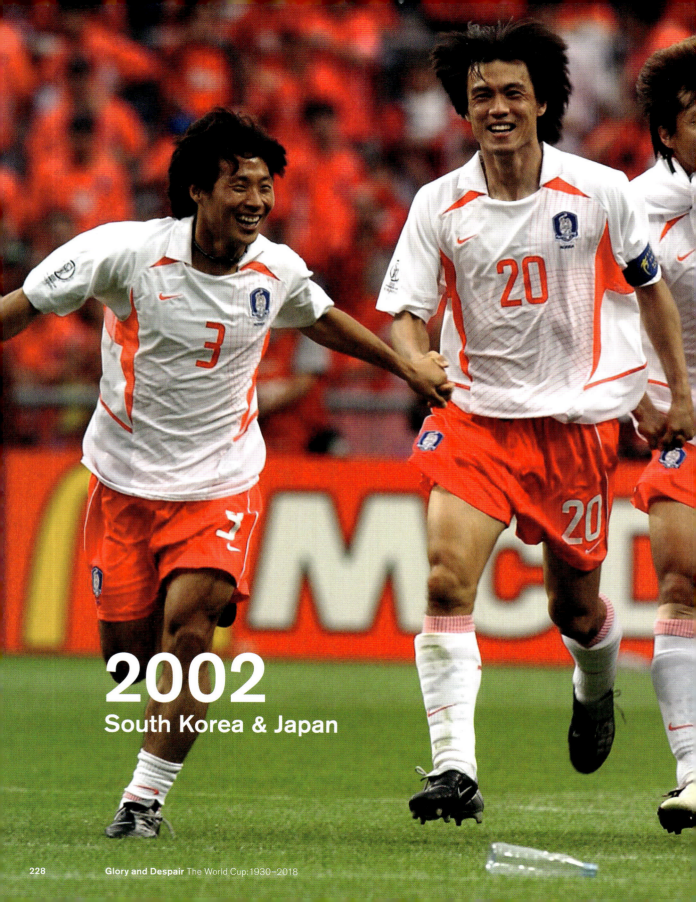

2002
South Korea & Japan

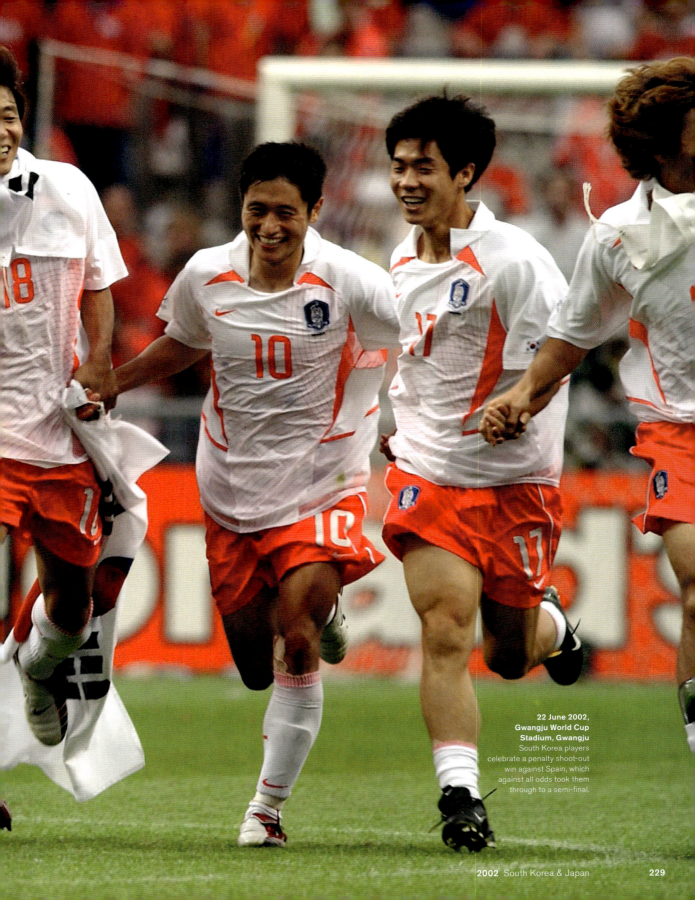

**22 June 2002,
Gwangju World Cup
Stadium, Gwangju**
South Korea players
celebrate a penalty shoot-out
win against Spain, which
against all odds took them
through to a semi-final.

2002 Japan and South Korea

The likelihood is that one day Australia will host a FIFA World Cup. Until that happens, 2002 will remain the furthest east that the tournament has ever been held. It goes down in history as the first and only World Cup in Asia, until Qatar in 2022, and the first time that the World Cup had two host nations. UEFA had already

18 Brazil were the tournament's top scoring team

held a joint competition as two years earlier neighbours Belgium and the Netherlands co-hosted Euro 2000. Initially Japan and South Korea were rival bidders, along with Mexico who after hosting 1970 and 1986 must have decided they were entitled to hold a World Cup once every 16 years. The compromise was that both Asian countries should organise the tournament together, with South Korea getting the opening ceremony and first game, which was a surprising 1-0 win for new boys Senegal against the reigning world and European champions France. Japan got to host the final, a showdown between the two most successful international countries, Brazil and Germany.

With the tournament being held in the Far East, fans in Europe, Africa and the Americas would be watching games at unconventional times. In Greenwich Mean Time, games kicked off at times ranging between 7.30am and midday. When England played Brazil in the quarter-final, Trafalgar Square in London was packed full of people watching the game on a giant screen at 7.30am, and what a weird feeling it was to be drinking and watching football at that time of day. At Shizuoka, where the match was being played, one England fan displayed a banner that read 'Farewell Japan – Perfect hosts'. They may have been great hosts and they managed to win a World Cup match for the first time, but they could not match their co-hosts

First Round Group A

Senegal	1	0	France
Denmark	2	1	Uruguay
Denmark	1	1	Senegal
France	0	0	Uruguay
Denmark	2	0	France
Senegal	3	3	Uruguay

	P	W	D	L	GD	Pts
Denmark	3	2	1	0	3	7
Senegal	3	1	2	0	1	5
Uruguay	3	0	2	1	-1	2
France	3	0	1	2	-3	1

First Round Group B

Paraguay	2	2	South Africa
Spain	3	1	Slovenia
Spain	3	1	Paraguay
South Africa	1	0	Slovenia
Spain	3	2	South Africa
Paraguay	3	1	Slovenia

	P	W	D	L	GD	Pts
Spain	3	3	0	0	5	9
Paraguay	3	1	1	1	0	4
South Africa	3	1	1	1	0	4
Slovenia	3	0	0	3	-5	0

First Round Group C

Brazil	2	1	Turkey
Costa Rica	2	0	China
Brazil	4	0	China
Costa Rica	1	1	Turkey
Brazil	5	2	Costa Rica
Turkey	3	0	China

	P	W	D	L	GD	Pts
Brazil	3	3	0	0	8	9
Turkey	3	1	1	1	2	4
Costa Rica	3	1	1	1	-1	4
China	3	0	0	3	-9	0

First Round Group D

South Korea	2	0	Poland
USA	3	2	Portugal
South Korea	1	1	USA
Portugal	4	0	Poland
South Korea	1	0	Portugal
Poland	3	1	USA

	P	W	D	L	GD	Pts
South Korea	3	2	1	0	3	7
USA	3	1	1	1	-1	4
Portugal	3	1	0	2	2	3
Poland	3	1	0	2	-4	3

South Korea who had a dream tournament, and at one point had a realistic chance of getting to the final. In the last four they faced a lacklustre Germany, who had beaten the USA 1-0 in the quarter-final, and looked far from invincible.

Thousands of Koreans packed the streets of Seoul in the hope that their nation could become the first team from outside of Europe and South America to reach a World Cup Final. However, the Germans repeated the 1-0 scoreline and progressed to their sixth final. Technically this was Brazil's sixth showpiece as 1950 didn't have a final game.

If Germany were to be victorious then they would equal Brazil's tally of four wins. However, there was little doubt that the South Americans would lift up their fifth World Cup. The Germany team had a favourable draw and played Paraguay, the USA and South Korea in the knockout rounds, scoring only three goals along

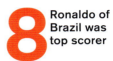

Ronaldo of Brazil was top scorer

the way. Brazil also had a favourable route to the final as well, being in an easy group, but in contrast they were far from average and possessed the three deadly Rs – Ronaldo, Rivaldo and Ronaldinho. England were the only strong team in Brazil's way, and after a promising start to their quarter-final they went out as Brazil improved in the second half and Ronaldinho scored an outrageous free kick that was from so far out, that many would question whether or not he actually meant it. In the final, Germany started well and played their best football of the tournament. However, Ronaldo sealed his status as the superstar of the era with two second-half goals as Brazil won 2-0 and became undisputed kings of World Cup football with five overall wins.

First Round Group E

Ireland	1	1	Cameroon
Germany	8	0	Saudi Arabia
Germany	1	1	Ireland
Cameroon	1	0	Saudi Arabia
Germany	2	0	Cameroon
Ireland	3	0	Saudi Arabia

	P	W	D	L	GD	Pts
Germany	3	2	1	0	10	7
Ireland	3	1	2	0	3	5
Cameroon	3	1	1	1	-1	4
Saudi Arabia	3	0	0	3	-12	0

First Round Group F

Argentina	1	0	Nigeria
England	1	1	Sweden
Sweden	2	1	Nigeria
England	1	0	Argentina
Sweden	1	1	Argentina
Nigeria	0	0	England

	P	W	D	L	GD	Pts
Sweden	3	1	2	0	1	5
England	3	1	2	0	1	5
Argentina	3	1	1	1	0	4
Nigeria	3	0	1	2	-2	1

First Round Group G

Mexico	1	0	Croatia
Italy	2	0	Ecuador
Croatia	2	1	Italy
Mexico	2	1	Ecuador
Mexico	1	1	Italy
Ecuador	1	0	Croatia

	P	W	D	L	GD	Pts
Mexico	3	2	1	0	2	7
Italy	3	1	1	1	1	4
Croatia	3	1	0	2	-1	3
Ecuador	3	1	0	2	-2	3

First Round Group H

Japan	2	2	Belgium
Russia	2	0	Tunisia
Japan	1	0	Russia
Tunisia	1	1	Belgium
Japan	2	0	Tunisia
Belgium	3	2	Russia

	P	W	D	L	GD	Pts
Japan	3	2	1	0	3	7
Belgium	3	1	2	0	1	5
Russia	3	1	0	2	0	3
Tunisia	3	0	1	2	-4	1

The other favoured teams in the tournament had nightmares. France went out in the group stage, as did Argentina. Portugal just needed a draw against South Korea to win the group, but they had two players sent off and the hosts won 1-0. Then Italy and Spain were eliminated by South Korea on their route to the semi-final, and once again the hosts were very grateful to the referee. In the round of 16, Italy's Francesco Totti was fouled in the area and instead of winning a penalty he was deemed to have dived and was dismissed after being given a second yellow card. Ahn Jung-hwan would then score the golden goal and Italy were gone. Nobody thought lightning could strike again, but it did as Korea eliminated another European heavyweight in Spain. Once again the result was questioned as the referee had ruled out two perfectly good Spanish goals, and South Korea won via a penalty shoot-out. The fallout from the Italy game was that scorer Ahn had his contract cancelled by his new club side Perugia with the chairman saying, 'I have no intention of paying a salary to someone who has ruined Italian football.' The Korean responded, 'I will no longer discuss my transfer to Perugia, who attacked my character instead of congratulating me for my goal in the World Cup.'

Some teams care little for the third/fourth place play-off game. It can be a depressing occasion, so far removed from the glory of reaching the final. However, for Turkey there were joyous celebrations in the streets of Istanbul when they beat South Korea 3-2. It meant something special, as up to that point they had only ever competed in the 1954 World Cup (2002 remains their last World Cup to date). They also created significant history in this game as Hakan Sükür's goal after just 10.8 seconds stands today as the fastest ever World Cup goal.

World Cup debutants: Slovenia, China, Senegal, Ecuador

Round of 16		Quarter-Finals		Semi-Finals		Final	
Germany	1						
Paraguay	0	Germany	1				
USA	2	USA	0				
Mexico	0			Germany	1		
				South Korea	0		
Spain	1 (3)**						
Ireland	1 (2)	Spain	0 (3)				
South Korea	2*	South Korea	0 (5)**			Germany	0
Italy	1					Brazil	2
England	3						
Denmark	0	England	1				
Brazil	2	Brazil	2				
Belgium	0			Brazil	1		
				Turkey	0		
Senegal	2*						
Sweden	1	Senegal	0				
Turkey	1	Turkey	1*				
Japan	0						

Third Place Play-Off

Turkey	3
South Korea	2

* After golden goal ** After extra-time and penalties

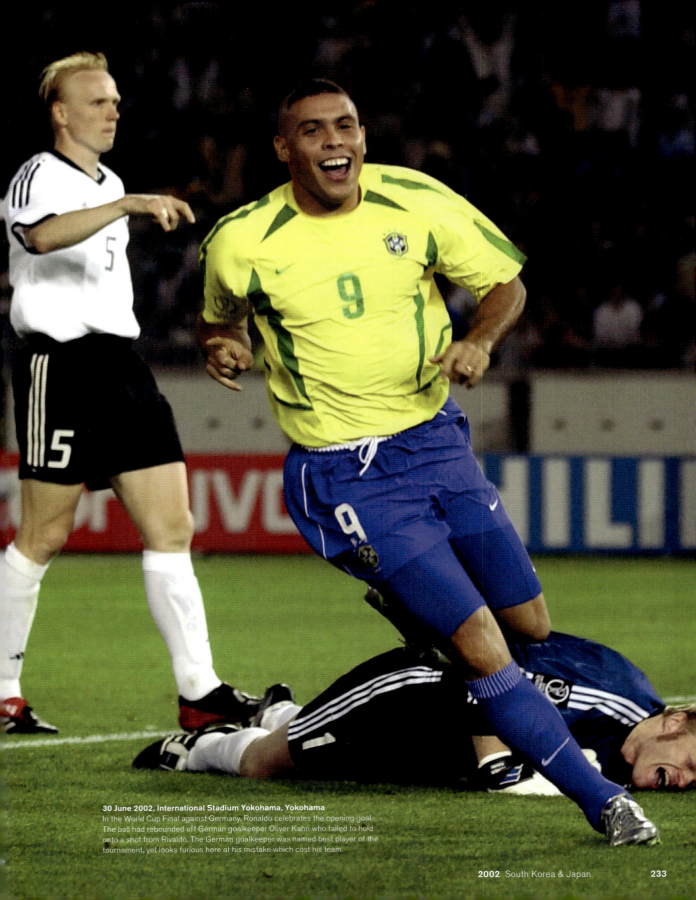

30 June 2002, International Stadium Yokohama, Yokohama
In the World Cup Final against Germany, Ronaldo celebrates the opening goal.
The ball had rebounded off German goalkeeper Oliver Kahn who failed to hold
onto a shot from Rivaldo. The German goalkeeper was named best player of the
tournament, yet looks furious here at his mistake which cost his team.

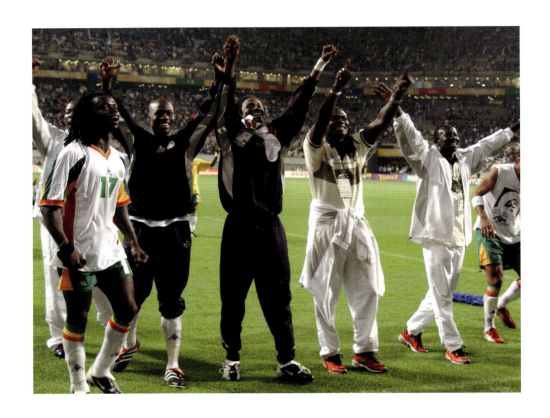

31 May 2002, Seoul World Cup Stadium, Seoul
A major upset, as Senegal celebrate a 1-0 win
against current world and European champions
France in the opening game of the tournament.

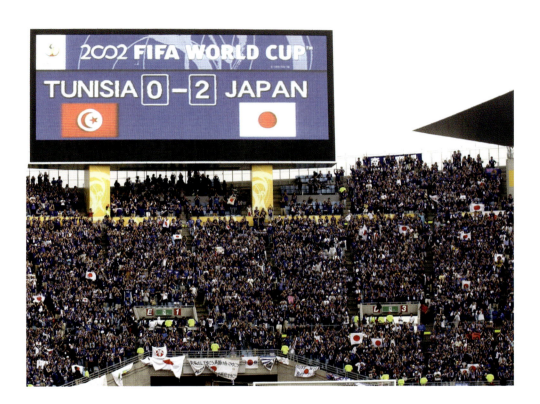

14 June 2002, Nagai Stadium, Osaka
Unlike co-hosts South Korea, Japan had started the group stage very well and had looked strong. A 2-0 win against Tunisia confirmed them as group winners. They were confident in progressing further when drawn against Turkey, however would ose 1-0.

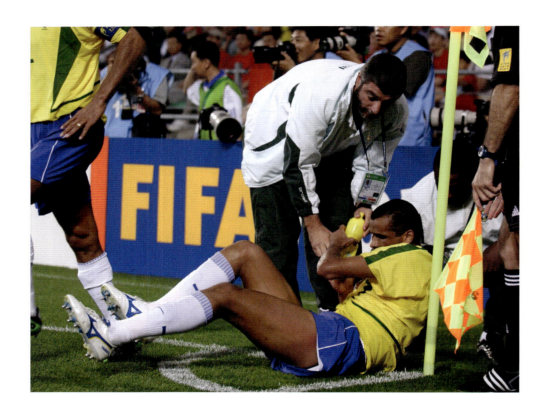

3 June 2002, Munsu Cup Stadium, Ulsan
One of the most ridiculous incidents in World Cup history. In a group stage game against Turkey, Rivaldo receives medical assistance after claiming to have been struck in the face by the ball. In fact, the Turkish player Hakan Unsal had kicked the ball at Rivaldo's knee in frustration and the Brazilian grabbed his face and fell to the floor as if being stuck by world heavyweight champion Lennox Lewis. Bizarrely the officials fell for it, Unsal was sent off and Rivaldo went on to say "Obviously the ball did not hit me in the face, but I was still the victim".

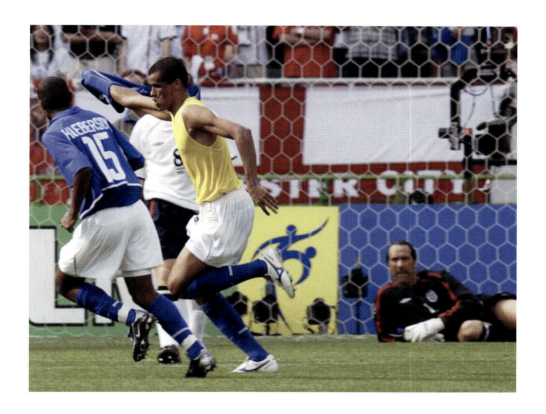

21 June 2002, Stadium Ecopa, Shizuoka
David Seaman looks on as Rivaldo celebrates
scoring the equalising goal in a quarter-final
tie with England. Brazil went on to win 2-1 and
progress to the semi-final.

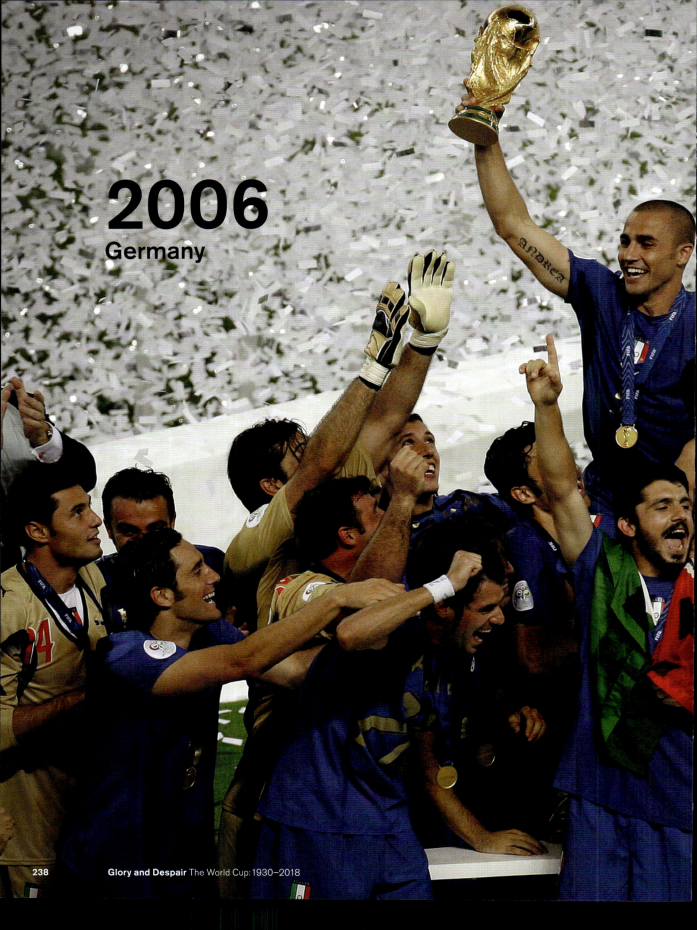

2006
Germany

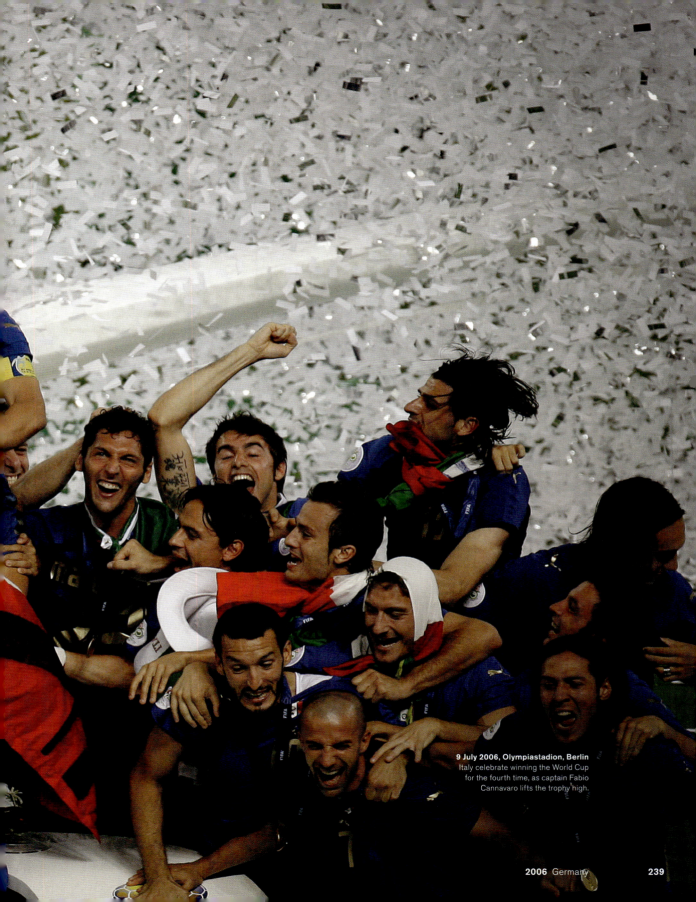

9 July 2006, Olympiastadion, Berlin
Italy celebrate winning the World Cup
for the fourth time, as captain Fabio
Cannavaro lifts the trophy high.

2006 Germany

In the World Cup of 1974 in West Germany, a new tradition began of the defending champions playing in the first game of the tournament. This changed in 2006 as FIFA went back to the original approach of the hosts being featured in the opening game. Germany's lucky appearance in the 2002 final had papered

14

Germany were the tournament's top scoring team

over the cracks with German football having been on the decline since the late 1990s, meaning we had the unusual scenario of Germany hosting a World Cup and not even being considered one of the favourites. In previous years that would be unthinkable. A new generation of German talent was emerging, although progression and promise – as opposed to winning – was the more realistic agenda.

The 2006 World Cup saw four of the standout players of the last 30 years all playing: Lionel Messi and Cristiano Ronaldo being nearer the start of their journeys while Zinedine Zidane and Brazilian Ronaldo were nearing the end of theirs. In 2006 Messi was the youngest player to compete in a World Cup for Argentina. When he scored in a 6-0 thrashing of Serbia & Montenegro it made him the sixth youngest player to score in a World Cup. However, he was dropped for Argentina's quarter-final against Germany in Berlin, which they lost on penalties, followed by a brawl as irate Argentina players reacted badly to the loss.

Cristiano Ronaldo led his Portugal team to the quarter-final against England, who were heavily fancied before the tournament and were branded the 'Golden Generation'. They never lived up to the hype, although would put in their best performance against Portugal as they played the second half and extra time with ten men. Wayne Rooney had stamped on Ricardo Carvalho and was red-carded after his Manchester

First Round Group A

Germany	4	2	Costa Rica
Ecuador	2	0	Poland
Germany	1	0	Poland
Ecuador	3	0	Costa Rica
Germany	3	0	Ecuador
Poland	2	1	Costa Rica

	P	W	D	L	GD	Pts
Germany	3	3	0	0	6	9
Ecuador	3	2	0	1	2	6
Poland	3	1	0	2	-2	3
Costa Rica	3	0	0	3	-6	0

First Round Group B

England	1	0	Paraguay
Trinidad & Tobago	0	0	Sweden
England	2	0	Trinidad & Tobago
Sweden	1	0	Paraguay
England	2	2	Sweden
Paraguay	2	0	Trinidad & Tobago

	P	W	D	L	GD	Pts
England	3	2	1	0	3	7
Sweden	3	1	2	0	1	5
Paraguay	3	1	0	2	0	3
Trinidad & Tobago	3	0	1	2	-4	1

First Round Group C

Argentina	2	1	Ivory Coast
Netherlands	1	0	Serbia & Montenegro
Argentina	6	0	Serbia & Montenegro
Netherlands	2	1	Ivory Coast
Netherlands	0	0	Argentina
Ivory Coast	3	2	Serbia & Montenegro

	P	W	D	L	GD	Pts
Argentina	3	2	1	0	7	7
Netherlands	3	2	1	0	2	7
Ivory Coast	3	1	0	2	-1	3
Serbia & Mont.	3	0	0	3	-8	0

First Round Group D

Mexico	3	1	Iran
Portugal	1	0	Angola
Mexico	0	0	Angola
Portugal	2	0	Iran
Portugal	2	1	Mexico
Iran	1	1	Angola

	P	W	D	L	GD	Pts
Portugal	3	3	0	0	4	9
Mexico	3	1	1	1	1	4
Angola	3	0	2	1	-1	2
Iran	3	0	1	2	-4	1

United team-mate Ronaldo had been one of the players to surround the referee and call for his dismissal. As in 1998, England's star player was sent off for kicking out, the team battled on with ten men, and they lost on penalties. Déjà vu. Portugal themselves had missed two penalties in the shoot-out, but England were not to be denied another loss and missed three. England might have been bad at penalties once again but Switzerland managed the worst performance possible in a shoot-out by losing 3-0 from the spot to Ukraine in the round of 16.

Brazilian Ronaldo made his impact by overtaking Gerd Müller as the all-time leading World Cup goalscorer. In the fifth minute against Ghana he scored the last of his 15 World Cup goals; a new record but one that would only last for eight years. In 2006, Miroslav Klose was adding to his tally and would be the one to overtake the great Brazilian in the future.

5 Miroslav Klose of Germany was top scorer

Zidane certainly made an impact in 2006. He guided France to their second World Cup Final, and scored a penalty after seven minutes against Italy. This made him one of only four players to have scored in more than one final, along with Brazilians Vavá (1958 and '62) and Pelé (1958 and '70), and West Germany's Paul Breitner (1974 and '82). The Italians had beaten a revitalised Germany in the semi-final, with the two goals coming in the final minute as the game was heading towards a penalty shoot-out. Against France, Italy equalised in the 19th minute through Materazzi, which would be the final strike of the tournament. In the group stages there were so many goals that talk centred around 2006 being the greatest World Cup of all time. The goals would dry up in the

First Round Group E

Czech Republic	3	0	USA
Italy	2	0	Ghana
Ghana	2	0	Czech Republic
Italy	1	1	USA
Italy	2	0	Czech Republic
Ghana	2	1	USA

	P	W	D	L	GD	Pts
Italy	3	2	1	0	4	7
Ghana	3	2	0	1	1	6
Czech Republic	3	1	0	2	-1	3
USA	3	0	1	2	-4	1

First Round Group F

Australia	3	1	Japan
Brazil	1	0	Croatia
Japan	0	0	Croatia
Brazil	2	0	Australia
Brazil	4	1	Japan
Australia	2	2	Croatia

	P	W	D	L	GD	Pts
Brazil	3	3	0	0	6	9
Australia	3	1	1	1	0	4
Croatia	3	0	2	1	-1	2
Japan	3	0	1	2	-5	1

First Round Group G

South Korea	2	1	Togo
France	0	0	Switzerland
France	1	1	South Korea
Switzerland	2	0	Togo
France	2	0	Togo
Switzerland	2	0	South Korea

	P	W	D	L	GD	Pts
Switzerland	3	2	1	0	4	7
France	3	1	2	0	2	5
South Korea	3	1	1	1	-1	4
Togo	3	0	0	3	-5	0

First Round Group H

Spain	4	0	Ukraine
Tunisia	2	2	Saudi Arabia
Ukraine	4	0	Saudi Arabia
Spain	3	1	Tunisia
Spain	1	0	Saudi Arabia
Ukraine	1	0	Tunisia

	P	W	D	L	GD	Pts
Spain	3	3	0	0	7	9
Ukraine	3	2	0	1	1	6
Tunisia	3	0	1	2	-3	1
Saudi Arabia	3	0	1	2	-5	1

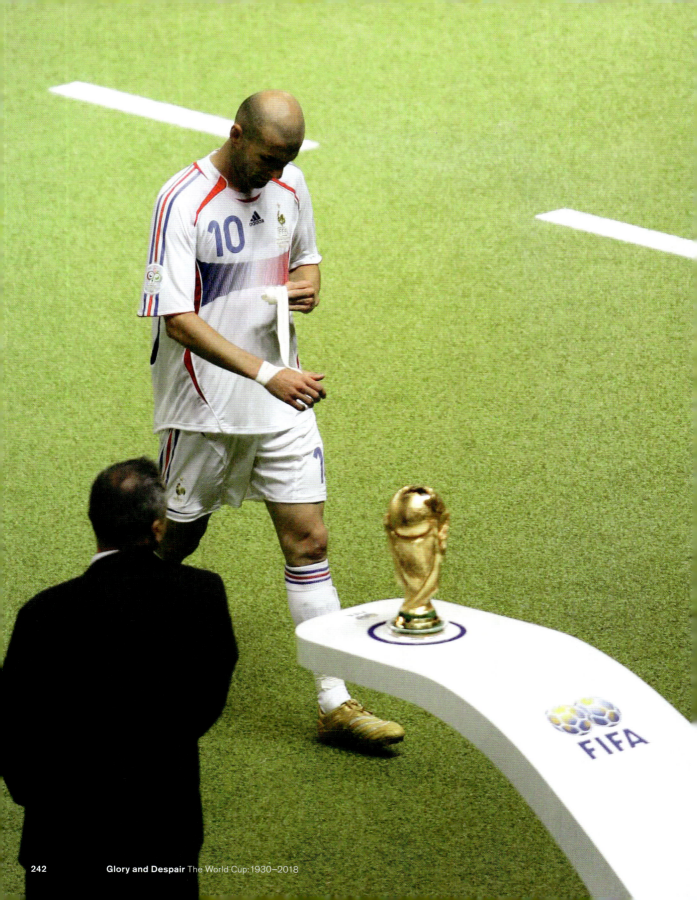

knockout stages but the same cannot be said of red and yellow cards. A staggering 28 red cards were pulled out, and 345 yellows. In 1954 we had the Battle of Berne between Hungary and Brazil. In 1962 we had the Battle of Santiago between Italy and Chile. And in 2006 we had the Battle of Nuremberg between the Netherlands and Portugal as 16 yellow cards were issued along with four reds. This would indicate a bloodbath, but this 'battle' was more a case of players throwing themselves to the ground at every opportunity and re-enacting the Willem Dafoe death scene from *Platoon*.

One red card came to define Germany 2006. Zidane had won the Golden Ball for the best player of the tournament, but he's not remembered for that. In the final he reacted to offensive verbal provocation from Materazzi and headbutted the defender in the chest, sending the Italian crashing to the ground. On the way to the dressing room, Zidane walked past the golden beacon that was the World Cup trophy in one of the saddest and most iconic images in the competition's history.

Up to 2006, Italy's record in shoot-outs was worse than England's − played five, lost five. However, this time they scored all five penalties and the World Cup was heading to Italy for the first time since 1982, and as four-times winners, they overtook Germany to be the second most successful team in the history of the competition.

World Cup debutants: Trinidad & Tobago, Serbia & Montenegro, Togo, Angola, Ivory Coast, Czech Republic, Ukraine, Ghana

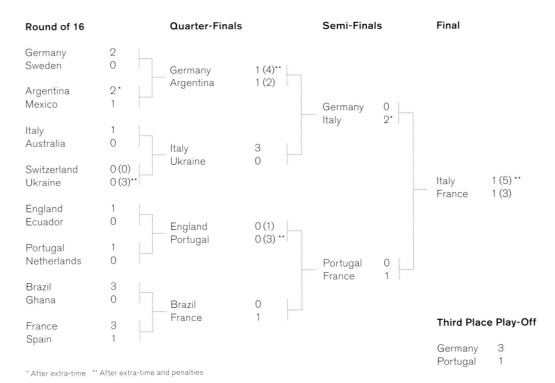

Round of 16		Quarter-Finals		Semi-Finals		Final	
Germany	2						
Sweden	0	Germany	1 (4)**				
Argentina	2*	Argentina	1 (2)	Germany	0		
Mexico	1			Italy	2*		
Italy	1						
Australia	0	Italy	3			Italy	1 (5)**
Switzerland	0 (0)	Ukraine	0			France	1 (3)
Ukraine	0 (3)**						
England	1						
Ecuador	0	England	0 (1)				
Portugal	1	Portugal	0 (3)**	Portugal	0		
Netherlands	0			France	1		
Brazil	3						
Ghana	0	Brazil	0				
France	3	France	1				
Spain	1						

* After extra-time ** After extra-time and penalties

Third Place Play-Off

Germany	3
Portugal	1

9 July 2006, Olympiastadion, Berlin
In one of the most shocking moments in World Cup history Zinedine Zidane is sent off in the final for headbutting Marco Materazzi.

30 June 2006, Olympiastadion, Berlin
Argentina fans make their presence felt in Berlin in a quarter-final
tie against the hosts. Germany won 4-2 in a penalty shoot-out, but
would go on to lose 2-0 to Italy in the semi-final.

25 June 2006, Frankenstadion, Nuremberg
Portugal beat the Netherlands 1-0 in this round of 16 clash,
however Cristiano Ronaldo walks off the pitch dejected
after picking up an injury. This game set a World Cup record
with 16 yellow cards and four red cards issued.

16 June 2006, FIFA World Cup Stadium, Gelsenkirchen
Like Cristiano Ronaldo, Lionel Messi was making his World
Cup debut in 2006. Here against Serbia & Montenegro, Messi
celebrates a goal in a 6-0 win that made him the sixth-youngest
goalscorer in the competition's history.

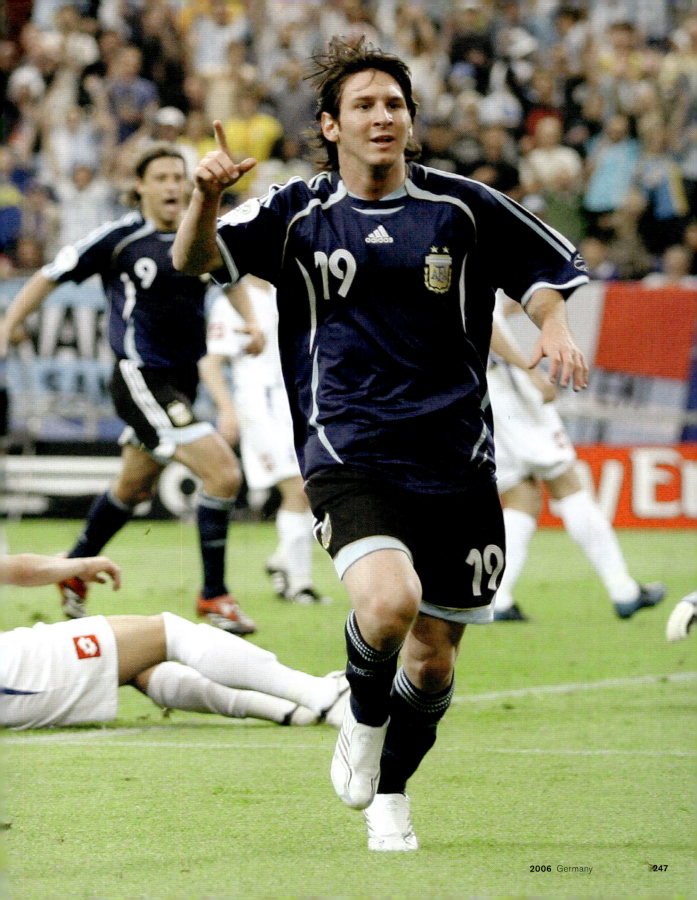

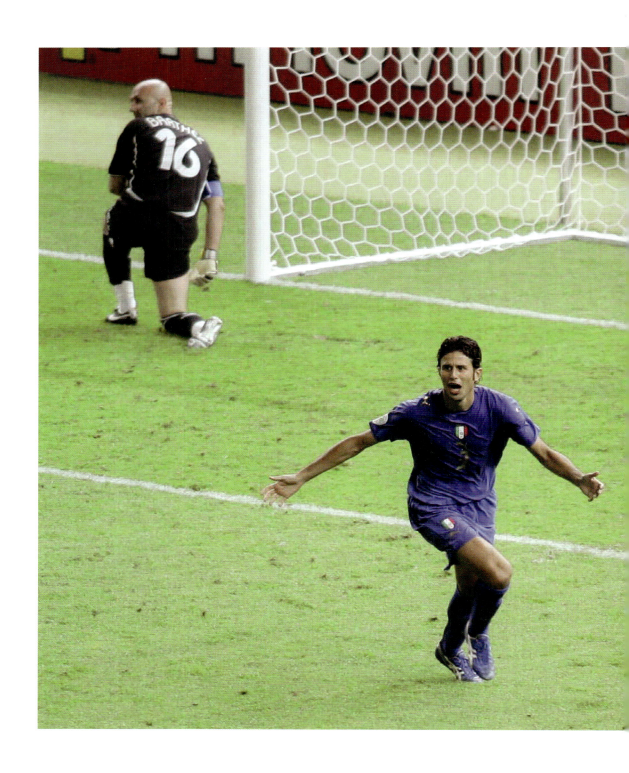

9 July 2006, Olympiastadion, Berlin
Fabio Grosso puts the ball past Fabien Barthez
as Italy win the penalty shoot-out against
France 5-3, and are crowned world champions.

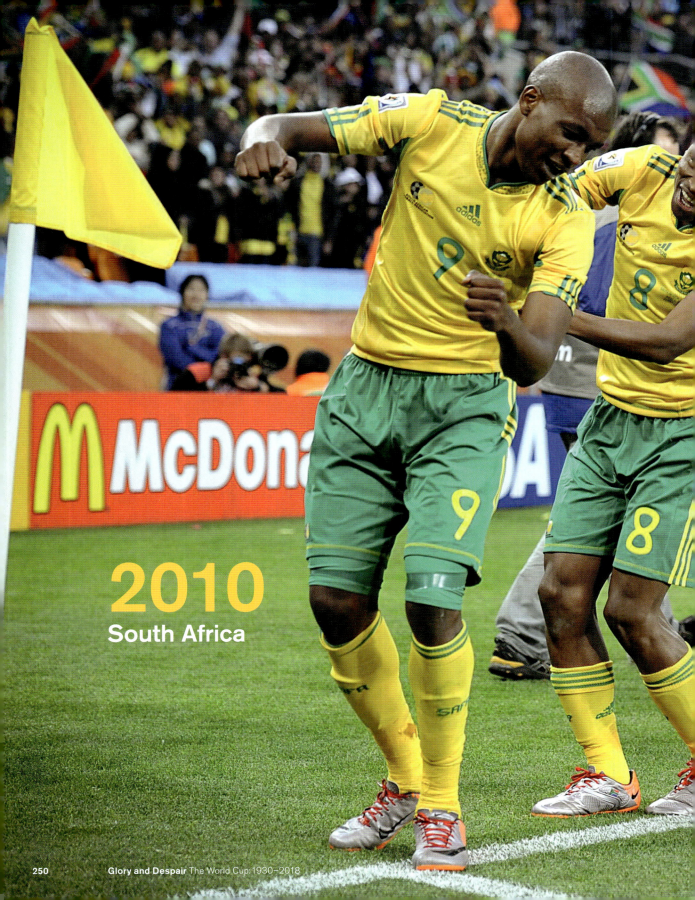

2010
South Africa

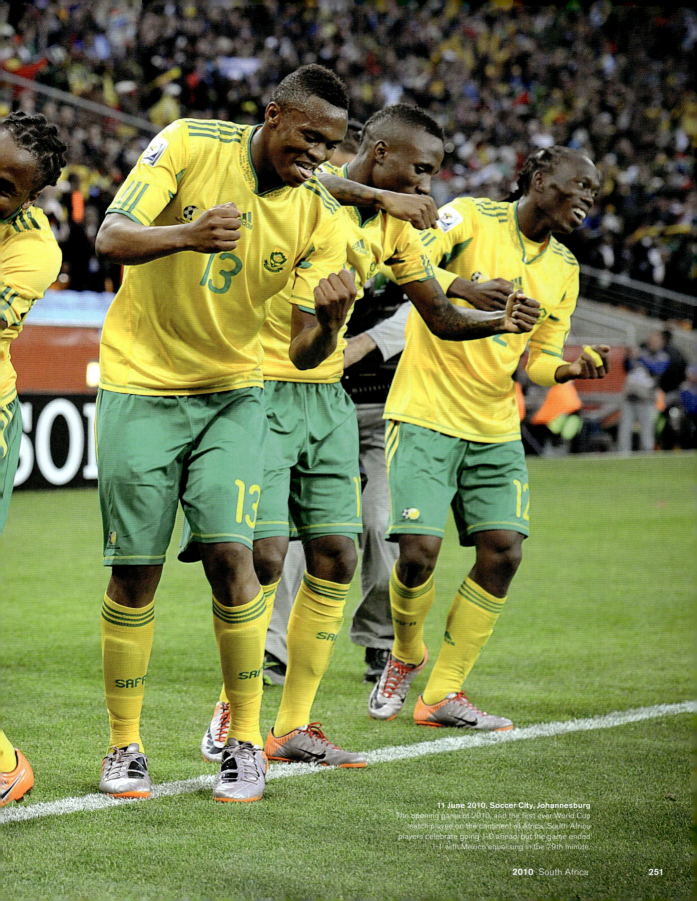

11 June 2010, Soccer City, Johannesburg
The opening game of 2010, and the first ever World Cup match played on the continent of Africa. South Africa players celebrate going 1-0 ahead, but the game ended 1-1 with Mexico equalising in the 79th minute.

2010 South Africa

In 1986 Morocco were the trailblazers for African football as they became the first nation from the continent to qualify from the group stages, going on to lose to West Germany in the last 16. In 1990, Cameroon went a step further by reaching the quarter-finals as they narrowly lost 3-2 to England. In 2002 Senegal played out a tight quarter-final with Turkey, which ended with a golden goal winning the game 1-0 for the Turks. In the first World Cup held in Africa, it looked like Ghana would take the continent's football to the next frontier and beat Uruguay and progress to a World Cup semi-final. At 1-1 with one minute to go in extra time Uruguay's Luis Suárez punched the ball away with both hands to prevent a certain goal, and he was sent off. Suárez walked towards the tunnel a distraught man, his shirt covering his face, then turned around just in time to see Asamoah Gyan fire the penalty against the crossbar and into the crowd. In a split second Suárez went from despair to then running down the tunnel waving his fists in the air as if he had just scored a goal. The tears after the penalty shoot-out came from Ghana, as Uruguay progressed to their first semi-final since 1970 and Suárez was cast as the latest in a long line of World Cup cheats and villains.

Whether or not South Africa should have been the host nation or not is riddled with the kind of controversy that has stained FIFA as an organisation viewed as corrupt to the core. Reports suggested that Morocco was the leading candidate, but $10m in bribes was used to sway opinion. There were also reports of mistreatment and underpayment of construction workers who built the stadiums, leading to strikes, as well as relocations of poor people near the venues.

16

Germany were the tournament's top scoring team

First Round Group A

South Africa	1	1	Mexico
Uruguay	0	0	France
Uruguay	3	0	South Africa
Mexico	2	0	France
Uruguay	1	0	Mexico
South Africa	2	1	France

	P	W	D	L	GD	Pts
Uruguay	3	2	1	0	4	7
Mexico	3	1	1	1	1	4
South Africa	3	1	1	1	-2	4
France	3	0	1	2	-3	1

First Round Group B

South Korea	2	0	Greece
Argentina	1	0	Nigeria
Argentina	4	1	South Korea
Greece	2	1	Nigeria
Nigeria	2	2	South Korea
Argentina	2	0	Greece

	P	W	D	L	GD	Pts
Argentina	3	3	0	0	6	9
South Korea	3	1	1	1	-1	4
Greece	3	1	0	2	-3	3
Nigeria	3	0	1	2	-2	1

First Round Group C

England	1	1	USA
Slovenia	1	0	Algeria
Slovenia	2	2	USA
England	0	0	Algeria
England	1	0	Slovenia
USA	1	0	Algeria

	P	W	D	L	GD	Pts
USA	3	1	2	0	1	5
England	3	1	2	0	1	5
Slovenia	3	1	1	1	0	4
Algeria	3	0	1	2	-2	1

First Round Group D

Ghana	1	0	Serbia
Germany	4	0	Australia
Serbia	1	0	Germany
Ghana	1	1	Australia
Germany	1	0	Ghana
Australia	2	1	Serbia

	P	W	D	L	GD	Pts
Germany	3	2	0	1	4	6
Ghana	3	1	1	1	0	4
Australia	3	1	1	1	-3	4
Serbia	3	1	0	2	-1	3

Corruption aside, once the tournament kicked off the South African fans responded with the kind of passion and colour that football was so desperate for, in a modern era when crowds had got quieter and less passionate. No World Cup has ever sounded quite like 2010, as thousands of vuvuzelas created an environment that made it sound like the stadium was populated by bees. The hum was an incredible soundtrack to football and would divide opinion, but in an era of controlled corporate culture there was something refreshing about regular football fans doing their own unique thing whether other people liked it or not.

The performance of the tournament was perhaps Germany's 4-0 beatdown of Argentina. Diego Maradona was in charge of the Argentina team, and was the polar opposite as a manager to what he was as a player. In the previous game Germany had put four past England, but they were also on the favourable end of one of the worst decisions in World Cup history. With the score at 2-1 and approaching half-time Frank Lampard struck a half volley from 20 yards out that hit the crossbar and bounced so far over the line that even Stevie Wonder in the back row of the upper tier saw it go in. The only two people on planet earth who never thought the ball crossed the line were the referee and linesman as the ghost of Geoff Hurst's goal in the 1966 final came back to haunt England.

5 Four players ended the tournament on five goals: Thomas Müller of Germany, Wesley Sneijder of Netherlands, David Villa of Spain and Diego Forlán of Uruguay

First Round Group E

Netherlands	2	0	Denmark
Japan	1	0	Cameroon
Netherlands	1	0	Japan
Denmark	2	1	Cameroon
Japan	3	1	Denmark
Netherlands	2	1	Cameroon

	P	W	D	L	GD	Pts
Netherlands	3	3	0	0	4	9
Japan	3	2	0	1	2	6
Denmark	3	1	0	2	-3	3
Cameroon	3	0	0	3	-3	0

First Round Group F

Italy	1	1	Paraguay
New Zealand	1	1	Slovakia
Paraguay	2	0	Slovakia
Italy	1	1	New Zealand
Slovakia	3	2	Italy
Paraguay	0	0	New Zealand

	P	W	D	L	GD	Pts
Paraguay	3	1	2	0	2	5
Slovakia	3	1	1	1	-1	4
New Zealand	3	0	3	0	0	3
Italy	3	0	2	1	-1	2

First Round Group G

Ivory Coast	0	0	Portugal
Brazil	2	1	North Korea
Brazil	3	1	Ivory Coast
Portugal	7	0	North Korea
Portugal	0	0	Brazil
Ivory Coast	3	0	North Korea

	P	W	D	L	GD	Pts
Brazil	3	2	1	0	3	7
Portugal	3	1	2	0	7	5
Ivory Coast	3	1	1	1	1	4
North Korea	3	0	0	3	-11	0

First Round Group H

Chile	1	0	Honduras
Switzerland	1	0	Spain
Chile	1	0	Switzerland
Spain	2	0	Honduras
Spain	2	1	Chile
Switzerland	0	0	Honduras

	P	W	D	L	GD	Pts
Spain	3	2	0	1	2	6
Chile	3	2	0	1	1	6
Switzerland	3	1	1	1	0	4
Honduras	3	0	1	2	-3	1

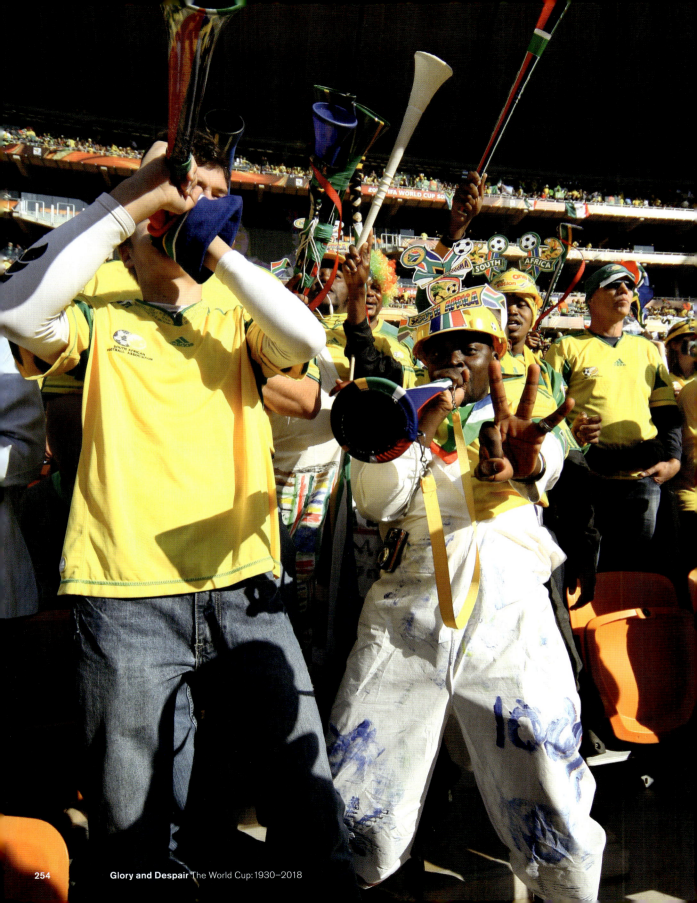

Despite scoring eight goals in two games, the Germans couldn't lay a glove on Spain in the semi-final. Up to 2010, Spain had never had a great World Cup or ever looked like going all the way. The typical Spanish experience was similar to England in that they would have star names, be uttered among the favourites, and then get dumped out by the quarter-finals. Their best World Cup had been finishing fourth in 1950, but in 2010 they were seeded second, partly off the back of winning the 2008 European Championship. That win in Europe had given the Spanish the self-belief that they could live up to expectation and win trophies. In their first game, against Switzerland, they lost 1-0 in a major upset, but they progressed past the group stage, and that 1-0 scoreline would go in their favour over the next four knockout ties as they won the World Cup in Johannesburg against the Netherlands.

It wasn't spectacular, and their 'tiki-taka' possession game didn't allow for compelling games of football; however it was highly technical, brilliantly effective and all Spain cared about was becoming one of only eight nations to be able to call themselves world champions. Another unwanted milestone went to the Netherlands who set the record at three for the most World Cup Final appearances without ever winning. Previously they had held the joint record along with Czechoslovakia and Hungary, who had both lost two finals each.

The two finalists of the previous World Cup, France and Italy, went out in the group stage, as did South Africa who set a new record of being the only host nation to not make it past the first phase (they will be watching keenly on how Qatar do in 2022). Despite disappointment on the field, the country had created history for Africa, as now five continents had hosted at least one World Cup tournament.

World Cup debutants: Slovakia

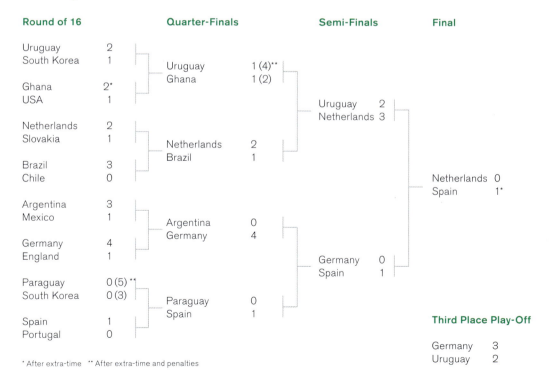

Round of 16		Quarter-Finals		Semi-Finals		Final	
Uruguay	2						
South Korea	1	Uruguay	1 (4)**				
Ghana	2*	Ghana	1 (2)	Uruguay	2		
USA	1			Netherlands	3		
Netherlands	2						
Slovakia	1	Netherlands	2				
Brazil	3	Brazil	1			Netherlands	0
Chile	0					Spain	1*
Argentina	3						
Mexico	1	Argentina	0				
Germany	4	Germany	4	Germany	0		
England	1			Spain	1		
Paraguay	0 (5) **						
South Korea	0 (3)	Paraguay	0				
Spain	1	Spain	1				
Portugal	0						

* After extra-time ** After extra-time and penalties

Third Place Play-Off

Germany	3
Uruguay	2

11 June 2010, Soccer City, Johannesburg
2010 was defined by the sound of the vuvuzelas.

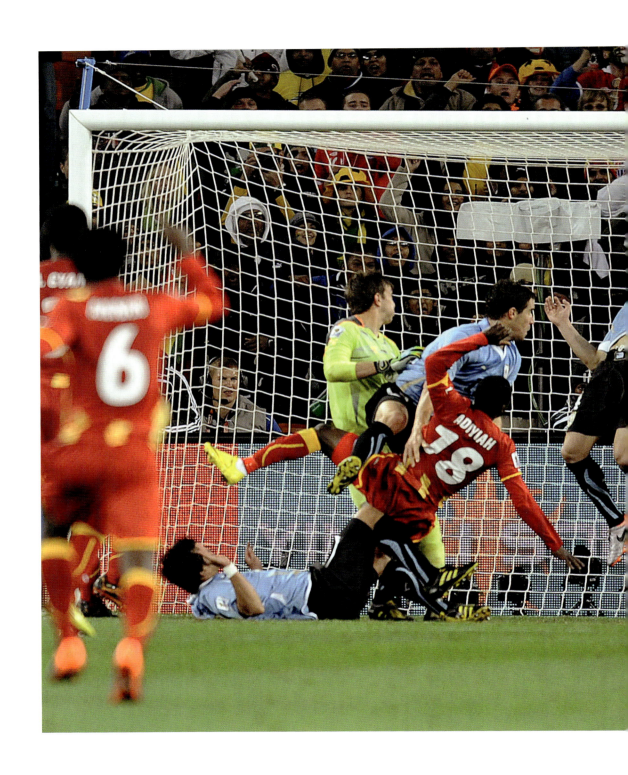

Glory and Despair The World Cup: 1930–2018

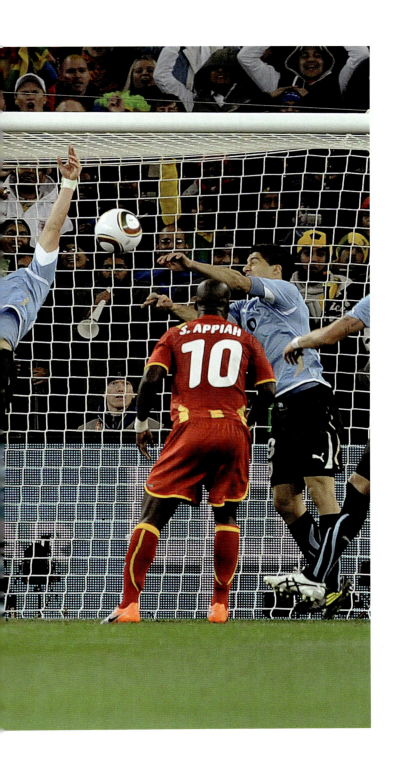

2 July 2010, Soccer City, Johannesburg
With the score at 1-1, Ghana think they have scored a last-minute goal that would send them through to the semi-final. However, Uruguay's Luis Suarez stops the ball with his hand. Suarez was sent off, however, the resulting penalty was missed and Uruguay went on to win the tie via a penalty shoot-out.

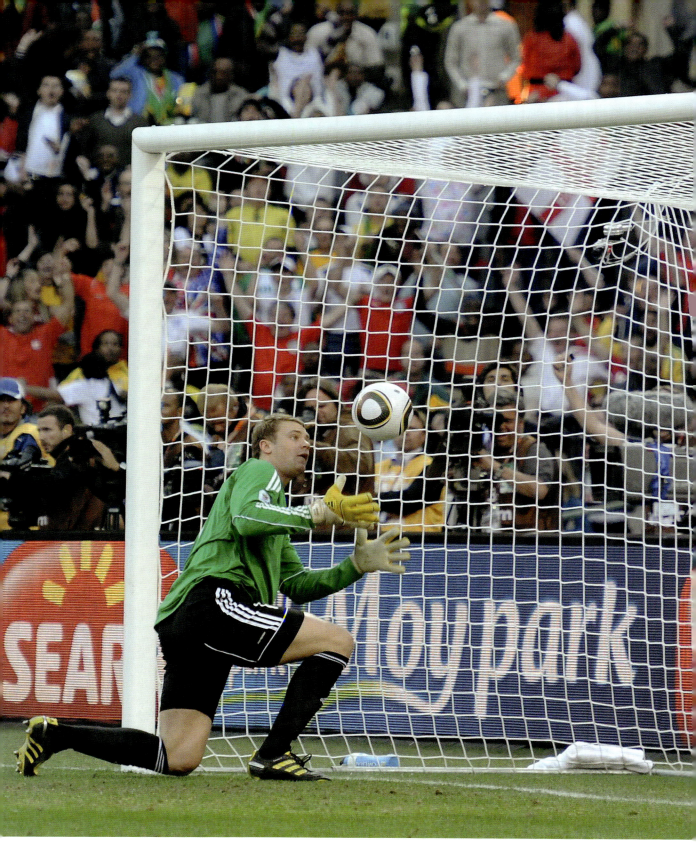

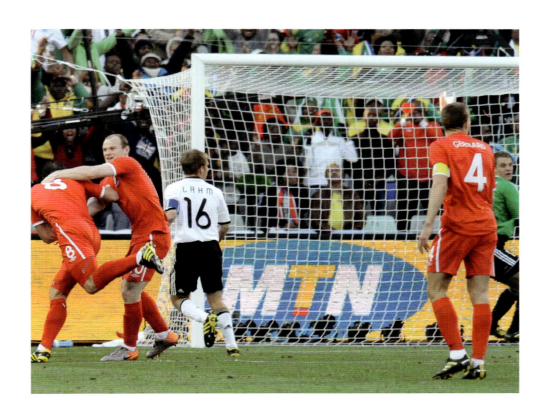

27 June 2010, Free State Stadium, Bloemfontein
One of the worst decisions in World Cup history, as both the referee and lineman fail to see
that Frank Lampard's volley had gone a yard or two over the line before it bounced back into
the hands of German goalkeeper Manuel Neuer. As the England players celebrated, the
official waved play on, Neuer threw the ball out and Germany came close to scoring down the
other end. The goal that wasn't would have made it 2-2, however Germany went on to win 4-1.

11 July 2020, Soccer City, Johannesburg
Glory for Spain and despair for the Netherlands in the final. With the game at 0-0 and just four minutes to go before a penalty shoot-out, Andres Iniesta struck a shot into the bottom corner for the Spaniards to win their one and only World Cup. The final was lacking in action, but most people felt that Spain were the best team of the era and were worthy winners.

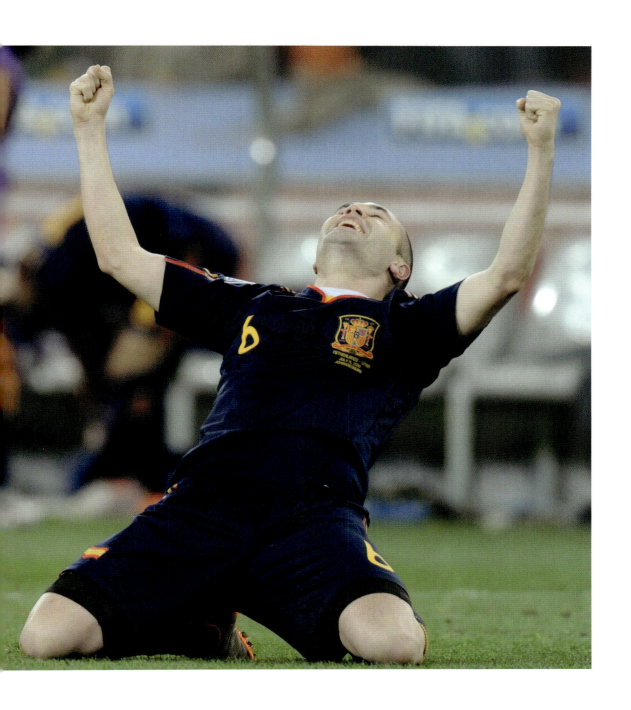

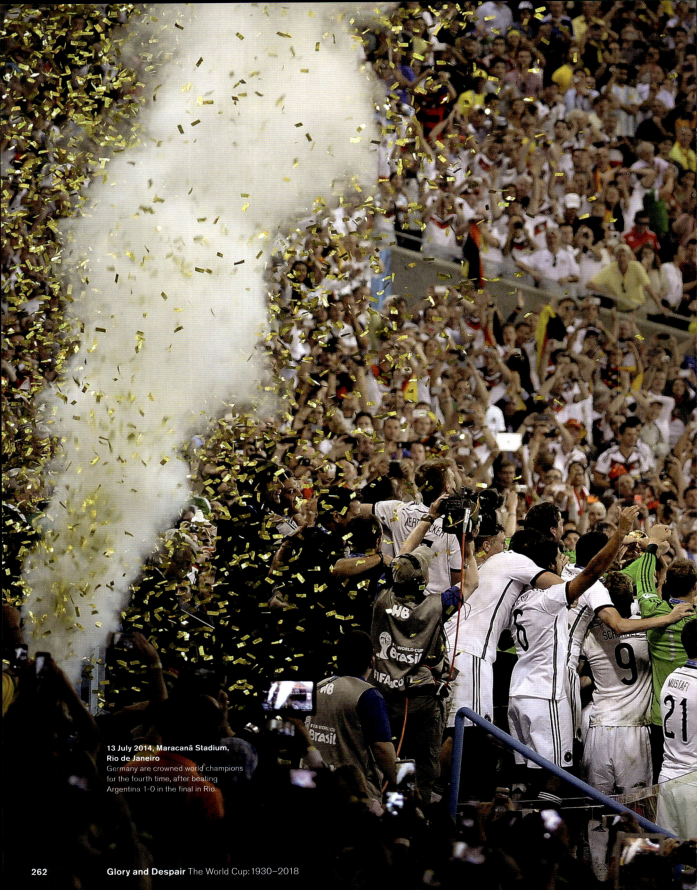

13 July 2014, Maracanã Stadium, Rio de Janeiro
Germany are crowned world champions for the fourth time, after beating Argentina 1-0 in the final in Rio.

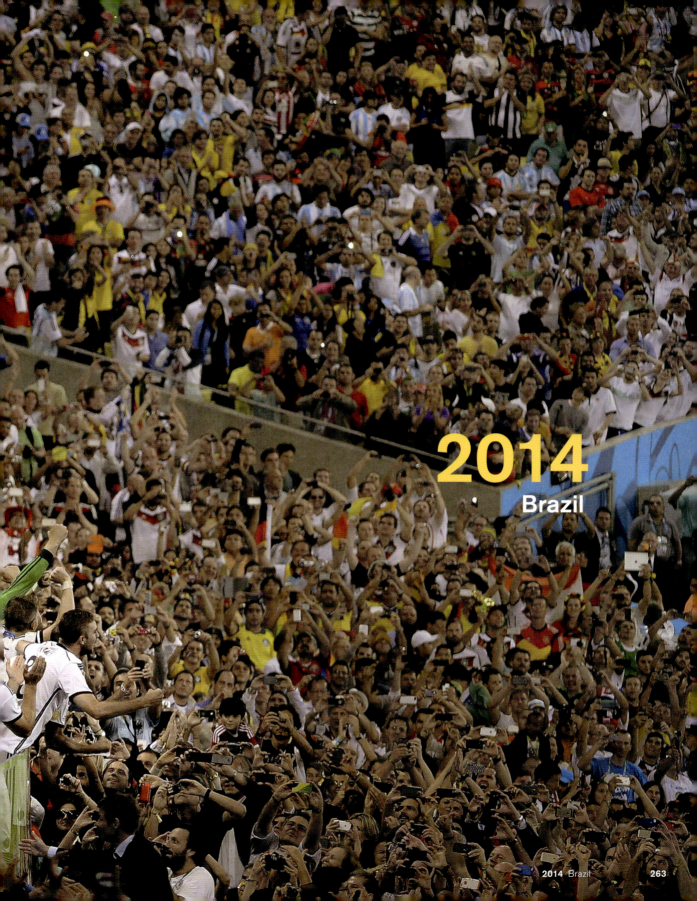

2014
Brazil

2014 Brazil

2014 was to be the first World Cup staged in South America since 1978, and was also the first time that Europe had gone two tournaments in a row without hosting. For the second time in four years it was a winter World Cup, albeit a Brazilian winter not a Russian one.

 Despite being the most decorated country in international history, it's said that Brazilians dwell more on their failures rather than their successes. As far as failures go for Brazil, the two tournaments held in their own country were both total disasters. 2014 was supposed to be the chance to bury the ghost of 1950, the worst moment in Brazilian football history, when Uruguay beat them 2-1 to win the World Cup in front of 200,000 devastated fans in the Maracanã. The 'Phantom of 50' was a defeat so hard to take that suicides took place, and some players never represented their country ever again. Such was the Brazilian desire to forget about losing in their home tournament that they changed their traditional kit colour from all white to yellow shirts and blue shorts in response. After 2014 it was lucky that they had so many great memories in yellow and blue, otherwise another kit may have been needed.

 Germany's 7-1 destruction of the host nation was perhaps the most humiliating defeat in the history of the World Cup. The home fans were crying during the first half as the Germans were 5-0 up with just 29 minutes on the clock, with four of the goals coming in a crazy seven-minute period. The World Cup had never seen anything like this. Heavy defeats had been a part of the tournament's history from the very beginning, but typically in games with a strong country against a far weaker one – not a semi-final between

First Round Group A

Brazil	3	1	Croatia
Mexico	1	0	Cameroon
Brazil	0	0	Mexico
Croatia	4	0	Cameroon
Brazil	4	1	Cameroon
Mexico	3	1	Croatia

	P	W	D	L	GD	Pts
Brazil	3	2	1	0	5	7
Mexico	3	2	1	0	3	7
Croatia	3	1	0	2	0	3
Cameroon	3	0	0	3	-8	0

First Round Group B

Netherlands	5	1	Spain
Chile	3	1	Australia
Netherlands	3	2	Australia
Chile	2	0	Spain
Spain	3	0	Australia
Netherlands	2	0	Chile

	P	W	D	L	GD	Pts
Netherlands	3	3	0	0	7	9
Chile	3	2	0	1	2	6
Spain	3	1	0	2	-3	3
Australia	3	0	0	3	-6	0

First Round Group C

Colombia	3	0	Greece
Ivory Coast	2	1	Japan
Colombia	2	1	Ivory Coast
Japan	0	0	Greece
Colombia	4	1	Japan
Greece	2	1	Ivory Coast

	P	W	D	L	GD	Pts
Colombia	3	3	0	0	7	9
Greece	3	1	1	1	-2	4
Ivory Coast	3	1	0	2	-1	3
Japan	3	0	1	2	-4	1

First Round Group D

Costa Rica	3	1	Uruguay
Italy	2	1	England
Costa Rica	1	0	Italy
Uruguay	2	1	England
Costa Rica	0	0	England
Uruguay	1	0	Italy

	P	W	D	L	GD	Pts
Costa Rica	3	2	1	0	3	7
Uruguay	3	2	0	1	0	6
Italy	3	1	0	2	-1	3
England	3	0	1	2	-2	1

the two most dominant forces of world football. The second goal was particularly significant as Miroslav Klose overtook Brazil's Ronaldo to become the leading scorer in World Cup finals history. The game could have ended 8-0 as in the last minute Mesut Özil missed a great chance, followed by Brazil going down the other end to gain a consolation goal from Oscar. That didn't stop one tear from rolling down the cheeks of the home fans, however.

To add extra salt in the wounds for Brazil, it denied them a chance to play against their biggest rivals, Argentina, which would have been the first meeting between the two in the final and the first all-South American showpiece since 1930. Argentina's match with the Netherlands in São Paulo had ended 0-0 and was decided on penalties, which they won 4-2. Along with England, who currently hold a record of won two lost seven, the Dutch have always been a close contender as the worst team in penalty shoot-out history. This defeat took their overall record to won two lost six, with a semi-final record of won none lost four.

6 James Rodríguez of Colombia was the top scorer

Instead of a repeat of the 1974 showdown between Germany and the Netherlands we got a repeat of the 1986 and 1990 finals, as Germany v Argentina overtook Brazil v Italy as the most played World Cup Final. The game in 1986 was a classic, but 1990 was painfully dull and unfortunately 2014 mirrored the latter as a contender for the least eventful and most boring World Cup Final. As in 1990 the score ended 1-0 with the Germans equalling Italy's tally of four World Cups. It also made them the first country to win the current World Cup trophy three times, and the first European team to win the World Cup

First Round Group E

Switzerland	2	1	Ecuador
France	3	0	Honduras
France	5	2	Switzerland
Ecuador	2	1	Honduras
Switzerland	3	0	Honduras
Ecuador	0	0	France

	P	W	D	L	GD	Pts
France	3	2	1	0	6	7
Switzerland	3	2	0	1	1	6
Ecuador	3	1	1	1	0	4
Honduras	3	0	0	3	-7	0

First Round Group F

Argentina	2	1	Bosnia & Herzegovina
Iran	0	0	Nigeria
Argentina	1	0	Iran
Nigeria	1	0	Bosnia & Herzegovina
Argentina	3	2	Nigeria
Bosnia & Herzegovina	3	1	Iran

	P	W	D	L	GD	Pts
Argentina	3	3	0	0	3	9
Nigeria	3	1	1	1	0	4
Bosnia & Herz.	3	1	0	2	0	3
Iran	3	0	1	2	-3	1

First Round Group G

Germany	4	0	Portugal
Ghana	1	2	USA
Germany	2	2	Ghana
USA	2	2	Portugal
USA	0	1	Germany
Portugal	2	1	Ghana

	P	W	D	L	GD	Pts
Germany	3	2	1	0	5	7
USA	3	1	1	1	0	4
Portugal	3	1	1	1	-3	4
Ghana	3	0	1	2	-2	1

First Round Group H

Belgium	2	1	Algeria
Russia	1	1	South Korea
Belgium	1	0	Russia
South Korea	2	4	Algeria
South Korea	0	1	Belgium
Algeria	1	1	Russia

	P	W	D	L	GD	Pts
Belgium	3	3	0	0	3	9
Algeria	3	1	1	1	1	4
Russia	3	0	2	1	-1	2
South Korea	3	0	1	2	-3	1

in South America. In 1990 the greatest player in the world, Diego Maradona, was cancelled out by West Germany, and 2014 saw a repeat of that as Lionel Messi had a quiet game.

England managed to produce their worst ever World Cup performance, with the highlight being a 0-0 draw with Costa Rica. In the previous tournament they had gone out in the round of 16, while denied a goal against Germany that was at least a yard over the line. From 2014 onwards goal-line technology was introduced and we would have no more ball over the line controversies between England and Germany, which was in danger of being a World Cup tradition.

The biggest upset was the elimination of Spain in the first round. The Spaniards entered as the number one seeds after having won three international tournaments in a row in an incredible golden period which they had never seen the likes of before. In their first game in 2014 they took the lead against the Netherlands, who were harshly seeded 15th. Everything looked to be in order but then the Spaniards fell apart dramatically as the brilliant Dutch scored five goals in what would have been the performance of the tournament, had Germany not torn apart Brazil in the semi-final. In Spain's first-round exit they conceded seven goals in three matches. To put that into context, in winning the European Championships of 2008 and 2012, as well as the 2010 World Cup, they had conceded just six goals in 19 games. The Spanish had come to the end of their golden era, while the old order of Germany had returned.

World Cup debutants: Bosnia and Herzegovina

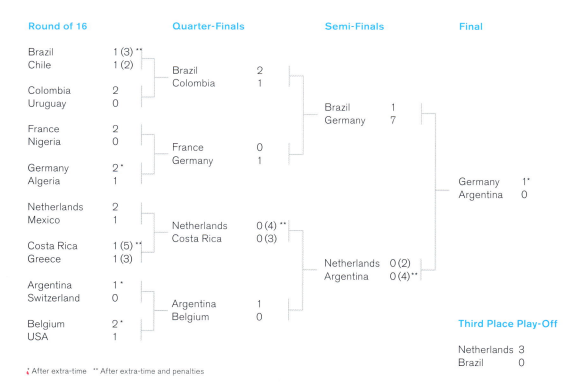

Round of 16		Quarter-Finals		Semi-Finals		Final	
Brazil	1 (3) **						
Chile	1 (2)	Brazil	2				
		Colombia	1				
Colombia	2			Brazil	1		
Uruguay	0			Germany	7		
France	2						
Nigeria	0	France	0				
		Germany	1				
Germany	2 *					Germany	1*
Algeria	1					Argentina	0
Netherlands	2						
Mexico	1	Netherlands	0 (4) **				
		Costa Rica	0 (3)				
Costa Rica	1 (5) **			Netherlands	0 (2)		
Greece	1 (3)			Argentina	0 (4) **		
Argentina	1 *						
Switzerland	0	Argentina	1				
		Belgium	0				
Belgium	2 *						
USA	1						

‹ After extra-time ** After extra-time and penalties

Third Place Play-Off

Netherlands 3
Brazil 0

9 July 2014, Arena Corinthians, São Paulo
In Sao Paulo, Argentina beat Netherlands 4-2 on penalties to go through to their fifth World Cup Final, and a chance to win the current trophy a record three times.

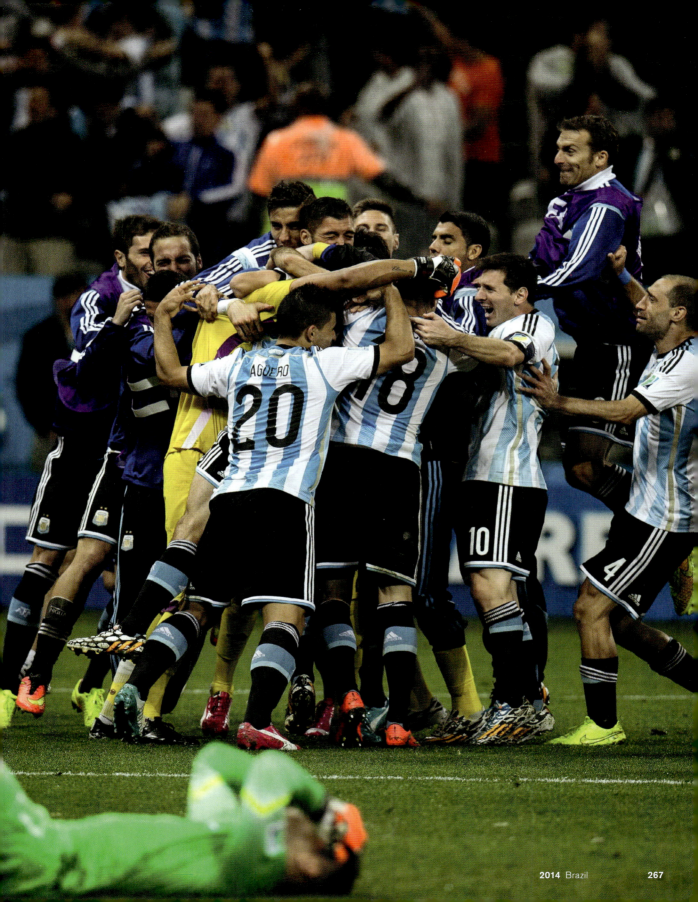

8 July 2014, Estádio Mineirão, Belo Horizonte
Neymar holds onto the net in despair and disbelief as his
Brazil side are mauled 7-1 by Germany in the semi-final.

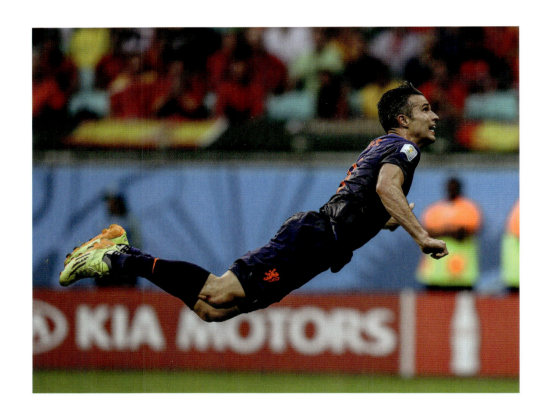

13 June 2014, Itaipava Arena Fonte Nova, Salvador
Dutchman Robin Van Persie scores a diving header from
20 yards out against Spain in a rematch of the 2010 final.
This was the equalising goal as the Dutch avenged their
final defeat, with a 5-1 thrashing of the world champions.

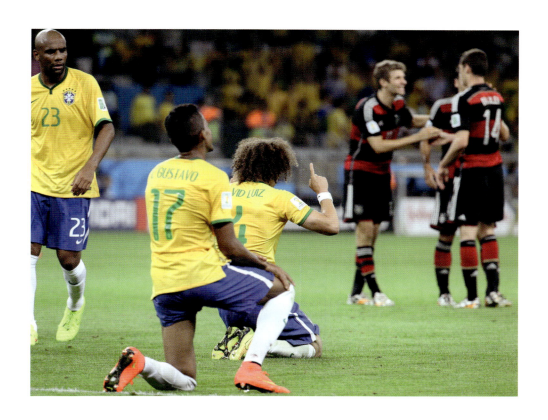

8 July 2014, Estádio Mineirão, Belo Horizonte
Brazil players say a prayer upon the final whistle of their 7-1
beatdown at the hands of Germany. The host nation were
stunned and humiliated as the game was over in the first half
with Germany 5-0 ahead by the 29th minute.

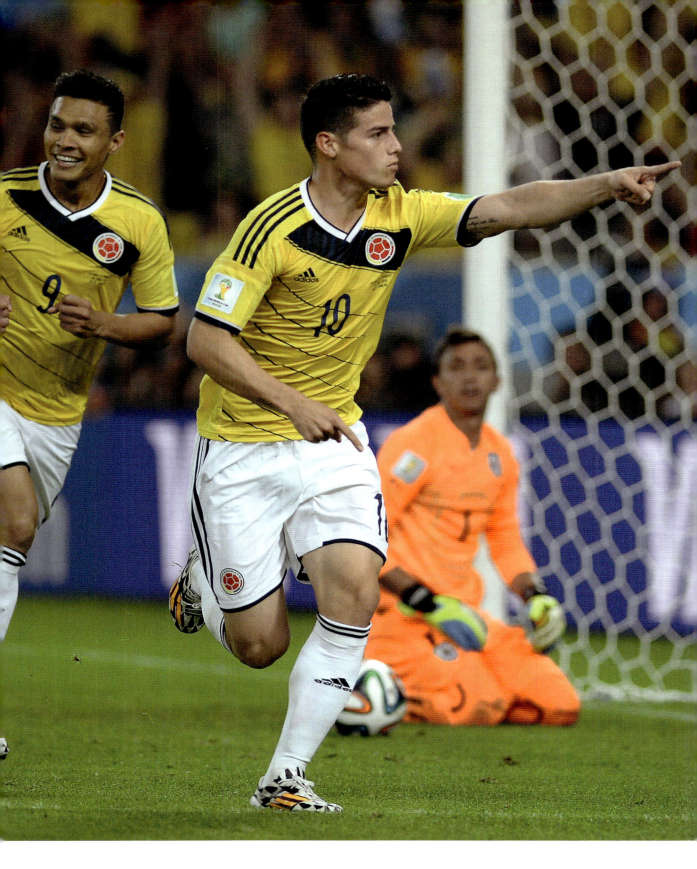

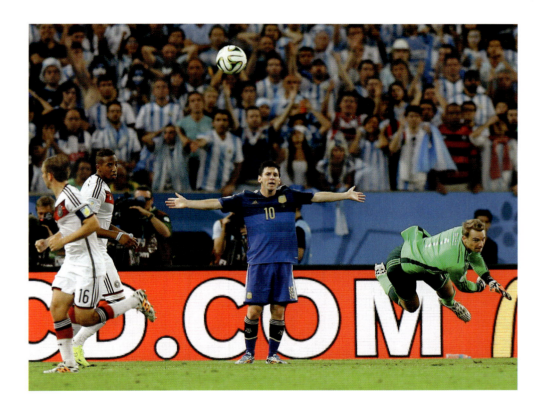

28 June 2014, Estádio do Maracanã, Rio de Janeiro
James Rodriguez, the top scorer of the tournament, celebrates his second goal in Colombia's 2-0 defeat of Uruguay in the round of 16.

13 July 2014, Estádio do Maracanã, Rio de Janeiro
A frustrated Lionel Messi is cancelled out by Germany in a lacklustre final. Germany won 1-0 with a goal from Mario Gotze in the 113th minute. Had Argentina won they would have equalled Germany's tally of three World Cup wins. Instead, Germany would equal Italy's achievement of four overall wins.

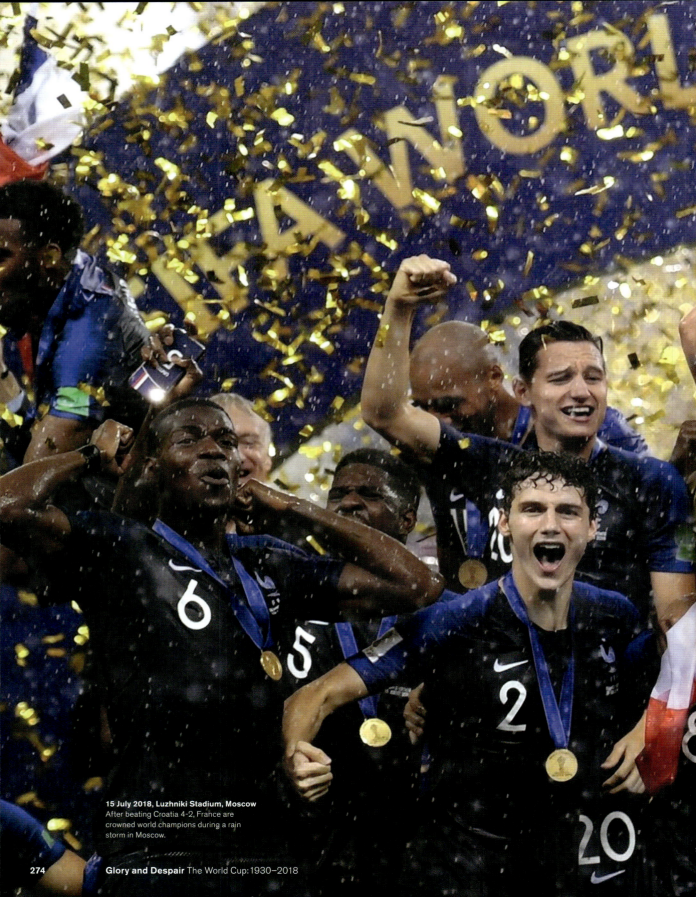

15 July 2018, Luzhniki Stadium, Moscow
After beating Croatia 4-2, France are
crowned world champions during a rain
storm in Moscow.

Glory and Despair The World Cup: 1930–2018

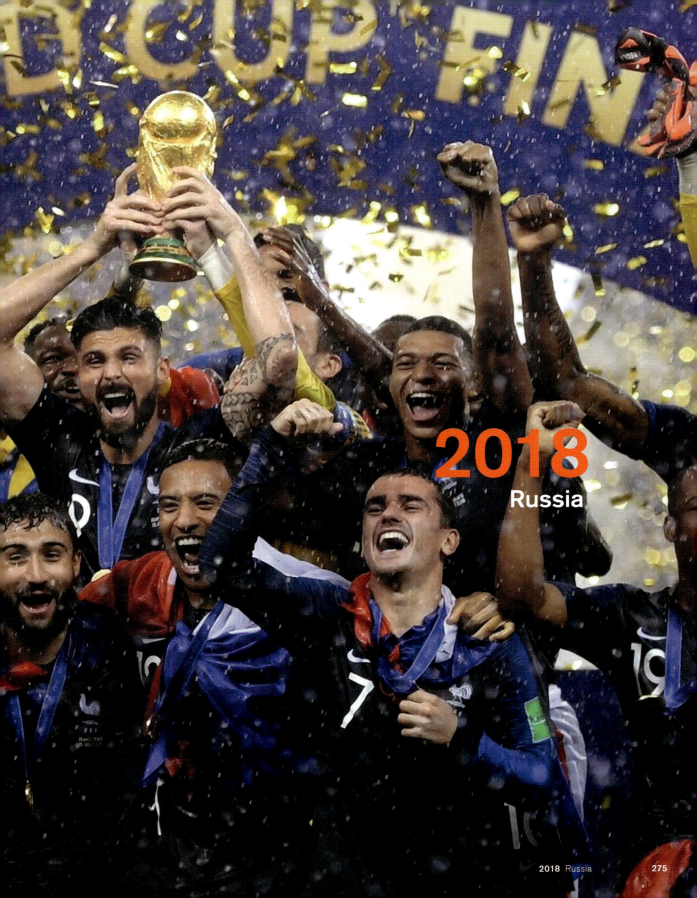

2018
Russia

2018 Russia

In 2018 the largest tournament on the planet was finally hosted by the largest nation on the planet and at a cost of $14bn. Despite the fact that Russia is so big most of the country is in Asia, the games were staged in its western cities, making it a European World Cup in what was the first time the tournament was held in eastern Europe (up to this point, the furthest east in Europe that the World Cup had been played in was Sweden in 1958).

16 Belgium were the tournament's top scoring team

There were some notable absentees from the 32 qualifying teams. The USA failed to reach the finals for the first time since 1990, despite being in the CONCACAF qualifying pool that many claim should be a walkover for any half-decent team. Instead it was Panama who qualified for their first tournament. The Chile team who were so impressive in the 2014 World Cup also failed to qualify, but most shocking of all was the absence of the Netherlands and Italy. For the Italians it was the first World Cup they had missed out on since 1958. Along with Panama, Iceland were also making their tournament debut, and with a population just short of 370,000 they set a record for being the country with the smallest population to ever compete in a World Cup. VAR beyond just goal-line technology also made its debut in 2018. For the first time, a referee could change their mind based on information fed via a person watching a screen in a room.

With the Dutch and Italians gone before the tournament had even kicked off, a door had already opened in which an outsider could perhaps progress all the way. This opportunity was compounded when in a huge upset the defending world champions and number one seeds Germany were eliminated in the group stage – their first exit so early since 1938. Argentina were gone by the second round, as were reigning

First Round Group A

Russia	5	0	Saudi Arabia
Uruguay	1	0	Egypt
Russia	3	1	Egypt
Uruguay	1	0	Saudi Arabia
Uruguay	3	0	Russia
Saudi Arabia	2	1	Egypt

	P	W	D	L	GD	Pts
Uruguay	3	3	0	0	5	9
Russia	3	2	0	1	4	6
Saudi Arabia	3	1	0	2	-5	3
Egypt	3	0	0	3	-4	0

First Round Group B

Iran	1	0	Morocco
Portugal	3	3	Spain
Portugal	1	0	Morocco
Spain	1	0	Iran
Iran	1	1	Portugal
Spain	2	2	Morocco

	P	W	D	L	GD	Pts
Spain	3	1	2	0	1	5
Portugal	3	1	2	0	1	5
Iran	3	1	1	1	0	4
Morocco	3	0	1	2	-2	1

First Round Group C

France	2	1	Australia
Denmark	1	0	Peru
Denmark	1	1	Australia
France	1	0	Peru
Denmark	0	0	France
Peru	2	0	Australia

	P	W	D	L	GD	Pts
France	3	2	1	0	2	7
Denmark	3	1	2	0	1	5
Peru	3	1	0	2	0	3
Australia	3	0	1	2	-3	1

First Round Group D

Argentina	1	1	Iceland
Croatia	2	0	Nigeria
Croatia	3	0	Argentina
Nigeria	2	0	Iceland
Argentina	2	1	Nigeria
Croatia	2	1	Iceland

	P	W	D	L	GD	Pts
Croatia	3	3	0	0	6	9
Argentina	3	1	1	1	-2	4
Nigeria	3	1	0	2	-1	3
Iceland	3	0	1	2	-3	1

European champions Portugal. Second favourites Brazil were eliminated in the quarter-final by Belgium. In the semi-finals two of the pre-tournament favourites, France and Belgium, played out a tight game in which the French progressed 1-0. The winner of the other semi would be an underdog given that England were seeded 12th and Croatia 20th. Croatia had convincingly beaten Argentina 3-0 in the group stage, but only just scraped through against the Russians on penalties in the quarter-final. The hosts had a great tournament and before the penalty shoot-out Russia had realistic ambitions of getting to the final, what with England looming in the semi-final for the first time since 1990.

Had England beaten Croatia, their presence in the final would have been hailed as a surprise given their low expectations before the tournament, but it would still have been the return of a former world champion and the rise of a former perennial contender after two abysmal World Cup showings in 2010 and 2014.

Harry Kane of England was the top scorer

Croatia's win, however, was something totally new; their presence in the final was unique in the modern history of the World Cup. Countries like Czechoslovakia and Hungary had both been finalists in the early years of the World Cup, but both were trailblazers for the game's tactical evolution. At that time it wasn't a surprise when those countries made it to the final, not to mention that the football world order and hierarchy had not been established in those early tournaments. When Hungary played West Germany in the 1954 final the Germans were the plucky underdogs, rather than Puskás and co.

First Round Group E

Serbia	1	0	Costa Rica
Brazil	1	1	Switzerland
Brazil	2	0	Costa Rica
Switzerland	2	1	Serbia
Brazil	2	0	Serbia
Switzerland	2	2	Costa Rica

	P	W	D	L	GD	Pts
Brazil	3	2	1	0	4	7
Switzerland	3	1	2	0	1	5
Serbia	3	1	0	2	-2	3
Costa Rica	3	0	1	2	-3	1

First Round Group F

Mexico	1	0	Germany
Sweden	1	0	South Korea
Mexico	2	1	South Korea
Germany	2	1	Sweden
South Korea	2	0	Germany
Sweden	3	0	Mexico

	P	W	D	L	GD	Pts
Sweden	3	2	0	1	3	6
Mexico	3	2	0	1	-1	6
South Korea	3	1	0	2	0	3
Germany	3	1	0	2	-2	3

First Round Group G

Belgium	3	0	Panama
England	2	1	Tunisia
Belgium	5	2	Tunisia
England	6	1	Panama
Belgium	1	0	England
Tunisia	2	1	Panama

	P	W	D	L	GD	Pts
Belgium	3	3	0	0	7	9
England	3	2	0	1	5	6
Tunisia	3	1	0	2	-3	3
Panama	3	0	0	3	-9	0

First Round Group H

Japan	2	1	Colombia
Senegal	2	1	Poland
Japan	2	2	Senegal
Colombia	3	0	Poland
Poland	1	0	Japan
Colombia	1	0	Senegal

	P	W	D	L	GD	Pts
Colombia	3	2	0	1	3	6
Japan	3	1	1	1	0	4
Senegal	3	1	1	1	0	4
Poland	3	1	0	2	-3	3

Croatia in international football used to be part of a far bigger pool of talent when they were immersed within Yugoslavia, and that country did reach the semi-finals in 1930 and 1962. However, as an independent country with just over four million people, Croatia fall just short of only Uruguay as being World Cup finalists with the smallest population. The Croatians had deserved their moment on the world stage, in front of an audience of over one billion people. They had been a solid contender in international football for 20 years since their World Cup semi-final against France in 1998, narrowly losing 2-1. In the same timeline the French reinvented themselves as the most consistent team in world football in a glorious 20-year period that included appearances in five major finals, winning three of them. They took an early lead when Croatian striker Mario Mandžukić became the first player to score an own goal in a World Cup Final. Croatia struck back with a great equaliser from Ivan Perišić, but Kylian Mbappé stole the show and scored France's final goal in a 4-2 thriller; the highest-scoring final since 1966. Mbappé, aged just 19, became the first teenager to score in a World Cup Final since Pelé in 1958. The last goal was scored by Mandžukić, this time in the opposition goal, making him the only player to score for both sides in a World Cup Final.

World Cup debutants: Iceland, Panama

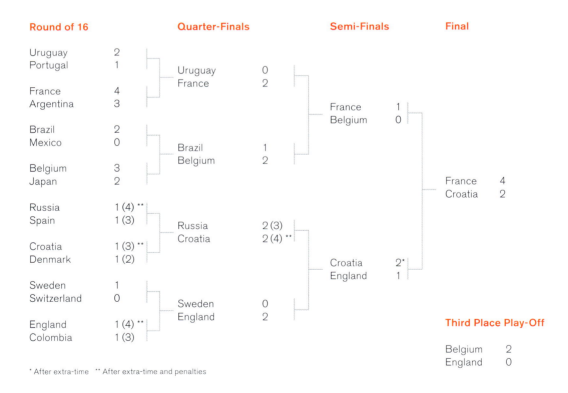

Round of 16		Quarter-Finals		Semi-Finals		Final	
Uruguay	2						
Portugal	1	Uruguay	0				
		France	2				
France	4			France	1		
Argentina	3			Belgium	0		
Brazil	2						
Mexico	0	Brazil	1				
		Belgium	2			France	4
Belgium	3					Croatia	2
Japan	2						
Russia	1 (4) **						
Spain	1 (3)	Russia	2 (3)				
		Croatia	2 (4) **				
Croatia	1 (3) **			Croatia	2*		
Denmark	1 (2)			England	1		
Sweden	1						
Switzerland	0	Sweden	0				
		England	2				
England	1 (4) **						
Colombia	1 (3)						

Third Place Play-Off

Belgium	2
England	0

* After extra-time ** After extra-time and penalties

6 July 2018, Kazan Arena, Kazan
Brazil's Fernandinho (right) looks on in despair as his header puts Belgium 1-0 up. De Bruyne scored a brilliant second goal in a 2-1 victory that advanced his team to the semi-final.

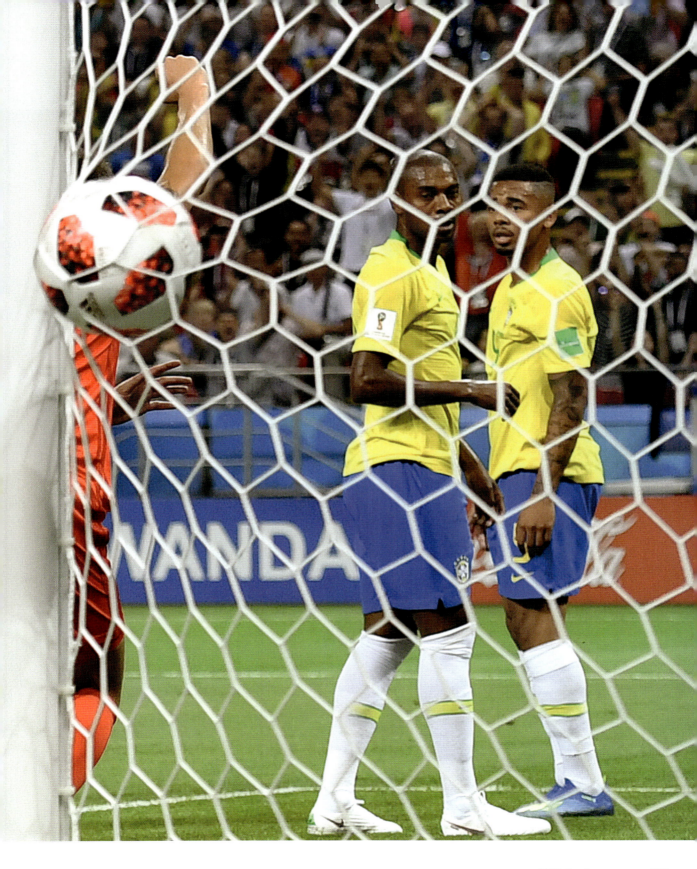

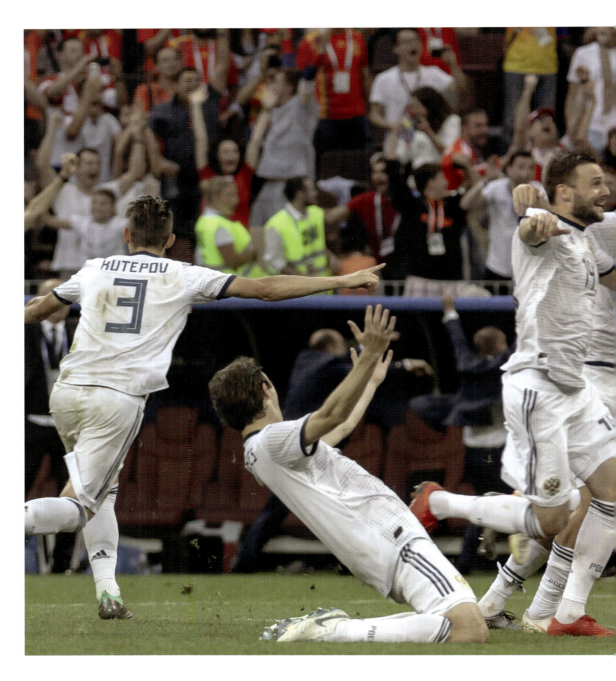

1 July 2018, Luzhniki Stadium, Moscow
Jubilation for Russia as they beat Spain 4-3 on penalties in the round of 16. The hosts had a good tournament but would lose in the quarter-finals on penalties to Croatia.

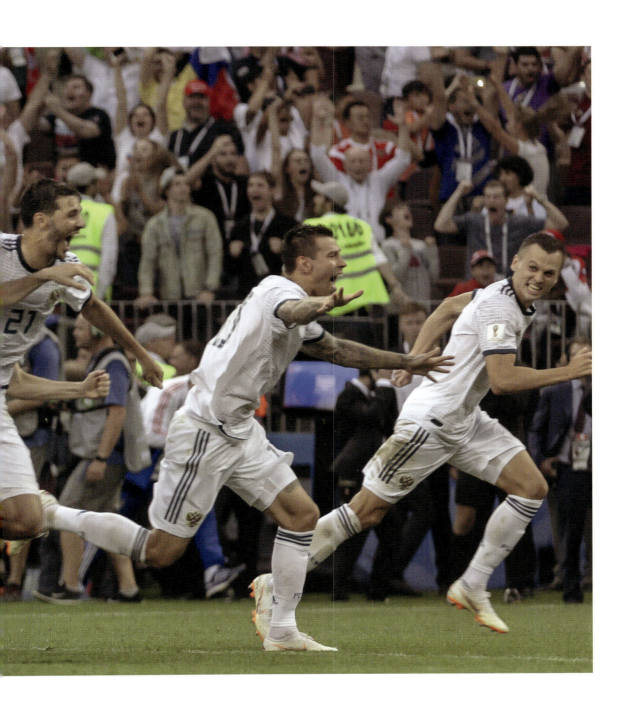

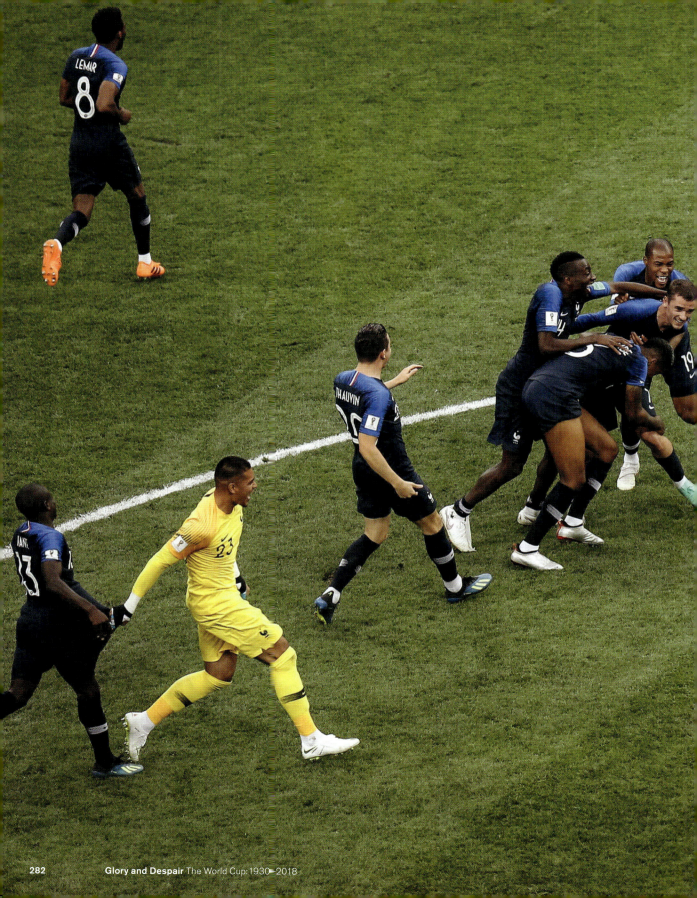

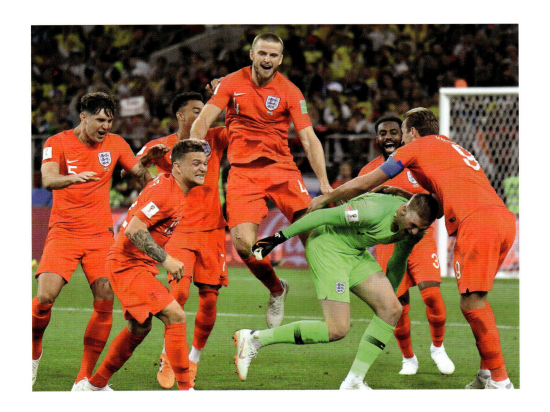

15 July 2018, Luzhniki Stadium, Moscow
France celebrate beating Croatia 4-2 in the
final in Moscow.

3 July 2018, Otkritie Arena, Moscow
England players can't believe that they have won a penalty
shoot-out against Colombia. The game ended 1-1 after
120 minutes and England won the shoot-out 4-3.

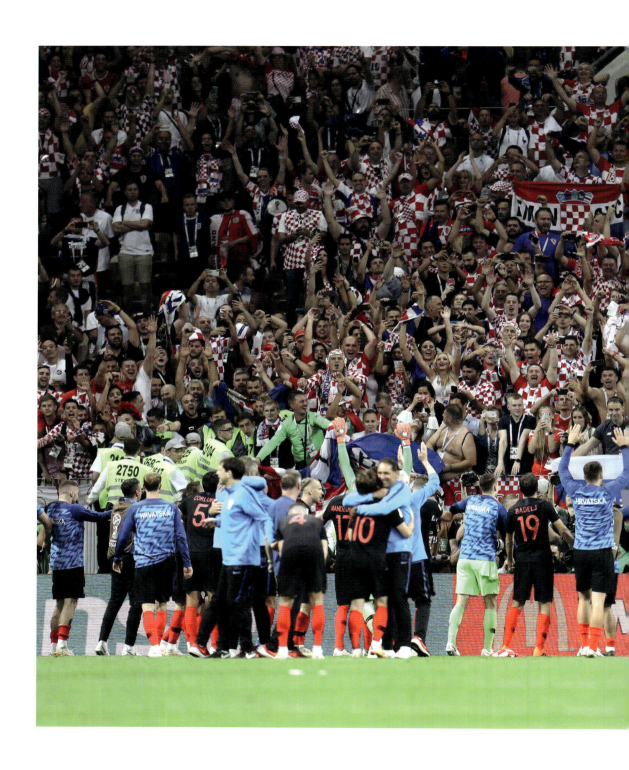

Glory and Despair The World Cup: 1930–2018

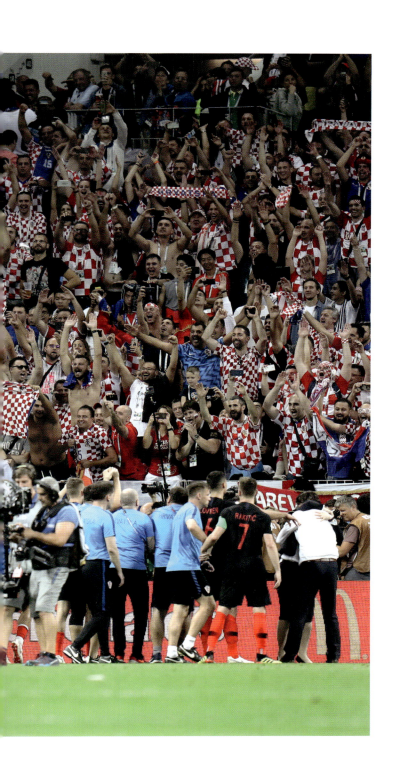

11 July 2018, Luzhniki Stadium, Moscow
Croatia players and fans celebrate the greatest
moment in their football history. They have
beaten England in the semi-final 2-1, after
being a goal down in the opening minutes. Their
presence in the final was unexpected given that
they were 20th seed before the tournament.

All-Time Participation

	Tournaments	Games	Won	Drawn	Lost	GF	GA	GD	Points
Brazil	21	109	73	18	18	229	105	124	237
Germany	19	109	67	20	22	226	125	101	221
Italy	18	83	45	21	17	128	77	51	156
Argentina	17	81	43	15	23	137	93	44	144
France	15	66	34	13	19	120	77	43	115
England	15	69	29	21	19	91	64	27	108
Spain	15	63	30	15	18	99	72	27	105
Netherlands	10	50	27	12	11	86	48	27	93
Uruguay	13	56	24	12	20	87	74	13	84
Sweden	12	51	19	13	19	80	73	7	70
Belgium	13	48	20	9	19	68	72	-4	69
Russia/Soviet Union	11	45	19	10	16	77	54	23	67
Serbia/Yugoslavia	12	46	18	8	20	66	63	3	62
Mexico	16	57	16	14	27	60	98	-38	62
Poland	8	34	16	5	13	46	45	1	53
Hungary	9	32	15	3	14	87	57	30	48
Portugal	7	30	14	6	10	49	35	14	48
Switzerland	11	37	12	8	17	50	64	-14	44
Czech Republic/Czechoslovakia	9	33	12	5	16	47	49	-2	41
Austria	7	29	12	4	13	43	47	-4	40
Chile	9	33	11	7	15	40	49	-9	40
Croatia	5	23	11	4	8	35	26	9	37
Denmark	5	20	9	5	6	30	26	4	32
Paraguay	8	27	7	10	10	30	38	-8	31
Colombia	6	22	9	3	10	32	30	2	30
USA	10	33	8	6	19	37	62	-25	30
Romania	7	21	8	5	8	30	32	-2	29
South Korea	10	34	6	9	19	34	70	-36	27
Nigeria	6	21	6	3	12	23	30	-7	21
Japan	6	21	5	5	11	20	29	-9	20
Costa Rica	5	18	5	5	8	19	28	-9	20
Scotland	8	23	4	7	12	25	41	-16	19
Cameroon	7	23	4	7	12	18	43	-25	19
Peru	5	18	5	3	10	21	33	-12	18
Bulgaria	7	26	3	8	15	22	53	-31	17
Turkey	2	10	5	1	4	20	17	3	16
Ghana	3	12	4	3	5	13	16	-3	15
Republic of Ireland	3	13	2	8	3	10	10	0	14
Northern Ireland	3	13	3	5	5	13	23	-10	14

	Tournaments	Games	Won	Drawn	Lost	GF	GA	GD	Points
Ecuador	3	10	4	1	5	10	11	-1	13
Senegal	2	8	3	3	2	11	10	1	12
Algeria	4	13	3	3	7	13	19	-6	12
Morocco	5	16	2	5	9	14	22	-8	11
Saudi Arabia	5	16	3	2	11	11	39	-28	11
Ivory Coast	3	9	3	1	5	13	14	-1	10
South Africa	3	9	2	4	3	11	16	-5	10
Tunisia	5	15	2	4	9	13	25	-12	10
Iran	5	15	2	4	9	9	24	-15	10
Australia	5	16	2	4	10	13	31	-18	10
Norway	3	8	2	3	3	7	8	-1	9
Greece	3	10	2	2	6	5	20	-15	8
Ukraine	1	5	2	1	2	5	7	-2	7
Wales	1	5	1	3	1	4	4	0	6
Slovakia	1	4	1	1	2	5	7	-2	4
Slovenia	2	6	1	1	4	5	10	-5	4
Cuba	1	3	1	1	1	5	12	-7	4
North Korea	2	7	1	1	5	6	21	-15	4
Bosnia & Herzegovina	1	3	1	0	2	4	4	0	3
Jamaica	1	3	1	0	2	3	9	-6	3
New Zealand	2	6	0	3	3	4	14	-10	3
Honduras	3	9	0	3	6	3	14	-11	3
Angola	1	3	0	2	1	1	2	-1	2
Israel	1	3	0	2	1	1	3	-2	2
Egypt	3	7	0	2	5	5	12	-7	2
Iceland	1	3	0	1	2	2	5	-3	1
Kuwait	1	3	0	1	2	2	6	-4	1
Trinidad & Tobago	1	3	0	1	2	0	4	-4	1
Bolivia	3	6	0	1	5	1	20	-19	1
Iraq	1	3	0	0	3	1	4	-3	0
Togo	1	3	0	0	3	1	6	-5	0
Canada	1	3	0	0	3	0	5	-5	0
Indonesia/Dutch East Indies	1	1	0	0	1	0	6	-6	0
Panama	1	3	0	0	3	2	11	-9	0
United Arab Emirates	1	3	0	0	3	2	11	-9	0
China	1	3	0	0	3	0	9	-9	0
Haiti	1	3	0	0	3	2	14	-12	0
DR Congo/Zaire	1	3	0	0	3	0	14	-14	0
El Salvador	2	6	0	0	6	1	22	-21	0

More from Matt Bazell

I would like to thank everyone who has bought a copy of this book for supporting authors and print media. Thanks to my parents Catherine Bazell and Ben Bazell for proofreading duties. I would like to say thanks to Pitch Publishing for sharing the same vision of the book as I did, and for being easy to work with. I'd like to dedicate the book to my nieces the double V's....Veronica Bazell and Vivienne Delaney.

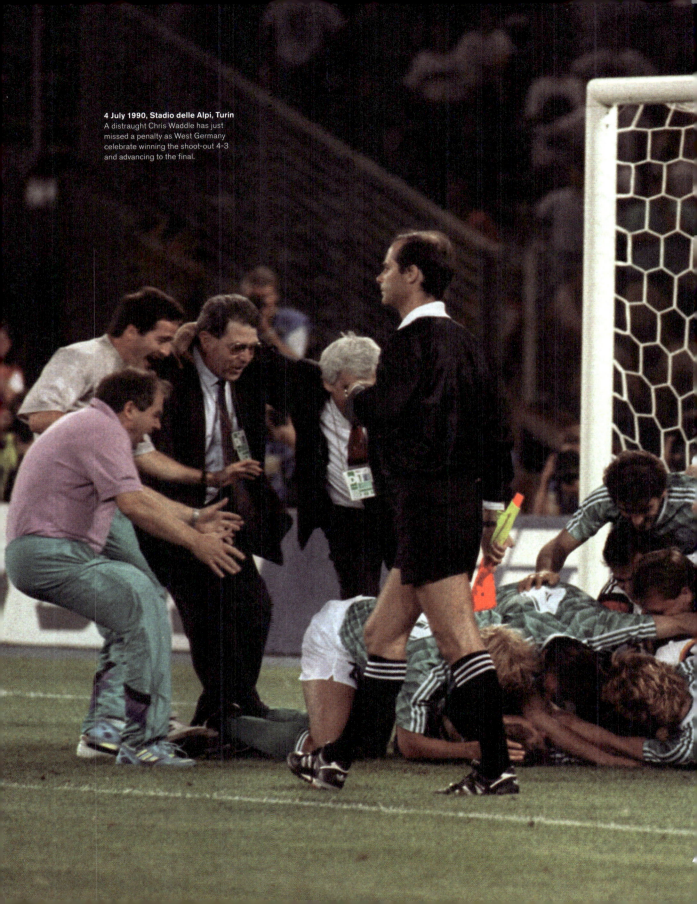

4 July 1990, Stadio delle Alpi, Turin
A distraught Chris Waddle has just missed a penalty as West Germany celebrate winning the shoot-out 4-3 and advancing to the final.